MANGA MANIA™

Magical Girls

WATSON-GUPTILL PUBLICATIONS/NEW YORK

and Friends

HOW TO DRAW THE SUPERPOPULAR ACTION-FANTASY CHARACTERS OF MANGA

CHRISTOPHER HART

Dedicated to my daughters,
the two most magical girls I know

Special Thanks

To my publishers at Watson-Guptill, MADA Design, and, of course, to my readers (yes, that means you guys!)

Executive Editor: Candace Raney
Designer: Bob Fillie, Graphiti Design, Inc.

First published in 2006 by
Watson-Guptill Publications
Nielsen Business Media
a division of the Nielsen Company
770 Broadway
New York, NY 10003
www.watsonguptill.com

Library of Congress Cataloging-in-Publication Data
Hart, Christopher.
 Manga mania magical girls and friends : how to draw
the super-popular action-fantasy characters of manga /
Christopher Hart.
 p. cm.
 Includes index.
 ISBN-13: 978-0-8230-2968-6 (pbk.)
 ISBN-10: 0-8230-2968-9 (pbk.)
 1. Girls in art. 2. Magic in art. 3. Comic books, strips,
etc.--Japan--Technique. 4. Cartooning--Technique. I. Title.
 NC1764.8.G57H37 2006
 741.53522'42--dc22
 2006007522

Typeset in Stone Sans, Harrington, Apple Chancery, League Night, Coronet

Printed in China

2 3 4 5 6 7 8 9 / 14 13 12 11 10 09 08 07

Contributing Artists:

Denise Akemi: 90–95, 104–109
Anzu: 12, 13, 47–49, 64–73
Diana Fernandez Devora: 18, 28–31, 122, 123
Vanessa Duran: 32, 33, 39–41, 50, 51, 54, 55, 76–89
Chris Hart: 23–27
Makiko Kanada: 96–99, 124–129
Chihiro Milley: 44–46, 56–63
Roberta Pares: 1, 4, 6, 38, 52, 53, 130, 134–143
PH: 8, 14, 15, 42, 43, 74, 75, 100, 110–115
Aurora Garcia Tejado: 16, 17, 101–103
Nao Yazawa: 2, 3, 9–11, 19–22, 34–37, 116–121, 131–133

Color by MADA Design, Inc., except for pages 44–46, 71, 73 by Anzu and 47–49, 56–63 by Chihiro Milley

VISIT US AT

www.artstudiollc.com

Contents

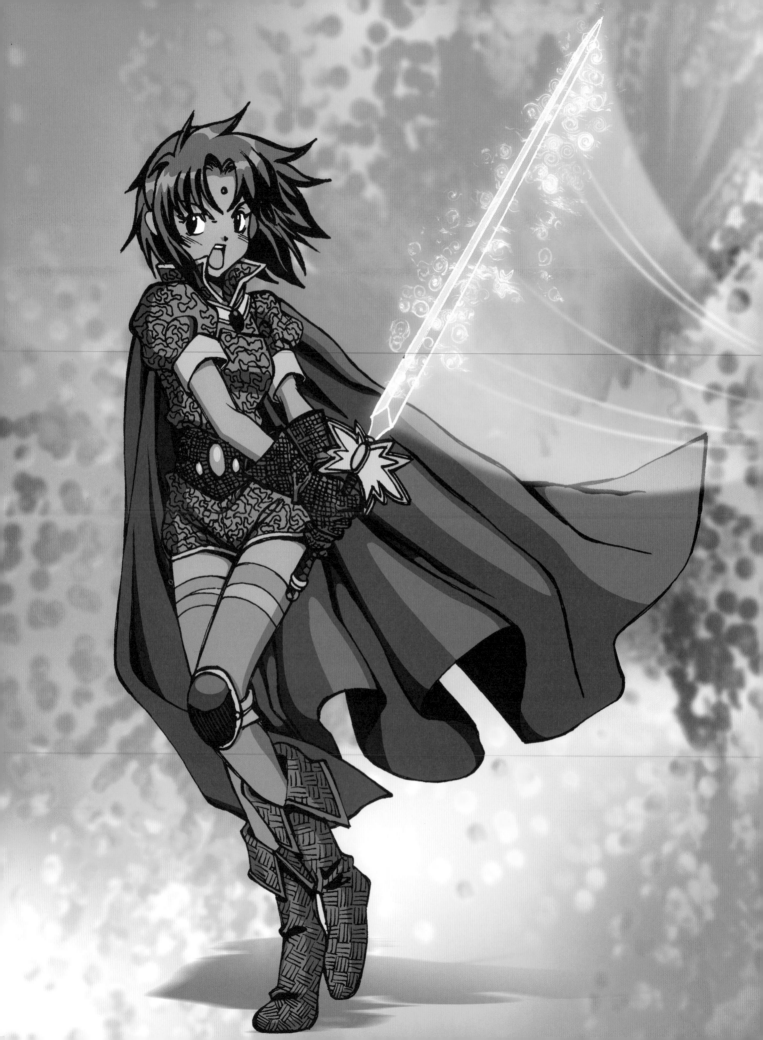

Introduction

THE MAGICAL GIRL CATEGORY is a huge part of the famous shoujo (pronounced show-joe) genre of manga. Shoujo is the giant genre that focuses on the charming look of Japanese comics, and leans more toward female characters and relationships. However, the readership is both male and female in North America, as well as in Japan.

The Magical Girl subgenre is a particularly popular twist on the shoujo theme—and perhaps the most popular of all. It owns a fiercely loyal fan base. Don't be surprised to see some of the most popular manga titles in this category. Among them are: *Sailor Moon*, *Magic Knight Rayearth*, *Saint Tail*, *Fushigi Yuugi*, *Cutey Honey*, *Tokyo Mew Mew*, *Card Captor Sakura*, *Magical Angel Sweet Mint*, and *Pretty Sammy*.

Magical girls are, typically, schoolgirls who are suddenly called upon to save another world that's in danger. To do this, they are given special powers that transform them into superidealized "magical" versions of themselves, which are glamorous and amazing. Sometimes, a magical girl can be sent from another world to come to Earth and fit in as an Earth girl, which is difficult given the superior powers that she must keep under control if she is to conceal her secret identity.

These stories show how ordinary girls are really extraordinary, and how we all possess amazing abilities if only we look deep within ourselves. These stories are packed with an abundance of compelling characters in addition to the magical girl. There are the magical girl's classmates, who sometimes also transform to create a team of magical fighters. There's the handsome, slightly older boy on whom the magical girl has a secret crush. There are the magical boys, who may also come from another dimension and who fight on the same side as the magical girls. And then there's everybody's favorite: the manga mascot! It's the cute, little, furry and squeezable sidekick. This humorous monster-creature helps the magical girl—or at least tries to but ends up getting in trouble more times than not.

This book will take you through all of the techniques you need to draw the newest breed of magical girls and their friends, from how to draw magical girl faces and body proportions, action poses, costumes, expressions, magical transformations, and special effects to designing funny mascots, magical boys, supporting characters, and layouts to creating girl fighting teams and more. There's no other book like this one—if you're a manga fan, this is a must-have. So put a little magic in your arsenal of drawing techniques, and let's get ready to bring some adventure to our sketch pads!

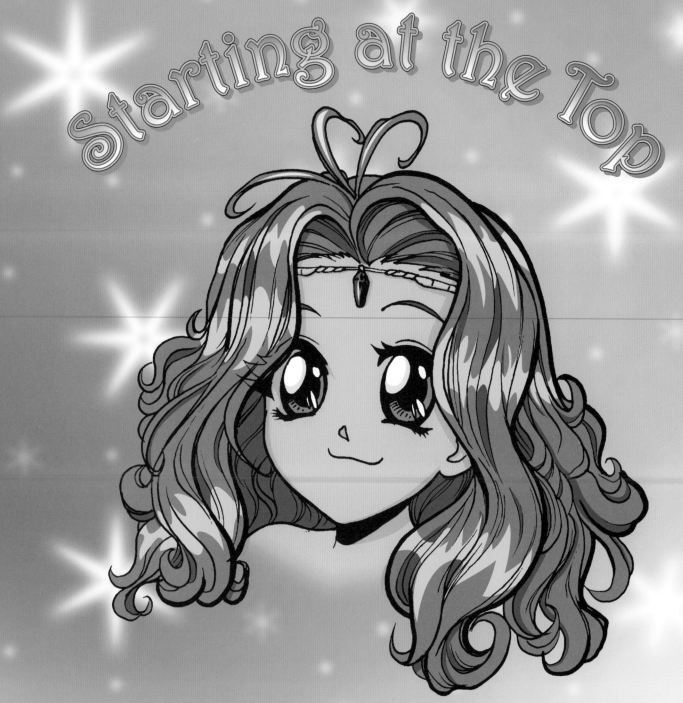

The magical girl's face is open, charming, and appealing. She is most often represented as being in the tween years. Although she's growing into adolescent proportions, she still retains the soft contours, roundness, big features, and innocent eyes of a youngster. This makes for a compelling leading character. Steer clear of sharp angles, place large eyes far apart, and draw a petite nose and mouth. With these basics in mind, everything else will begin to fall into place.

Magical Girl Faces

The face of the magical girl retains the soft, round look of a preteen but with the feminine features of an older teenager, notably the heavy eyeliner and eyelashes. The magical girl should have a friendly, youthful face, which you can give her by drawing large eyes. Leave a good amount of space between the eyelids and the eyeball. That makes her look sincere and honest. Keep her face on the round side. If you make it too angular or sleek, she'll look older and less innocent.

It's very important, when drawing the front view, to use horizontal guidelines so that you make sure to keep both eyes, as well as both ears, at the same level. You don't want one to look higher than the other!

Front View

Head is a simple egg shape.

Center line.

Headband never goes straight across, but dips in the middle.

Eyes and nose are on the same level.

Sculpt chin to a point.

Thin neck.

Eyelids rise up, off the eyes.

Add a tiny shadow off one side of the nose.

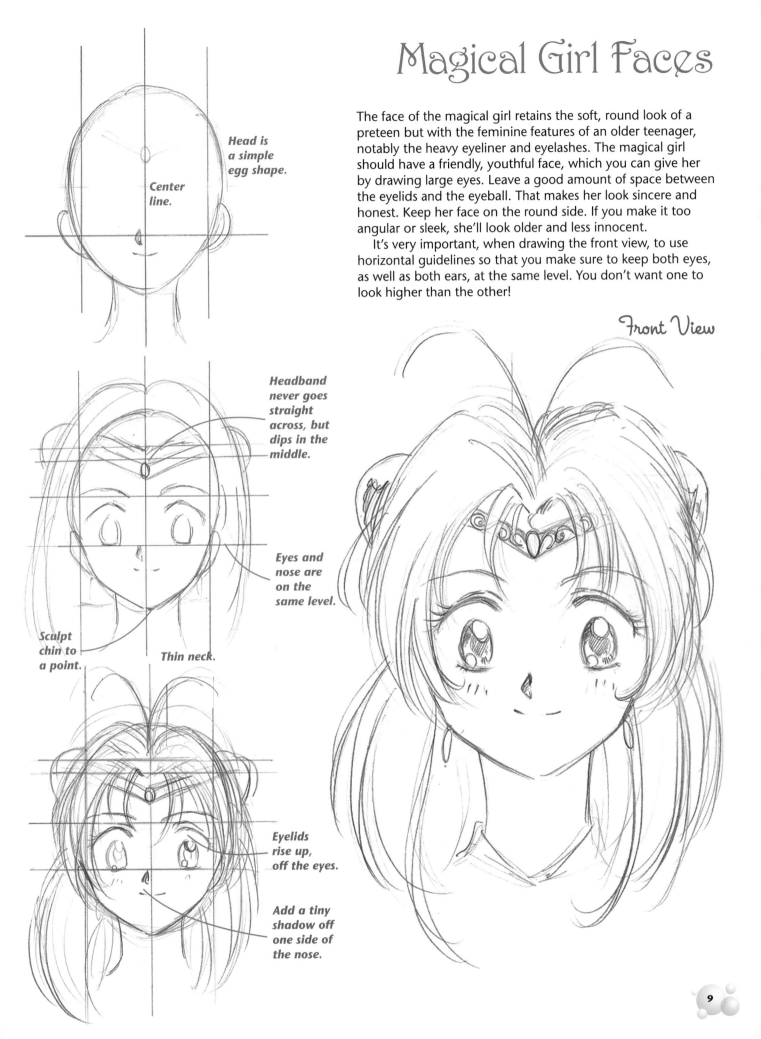

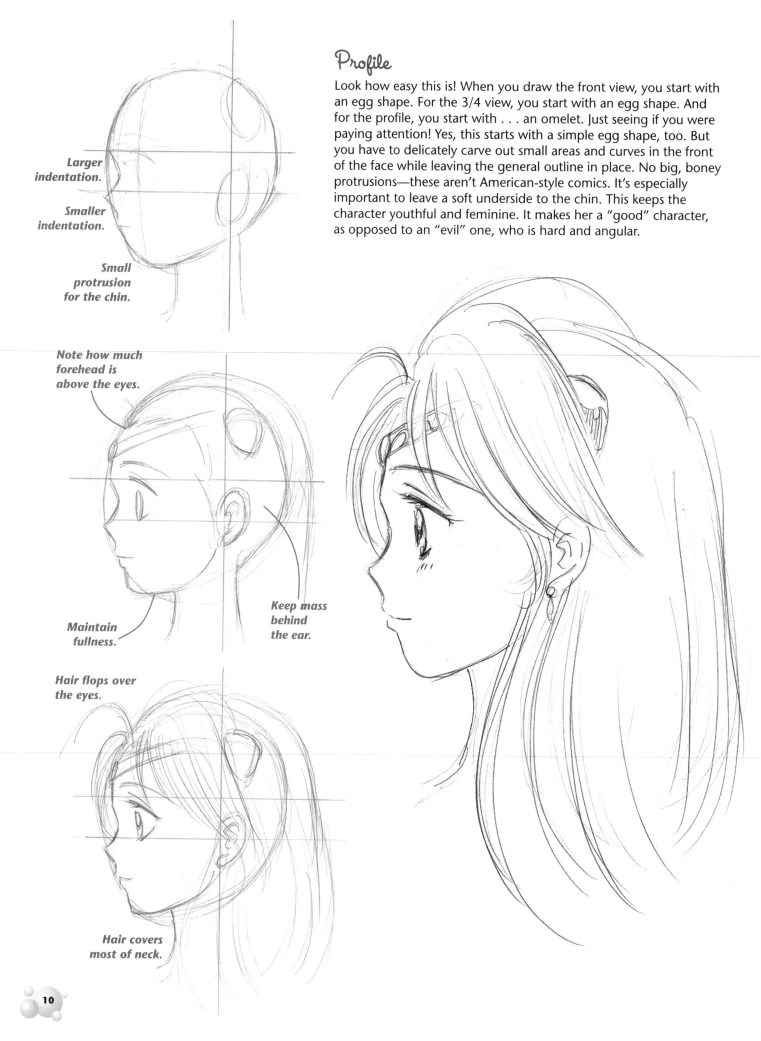

Profile

Look how easy this is! When you draw the front view, you start with an egg shape. For the 3/4 view, you start with an egg shape. And for the profile, you start with . . . an omelet. Just seeing if you were paying attention! Yes, this starts with a simple egg shape, too. But you have to delicately carve out small areas and curves in the front of the face while leaving the general outline in place. No big, boney protrusions—these aren't American-style comics. It's especially important to leave a soft underside to the chin. This keeps the character youthful and feminine. It makes her a "good" character, as opposed to an "evil" one, who is hard and angular.

Larger indentation.

Smaller indentation.

Small protrusion for the chin.

Note how much forehead is above the eyes.

Maintain fullness.

Keep mass behind the ear.

Hair flops over the eyes.

Hair covers most of neck.

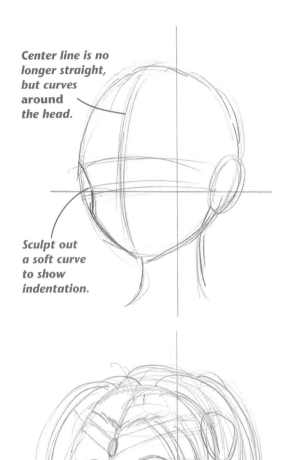

Center line is no longer straight, but curves around the head.

Sculpt out a soft curve to show indentation.

Nose goes on the center line.

Neck indents just behind the point of the chin.

3/4 View

In this pose, try to maintain the soft curves that appear in the outline of the front of the face. This will make her look young and charming. If the line gets too angular, you run the risk of making her look hard. In this angle, it's important to draw the far eye in perspective, which means drawing it more slender than the near eye. This helps give the head a round look. Also, even though you start with the same egg shape as in the front view, you have to chip away at it in order to get the natural indentation that occurs at the far eye socket.

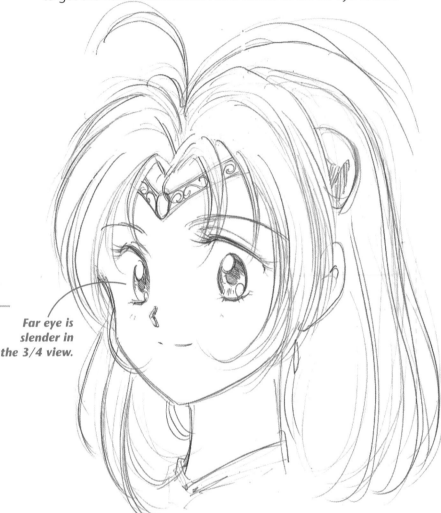

Far eye is slender in the 3/4 view.

What Makes a Magical Girl?

The magical girl is a derivation of the types of characters found in shoujo (Japanese comics aimed at young girls); however, magical girls are of a more specific age range than shoujo characters. Shoujo characters can be anywhere from 6 to 16 years old. But magical girls are usually in the 10- to 16-year age range, most often 14 years old. So, that narrows it down considerably. This is a girl in transition between girlhood and womanhood. That's the nature of the magical girl genre. The magical girl starts out as a typical schoolgirl. Her transformation—via a glamorous costume, and amplified by special powers—gives her a new identity. She would be the last person in the world to believe that something amazing was about to happen to her.

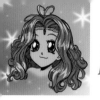

Magical Eyes

The eyes of the magical girl must be captivating and enchanting. For that to happen, they've got to be the center of attention of the face. They must pull the reader's attention away from everything else. Manga characters are, by definition, set up to feature the eyes as the center of focus. Manga eyes are oversized, contrasting with the rest of the facial features, which are "underdrawn."

For magical girls, however, more glamour is required. Use of heavier lines for the eyelids and more detail for the eyelashes is necessary. To make the eyeball itself sparkle, you'll need to use contrast. That means you need to draw shines amidst heavy pools of black. Shines only "sparkle" when surrounded by dark areas. But if the dark area is pure black, the shines may end up looking like white spots, not reflective or moist, which is what you're after.

Manga artists have developed very effective methods of creating brilliant canvases on which to lay down their eye shines. They use solid black areas that radiate outward into streaked lines that mimic the look of irises. The results are so effective that the eyes seem to almost glitter. This streaked effect—migrating out of the pools of darkness, combined with multiple shines of varying sizes—makes the eyes really pop. In addition, note the natural path that the eyelashes take, as well as the heavy lines of the eyelids. Remember this rule: The heavier the eyelids, the more glamorous the eye!

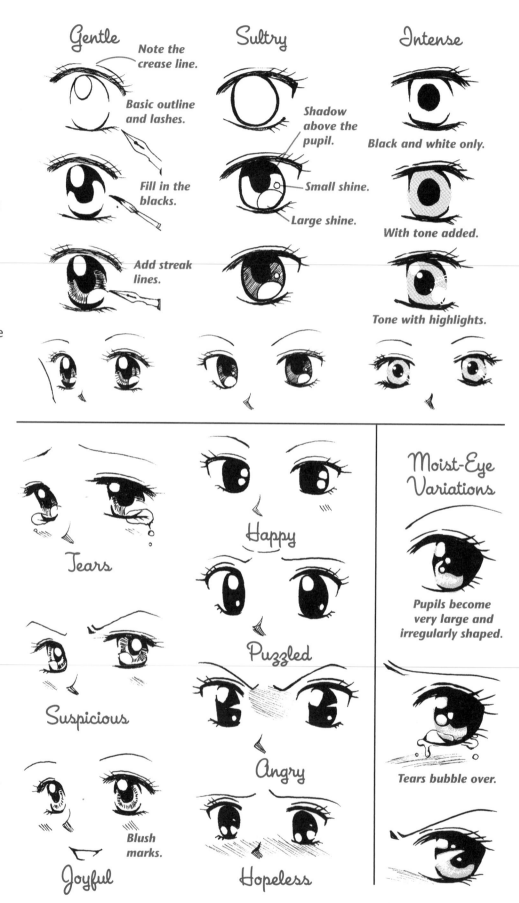

Gentle — Note the crease line. Basic outline and lashes. Fill in the blacks. Add streak lines.

Sultry — Shadow above the pupil. Small shine. Large shine.

Intense — Black and white only. With tone added. Tone with highlights.

Tears

Suspicious

Joyful — Blush marks.

Happy

Puzzled

Angry

Hopeless

Moist-Eye Variations — Pupils become very large and irregularly shaped. Tears bubble over.

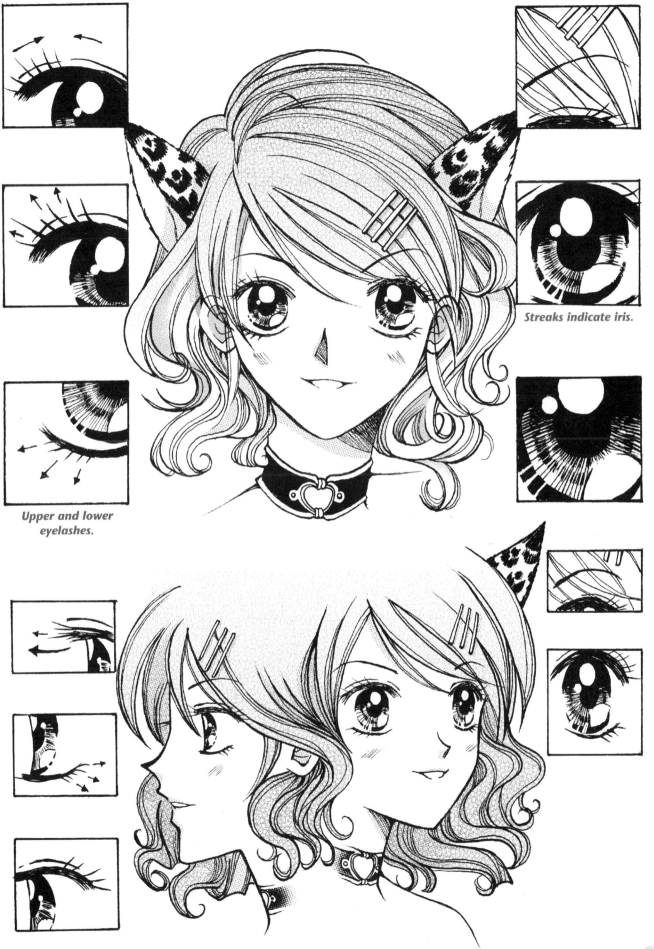

Streaks indicate iris.

Upper and lower eyelashes.

The Magical Salon

Ready for your magical makeover? This is the only salon where the customer comes out with more hair than when she came in! When a magical girl transforms, her hair—like everything else—goes into glamour and grace overdrive. It becomes longer, more flowing, more dramatic—a real eye-catcher. But—and here's a secret that most people won't tell you—you have to work backward to achieve this effectively. What do I mean by that? You don't want to start with a character who's too charismatic, too over-the-top to begin with; otherwise, you'll have nowhere to go. You'd have to exaggerate her to ridiculous lengths to transform her into a magical girl. Remember, you want her to look idealized as a magical girl, not bizarre. The whole conceit of the magical girl genre is that any "average" girl can turn into a superstar.

It's a concept that pops up in many cultures: Remember how "average" Lois Lane became Superman's girlfriend? It's more dramatic if something spectacular happens to someone ordinary. That way, everyone can relate to it. So make your life easier—start with a character whose hair isn't wildly cutting edge to begin with. Then, when she transforms, you'll have more room to play with.

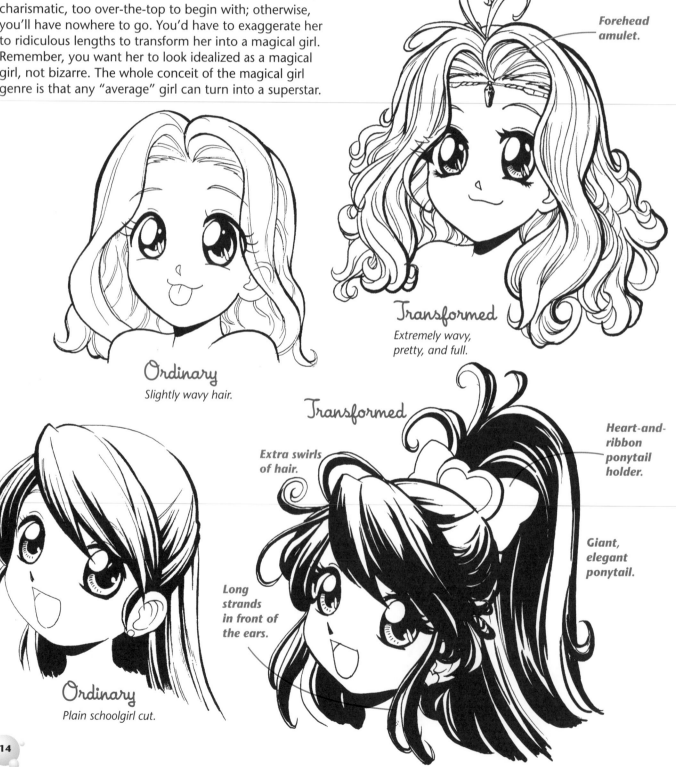

Forehead amulet.

Ordinary
Slightly wavy hair.

Transformed
Extremely wavy, pretty, and full.

Transformed

Extra swirls of hair.

Heart-and-ribbon ponytail holder.

Long strands in front of the ears.

Giant, elegant ponytail.

Ordinary
Plain schoolgirl cut.

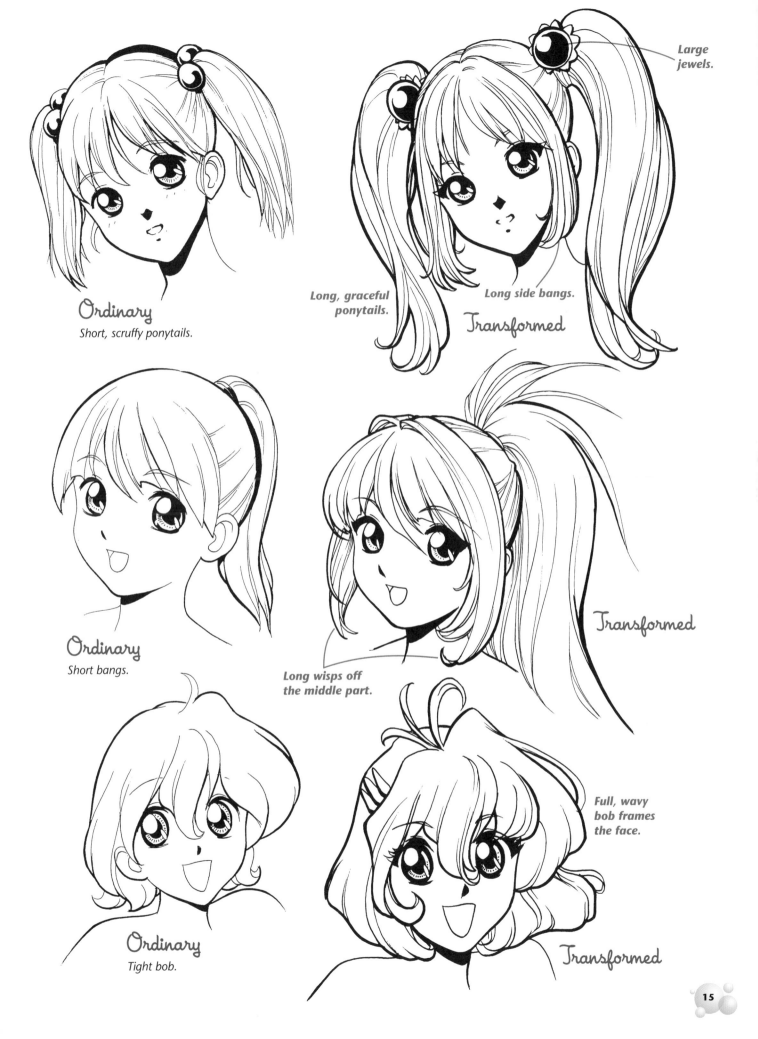

Large jewels.

Ordinary

Short, scruffy ponytails.

Long, graceful ponytails.

Long side bangs.

Transformed

Ordinary

Short bangs.

Long wisps off the middle part.

Transformed

Ordinary

Tight bob.

Full, wavy bob frames the face.

Transformed

15

Expressions

Okay, let's set down the ground rules: You must draw expressions exactly like this and never vary them. KIDDING!!! You can draw them any way you like—hey, you're the artist. What I'm showing you are the classic renderings of magical girl expressions. In other words, you can't go wrong by drawing expressions like the ones shown here. However, if you want to make adjustments and add your own personal touches to these examples, great. Use these as a starting point, a springboard for your own creations. And keep in mind that just because magical girls are pretty and graceful doesn't mean that they don't clown around. You know from reading your favorite manga that even the prettiest magical girls can be giant klutzes! Go broad with expressions and attitudes.

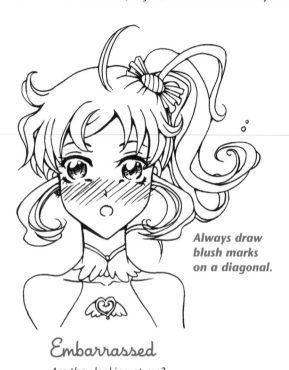

Always draw blush marks on a diagonal.

Embarrassed

Are they looking at me?

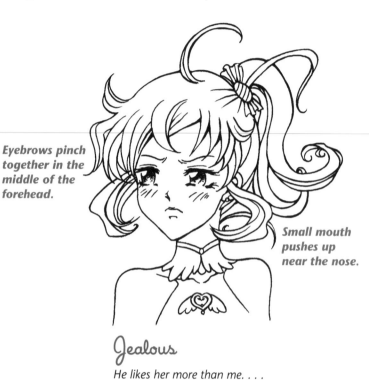

Eyebrows pinch together in the middle of the forehead.

Small mouth pushes up near the nose.

Jealous

He likes her more than me. . . .

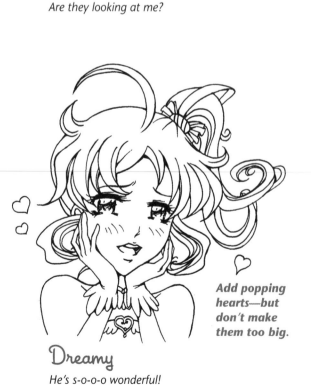

Add popping hearts—but don't make them too big.

Dreamy

He's s-o-o-o wonderful!

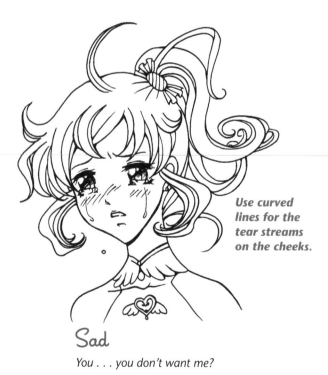

Use curved lines for the tear streams on the cheeks.

Sad

You . . . you don't want me?

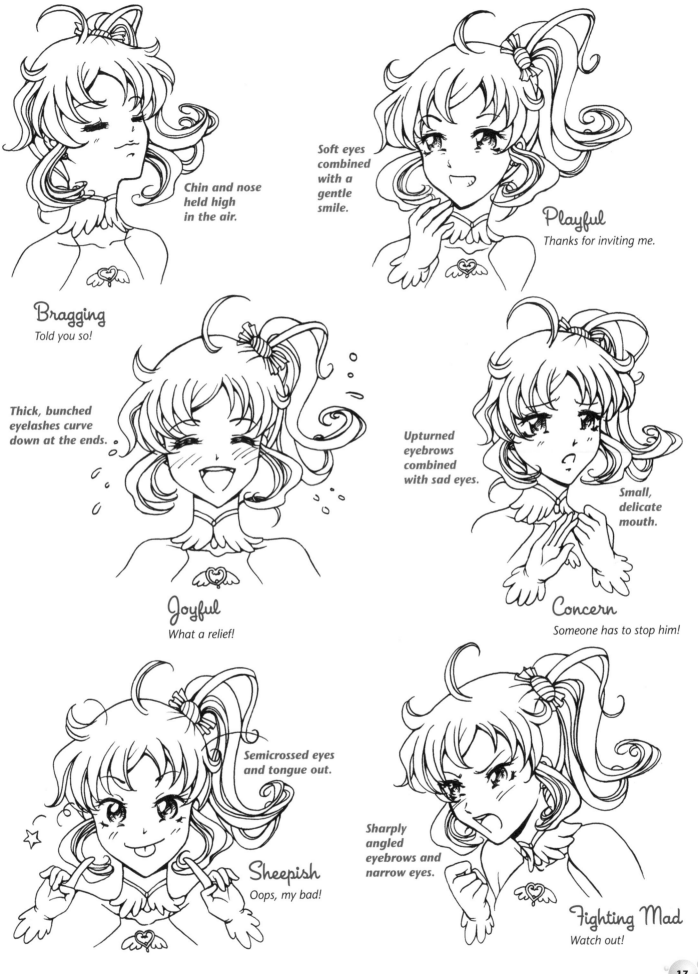

Chin and nose held high in the air.

Bragging

Told you so!

Soft eyes combined with a gentle smile.

Playful

Thanks for inviting me.

Thick, bunched eyelashes curve down at the ends.

Joyful

What a relief!

Upturned eyebrows combined with sad eyes.

Small, delicate mouth.

Concern

Someone has to stop him!

Semicrossed eyes and tongue out.

Sheepish

Oops, my bad!

Sharply angled eyebrows and narrow eyes.

Fighting Mad

Watch out!

The Body

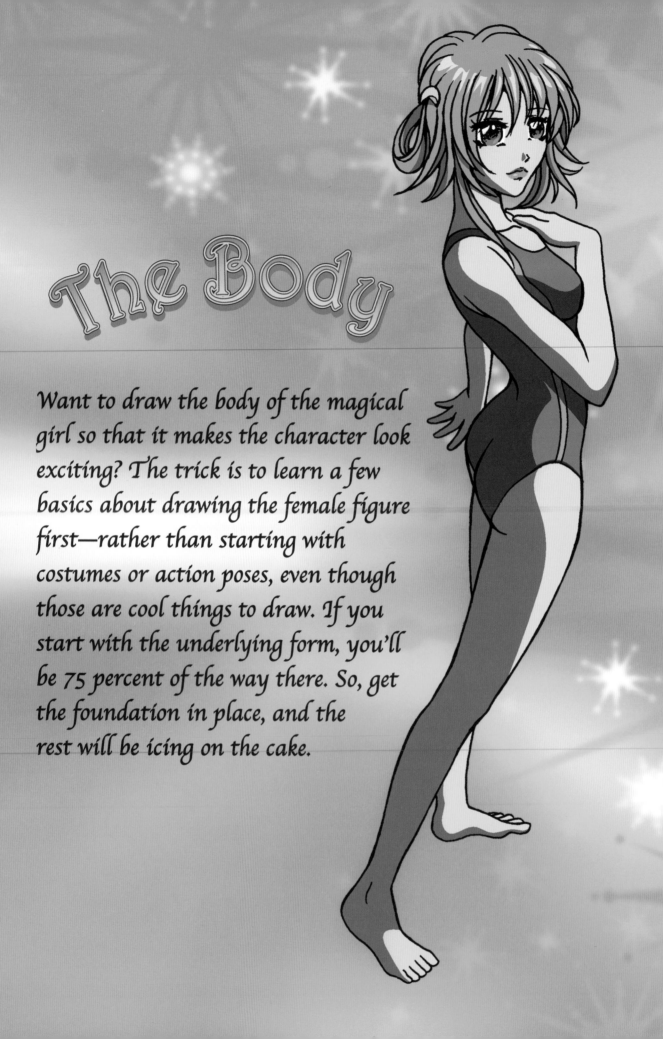

Want to draw the body of the magical girl so that it makes the character look exciting? The trick is to learn a few basics about drawing the female figure first—rather than starting with costumes or action poses, even though those are cool things to draw. If you start with the underlying form, you'll be 75 percent of the way there. So, get the foundation in place, and the rest will be icing on the cake.

Schoolgirl vs. Magical Girl

Before we go into how to actually construct the bodies, it's important to note the subtle proportion differences between an ordinary schoolgirl (*before* her transformation) and a magical girl (*after* the transformation). A magical girl is actually a bit taller than a regular schoolgirl—it's almost unnoticeable really, but the added length makes her appear more graceful. The extra height is added in the legs only. The torso, neck, and head retain the same basic proportions but are refined so that the figure has more of an hourglass shape—and the uniform is formfitting to reveal it.

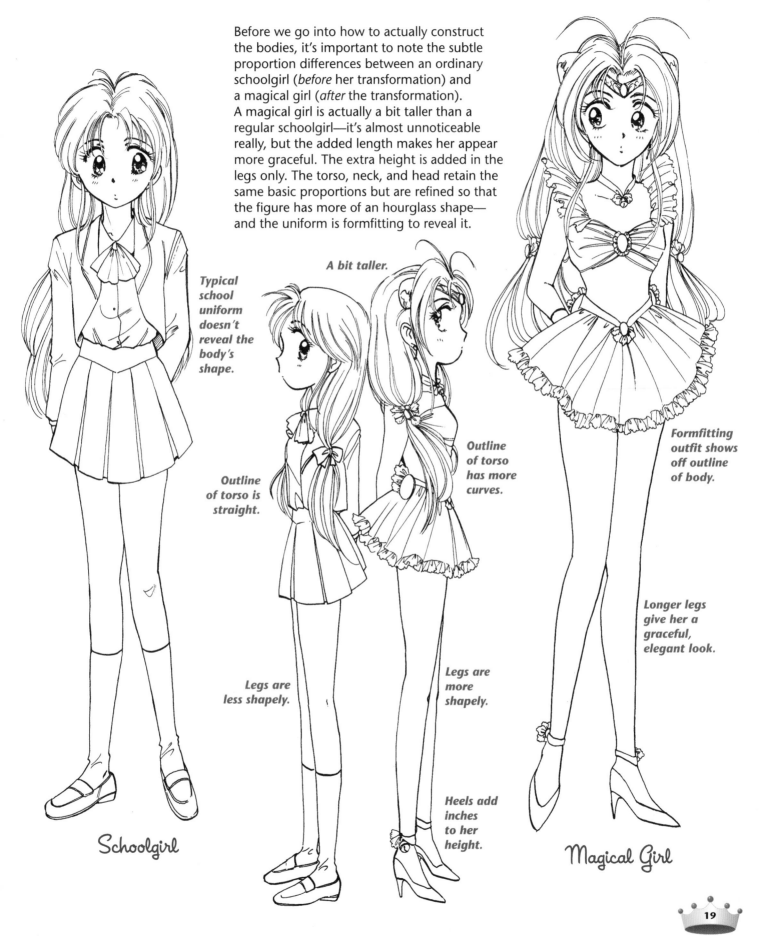

Typical school uniform doesn't reveal the body's shape.

A bit taller.

Outline of torso is straight.

Outline of torso has more curves.

Formfitting outfit shows off outline of body.

Legs are less shapely.

Legs are more shapely.

Longer legs give her a graceful, elegant look.

Heels add inches to her height.

Schoolgirl

Magical Girl

Where to Add the Extra Height

By lightly sketching horizontal guidelines across the pit of the neck and the hips of both the magical girl and the schoolgirl, you can see that the proportions of the two upper bodies are identical. But when you draw a guideline at the ankles of the schoolgirl, you see that it doesn't match up with the ankles of the magical girl, whose legs have been lengthened to give her extra height. The longer legs give her that "runway model" look—proportions that add glamour.

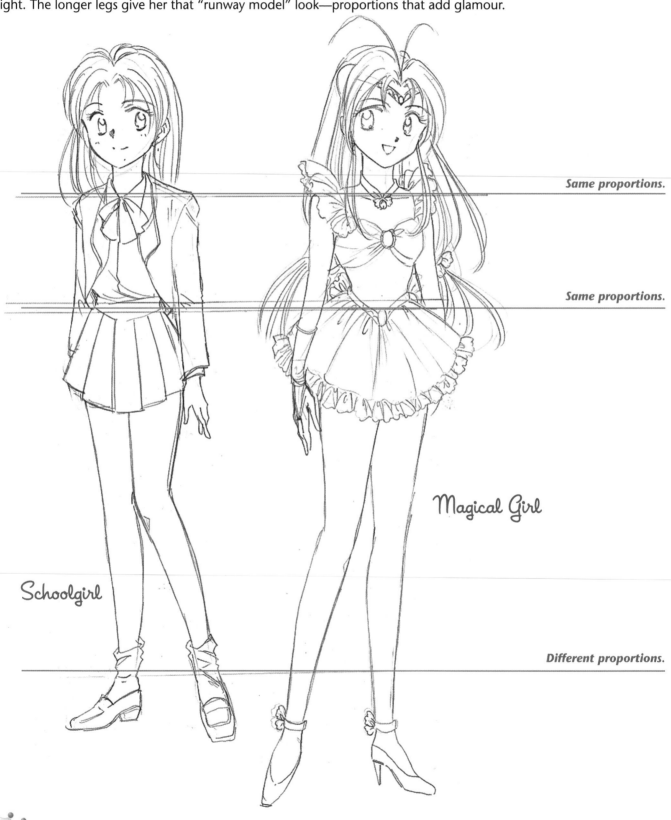

Same proportions.

Same proportions.

Magical Girl

Schoolgirl

Different proportions.

Yes, I know, you love drawing the face but worry that you'll ruin it when you draw the body. Don't worry. A few important hints will take the guesswork right out of it, and you'll be able to draw the body with confidence.

The first hint is this: Two-thirds of the upper body are taken up by the rib cage, and only one-third is taken up by the hip area. In addition, you can simplify both these areas into easy-to-draw shapes, as shown on the first construction step.

Now, here's something really important to keep in mind: The rib cage area *wedges down* into the hip area, so that both areas fit snugly into each other like a lightbulb into a socket. The torso is small and compact on magical girls and, therefore, must have a sharply accentuated waistline.

The next thing to notice is that the legs attach to the hips at a *diagonal*. See the labels on the first construction. This hint will help you whenever you're drawing legs, whether on magical girls, boys, villains, or any character!

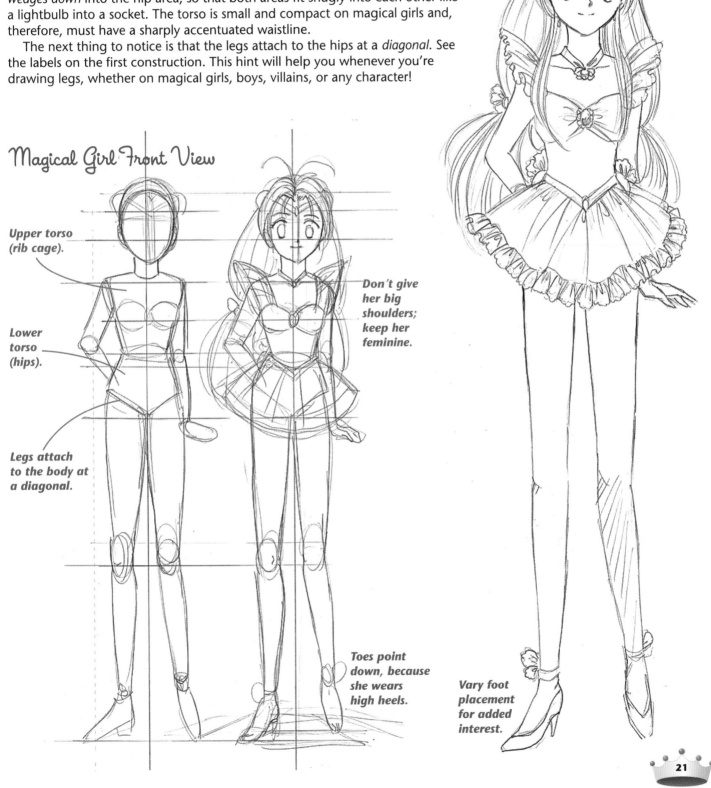

Magical Girl Front View

Upper torso (rib cage).

Lower torso (hips).

Legs attach to the body at a diagonal.

Don't give her big shoulders; keep her feminine.

Toes point down, because she wears high heels.

Vary foot placement for added interest.

21

Magical Girl Side View

As in the front view, in the side view the torso snaps together like pieces of a plastic model, one part into the other. The rib cage snaps into the top of the hips, and the legs snap diagonally into the bottom of the hips.

 If you want to define the torso further, you can draw the midsection. That's the area within the rib cage that appears below the sternum (the chest bone) and above the pelvic bone. Health club devotees call this the "abs" or the "core." On manga schoolgirls and magical girls, the midsection is short because of the truncated upper bodies, so it often goes unarticulated. Older teens have longer midsections; it's something that comes with age. A longer midsection gives a character added flexibility in a pose, because it acts as connective tissue that can bend, turn, and twist.

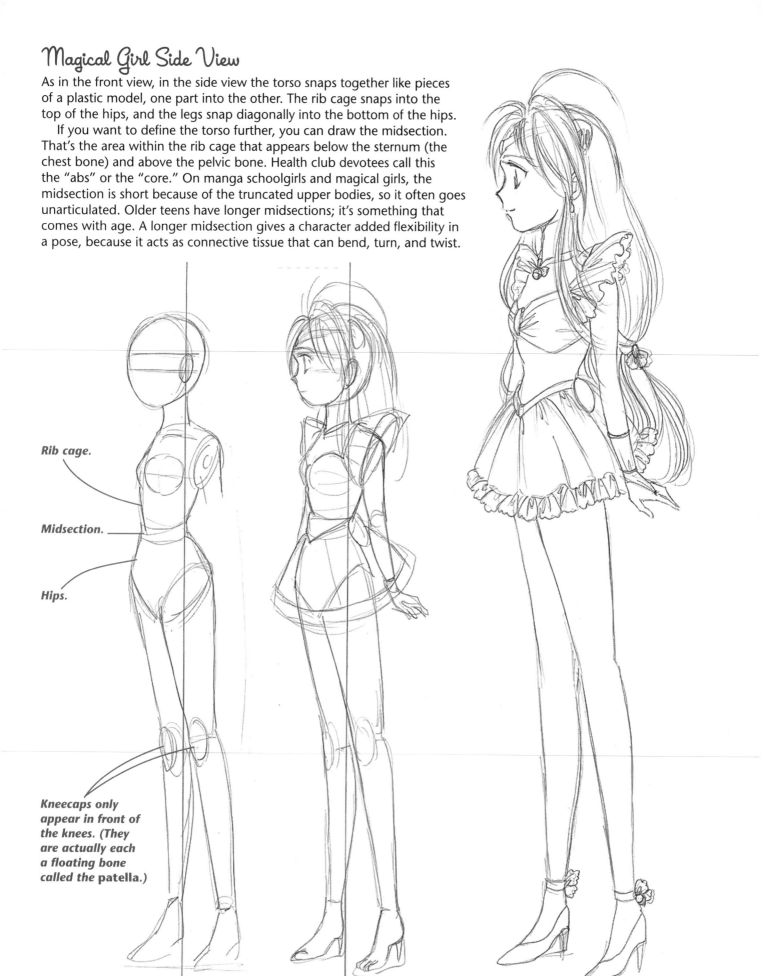

Rib cage.

Midsection.

Hips.

Kneecaps only appear in front of the knees. (They are actually each a floating bone called the patella.)

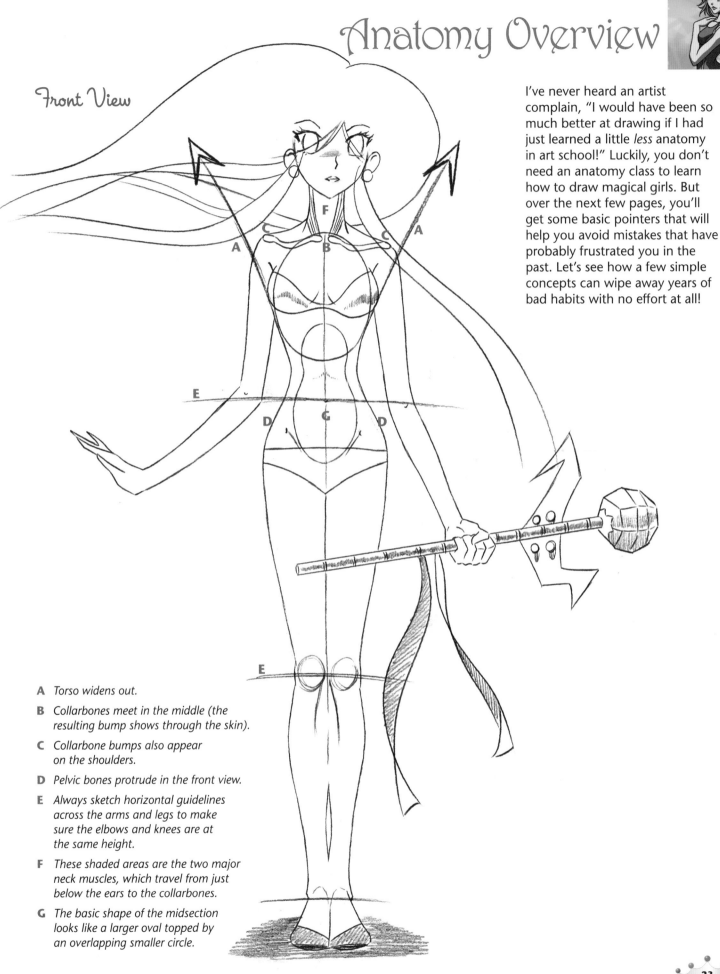

Front View

I've never heard an artist complain, "I would have been so much better at drawing if I had just learned a little *less* anatomy in art school!" Luckily, you don't need an anatomy class to learn how to draw magical girls. But over the next few pages, you'll get some basic pointers that will help you avoid mistakes that have probably frustrated you in the past. Let's see how a few simple concepts can wipe away years of bad habits with no effort at all!

A Torso widens out.

B Collarbones meet in the middle (the resulting bump shows through the skin).

C Collarbone bumps also appear on the shoulders.

D Pelvic bones protrude in the front view.

E Always sketch horizontal guidelines across the arms and legs to make sure the elbows and knees are at the same height.

F These shaded areas are the two major neck muscles, which travel from just below the ears to the collarbones.

G The basic shape of the midsection looks like a larger oval topped by an overlapping smaller circle.

Side View

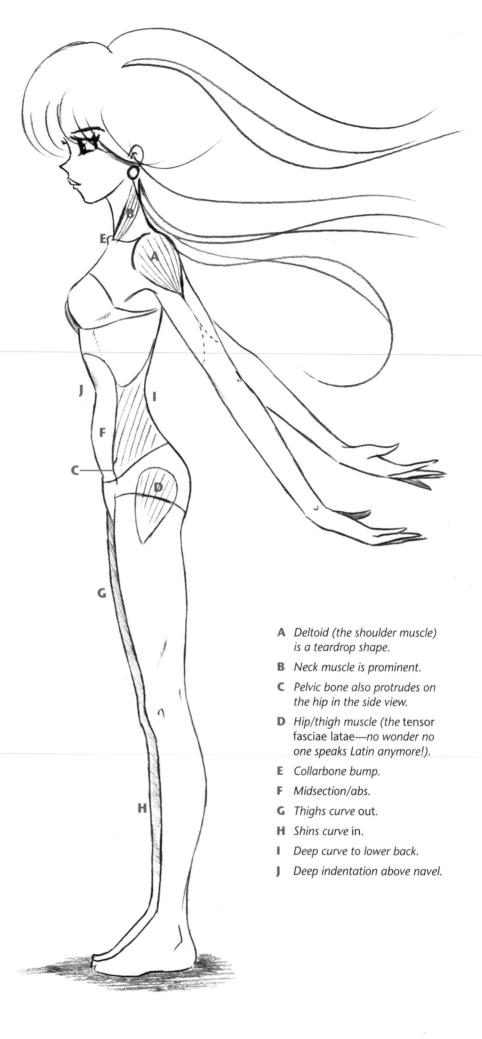

A *Deltoid (the shoulder muscle) is a teardrop shape.*

B *Neck muscle is prominent.*

C *Pelvic bone also protrudes on the hip in the side view.*

D *Hip/thigh muscle (the tensor fasciae latae—no wonder no one speaks Latin anymore!).*

E *Collarbone bump.*

F *Midsection/abs.*

G *Thighs curve out.*

H *Shins curve in.*

I *Deep curve to lower back.*

J *Deep indentation above navel.*

Back View

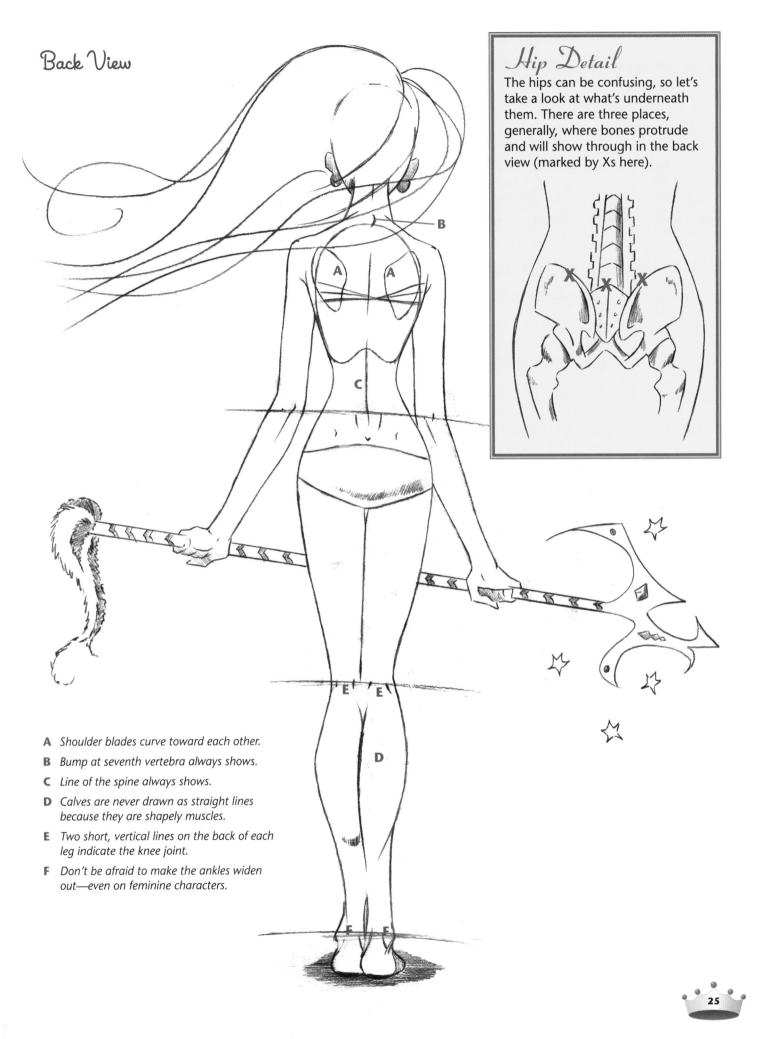

Hip Detail

The hips can be confusing, so let's take a look at what's underneath them. There are three places, generally, where bones protrude and will show through in the back view (marked by Xs here).

A Shoulder blades curve toward each other.

B Bump at seventh vertebra always shows.

C Line of the spine always shows.

D Calves are never drawn as straight lines because they are shapely muscles.

E Two short, vertical lines on the back of each leg indicate the knee joint.

F Don't be afraid to make the ankles widen out—even on feminine characters.

Tips for Drawing Hands

Fingers naturally curve inward due to the placement of the knuckles . . .

. . . but this won't prevent you from posing hands in a variety of ways.

Hands (Side Views)

Thumb heel.

Palm heel.

Finger Positioning

Just okay.

Better—lifting the pinky adds femininity.

Best—a tilt of the wrist does the trick!

Palm Down and Up

The thumb has three moveable joints, not two. Note the shift in angle of each thumb bone.

Closed Fist (3/4 View)

Thumb Joints

Relaxed (Side View)

Relaxed (Side View Variation)

Wrist turns down and top of knuckles make contact.

Punch

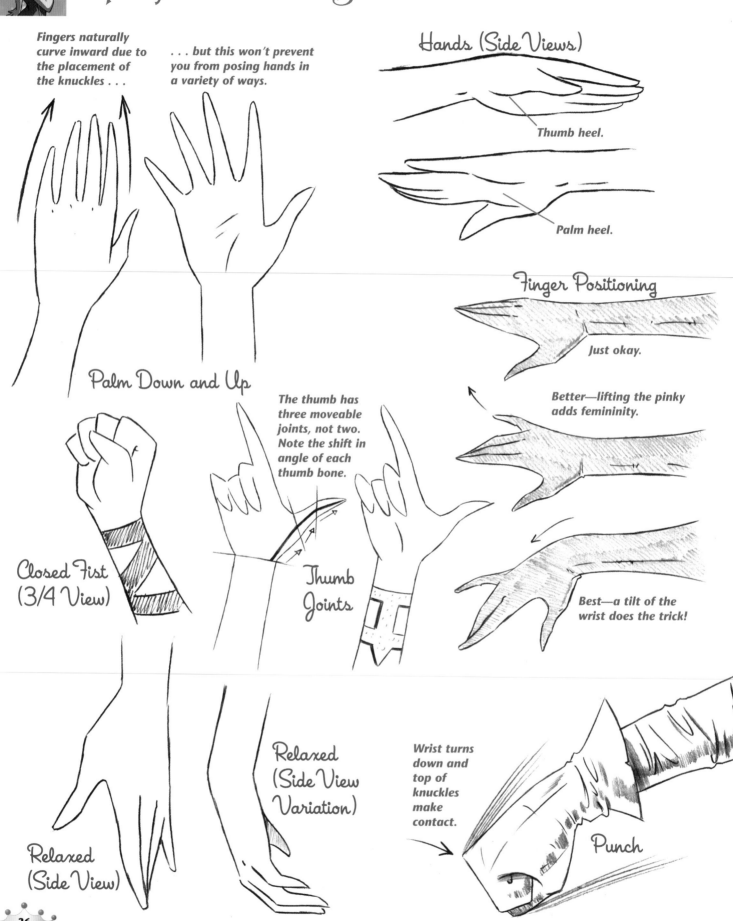

Tips for Drawing Feet

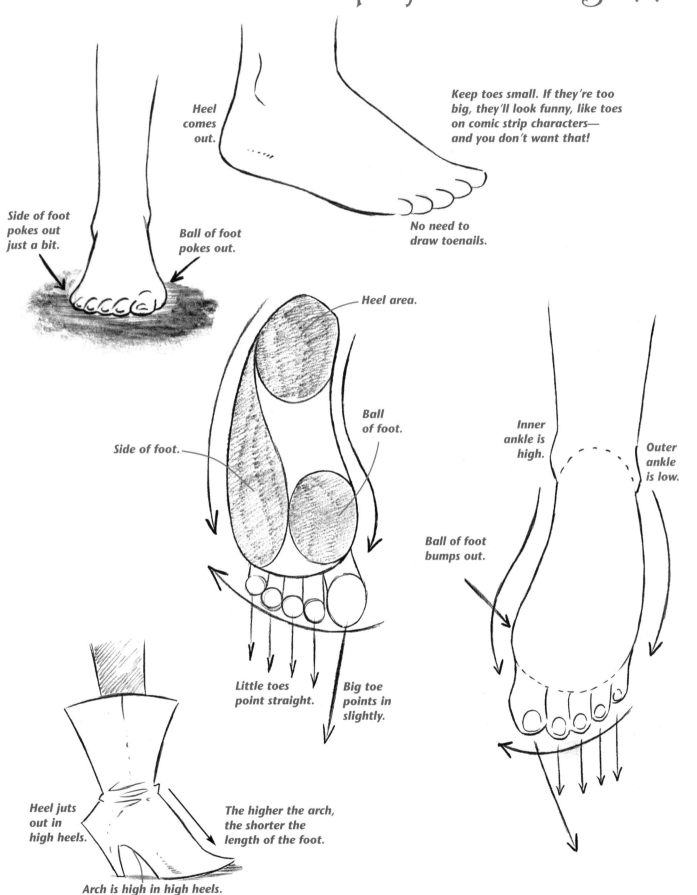

Heel comes out.

Keep toes small. If they're too big, they'll look funny, like toes on comic strip characters—and you don't want that!

Side of foot pokes out just a bit.

Ball of foot pokes out.

No need to draw toenails.

Heel area.

Side of foot.

Ball of foot.

Inner ankle is high.

Outer ankle is low.

Ball of foot bumps out.

Little toes point straight.

Big toe points in slightly.

Heel juts out in high heels.

The higher the arch, the shorter the length of the foot.

Arch is high in high heels.

Seeing through the Figure

See if you recognize yourself this scenario: You're starting to sketch a figure. Halfway through the pose, it's going well. You're impressed with yourself. Three-fourths of the way through, still no glitches. But about twenty yards from the goal line, you get that nagging feeling in your stomach. The way your character is positioned hides or cuts off part of her arm or leg so that only part of it shows. And you're not sure how to draw it so that it looks natural and not just stuck onto the body.

Perhaps the pose requires some perspective, and no matter how you draw it, you can't quite get it to look right. If only you could draw that one part correctly, you could save an otherwise terrific picture. Nonartists have no idea what I'm talking about. But you do. You're not alone, believe me! It's one of the little devils of drawing that drives us all mad at sometime in our careers. Hang on—hope has arrived. It's a process called I call *seeing through* the drawing.

A pose is like a riddle. Sometimes it needs to be solved. Best guesses are useless. Isn't that a relief? You can finally give up on guessing. Here's the answer: When drawing, it's just as important—if not *more* important—to draw the lines that the eye eventually *will not see* as it is to draw the lines that the eye will see. That's right. On challenging poses, try drawing all the lines initially—that means the limbs that are hidden behind the body or behind props, as well. Draw them as if your character were transparent and you could see right through her. This is the *draw through* method.

Far Arm Partially Hidden by Body

Very common problem. Sometimes the solution can look wrong to you when you just eyeball it. There's only one way to know for sure if you've gotten it right: Draw the far arm—but remember, since it's further away from you than the near arm, you will have to make it the slightly shorter of the two.

Far Leg Partially Hidden by Near Leg

As with the arm example, draw the entire back leg. It's important to indicate where the back leg's knee is, or you'll lose all sense of proportion. Again remember, since the back leg is further away from you than the front leg, it will appear shorter, due to perspective (which means that its knee will appear higher up than the nearer knee).

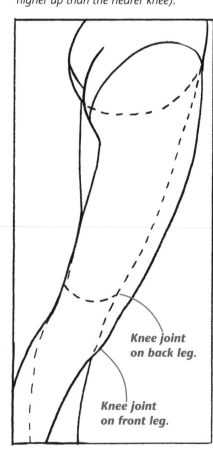

Knee joint on back leg.

Knee joint on front leg.

Perspective

Perspective is the visual representation of the special relationships between forms as they appear to the eye. The rules of perspective tell us that objects that are closer to us appear larger than objects that are farther away from us. And in order for your figures to look realistic and convincing, you need to draw them in perspective. Perspective gets a bad wrap. People sometimes mistakenly think that in order to use perspective, they have to get out a set of rulers and T squares. It's not always such a complicated affair. Sometimes, it's just a matter of making a few smart adjustments to the figure in order to make a pose more convincing. Take a look at these figures to get a feel for how perspective affects the look of the body in various positions. If you keep these concepts in mind, your figures will begin to improve.

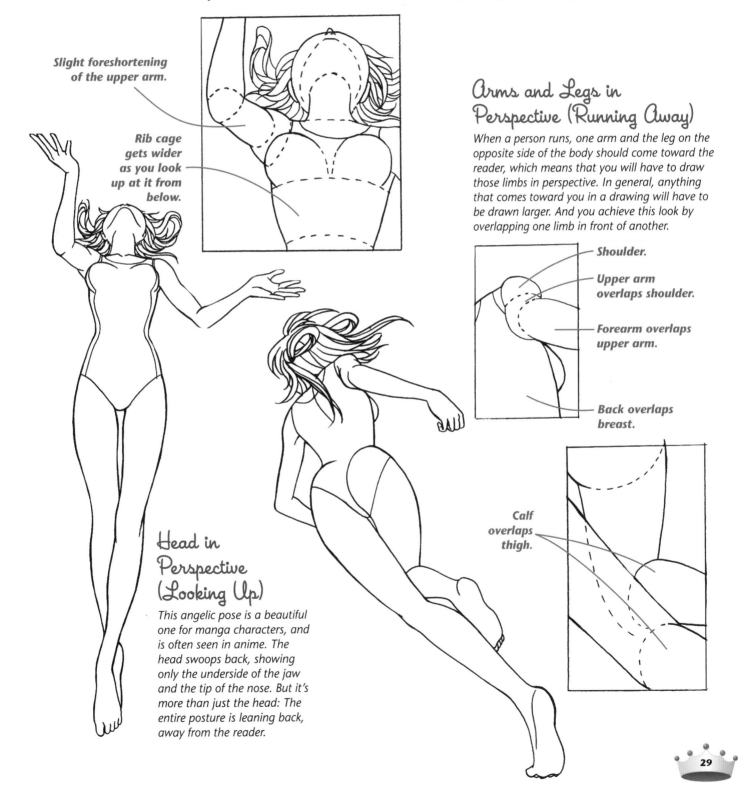

Slight foreshortening of the upper arm.

Rib cage gets wider as you look up at it from below.

Head in Perspective (Looking Up)

This angelic pose is a beautiful one for manga characters, and is often seen in anime. The head swoops back, showing only the underside of the jaw and the tip of the nose. But it's more than just the head: The entire posture is leaning back, away from the reader.

Arms and Legs in Perspective (Running Away)

When a person runs, one arm and the leg on the opposite side of the body should come toward the reader, which means that you will have to draw those limbs in perspective. In general, anything that comes toward you in a drawing will have to be drawn larger. And you achieve this look by overlapping one limb in front of another.

Shoulder.

Upper arm overlaps shoulder.

Forearm overlaps upper arm.

Back overlaps breast.

Calf overlaps thigh.

Poses That Illustrate Perspective

Sure, magical girls save the universe from the Lords of Evil, but they also need time to gossip online. So here are a few poses that reflect that downtime and also make good use of perspective, showing how to handle positions that hide parts of the body.

You don't want to always resort to a flat, side-view pose of a girl lying on her stomach on her bed. It's sort of plain, you know? Comics and manga are about being creative—not just in the way you draw the face, but in what you do with the character, how you pose her. Get creative. You want to come up with interesting poses. When you learn to *draw through* the figure, you're not as reluctant to try new or unusual poses.

Arm Hides the Back

In this angle, you see not only the chest but also some of the back of the character. Draw through the upper arm, as if it were transparent, in order to maintain the continuity of the line of the back. If you start the line of the back, then stop to draw the arm, and then begin the back again after you've drawn the arm, there's a good chance that the back won't look like one fluid line. You're guessing at where the back stops and starts again. By drawing through the arm, you take the guesswork out of it.

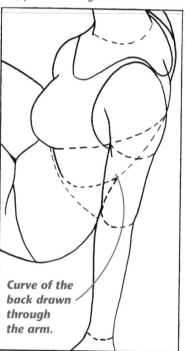

Curve of the back drawn through the arm.

Arm Hides the Rib Cage

Similarly, by continuing to draw the natural line of the rib cage and hips through the arm, you give a more fluid sweep to the torso. (Of course, any draw-through lines will be erased in the final drawing.)

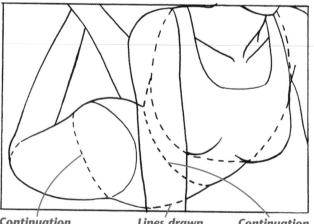

Continuation of the natural hip line.

Lines drawn through the arm.

Continuation of the natural rib cage line.

Knee Hides Hips and Other Leg

In this pose, the knee crosses the body, hiding the hips and the upper part of the other leg.

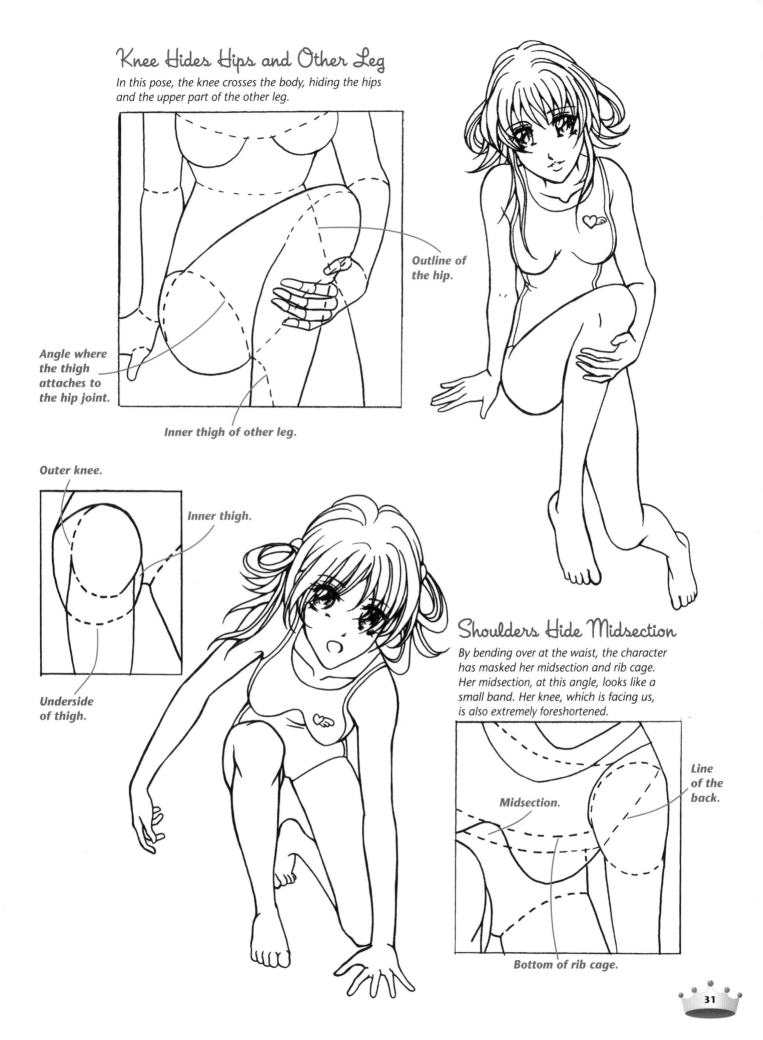

Outline of the hip.

Angle where the thigh attaches to the hip joint.

Inner thigh of other leg.

Outer knee.

Inner thigh.

Underside of thigh.

Shoulders Hide Midsection

By bending over at the waist, the character has masked her midsection and rib cage. Her midsection, at this angle, looks like a small band. Her knee, which is facing us, is also extremely foreshortened.

Line of the back.

Midsection.

Bottom of rib cage.

Finished Magical Girl Poses

Sometimes in art instruction books, after drawing a few pages of technical-looking stuff, you forget what the point was in the first place! So, it's important that we complete this section on drawing through a pose with some finished drawings of magical girls. And in the construction steps, you'll see the draw-through techniques you've been practicing. Compare the construction drawings to the finished versions of each pose so that you can see how perspective affects the final image and can then draw them.

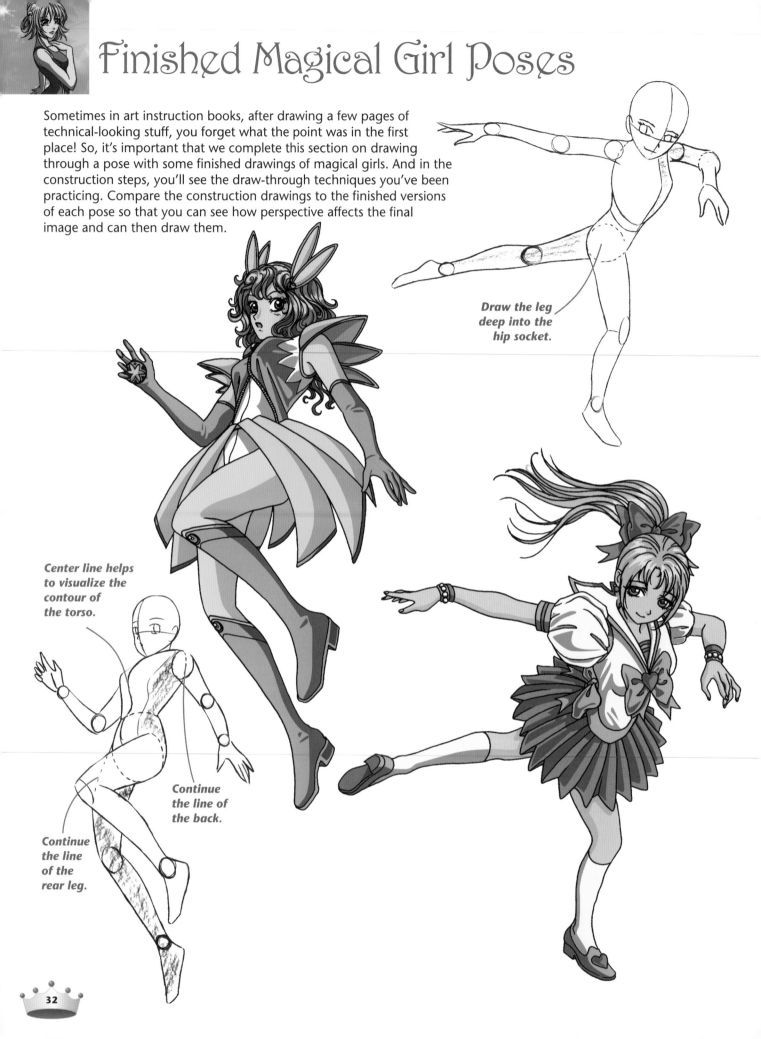

Draw the leg deep into the hip socket.

Center line helps to visualize the contour of the torso.

Continue the line of the back.

Continue the line of the rear leg.

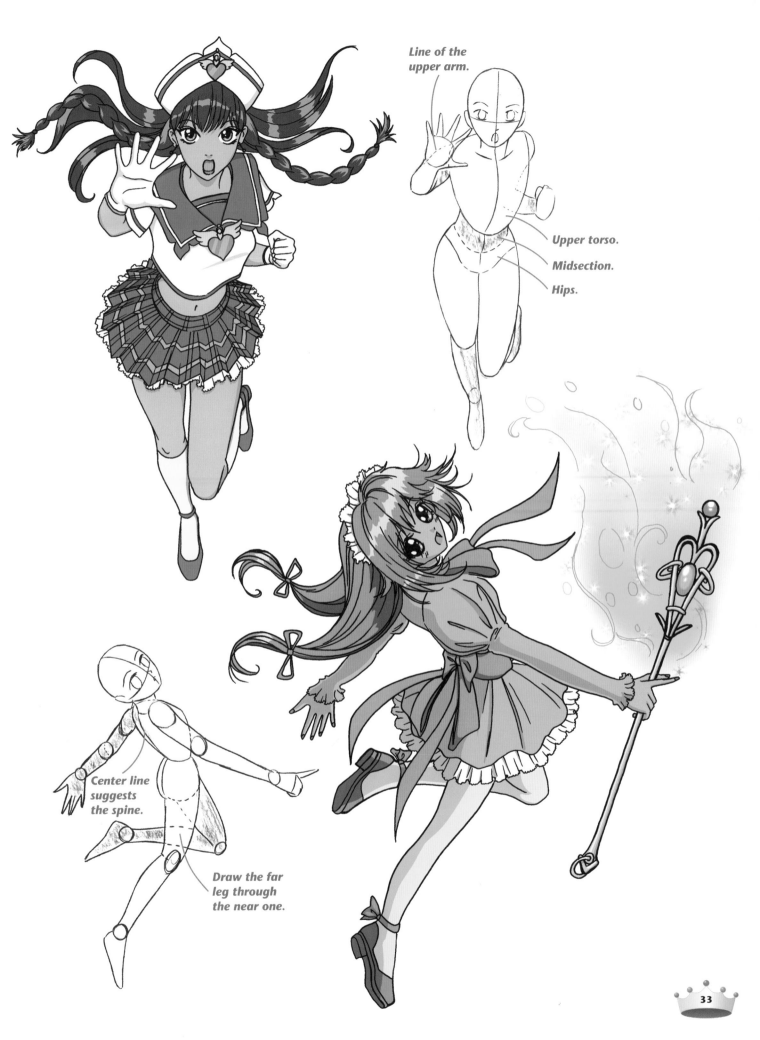

Line of the
upper arm.

Upper torso.

Midsection.

Hips.

Center line
suggests
the spine.

Draw the far
leg through
the near one.

Drawing Along Vanishing Lines

I'm sure you're well aware of the perspective effect I'm about to describe, but you may not know how to apply it to the human body. Well, you will now . . . just read on. I'm talking about the visual effect that causes a set of receding parallel lines to appear to converge. Think of train tracks that seem to meet at some distant point on the horizon. This, too, is perspective in action.

Think of a magical girl, posed in such a way that she looks as if she is moving toward you or away from you at high speed. For example, take a magical girl flying toward you. Her head is big, but her body diminishes to a really small size so that her feet are very tiny. Is it just a matter of drawing a big head and tiny feet? If it were, everyone could draw manga action scenes in perspective. But it's more complicated than that, which is actually a good thing because this means there's a secret that I can tell you that you can withhold from your friends and tease them about mercilessly. Think of all the power you will have! It will be glorious! You will rule the world!!!

But moving right along, let's turn to those sketch lines in the initial figure constructions here. Those aren't actually sketch lines; those are called *vanishing lines* because they converge to a point at the bottom right, where they *vanish*. Artists use vanishing lines as a loose guide for drawing the figure; the lines form a cone into which the artist fits the figure. This helps to indicate how the body should get gradually smaller as the figure follows the vanishing lines back to the vanishing point. It's what makes the figure look like it's receding into the distance *at a uniform rate*. Now you've got a convincing drawing.

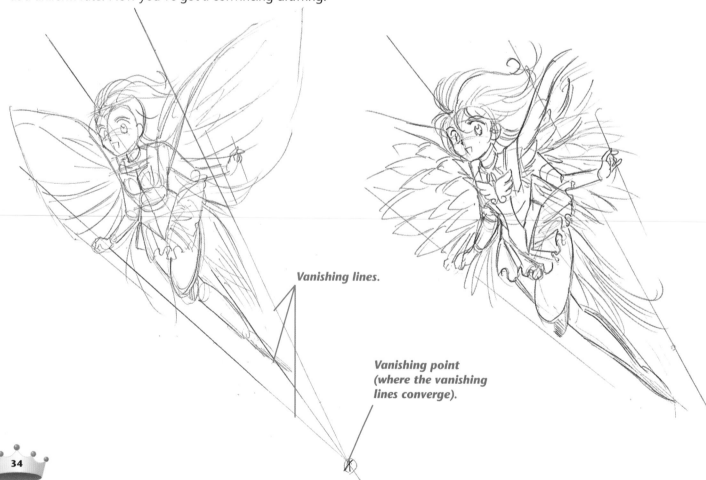

Vanishing lines.

Vanishing point (where the vanishing lines converge).

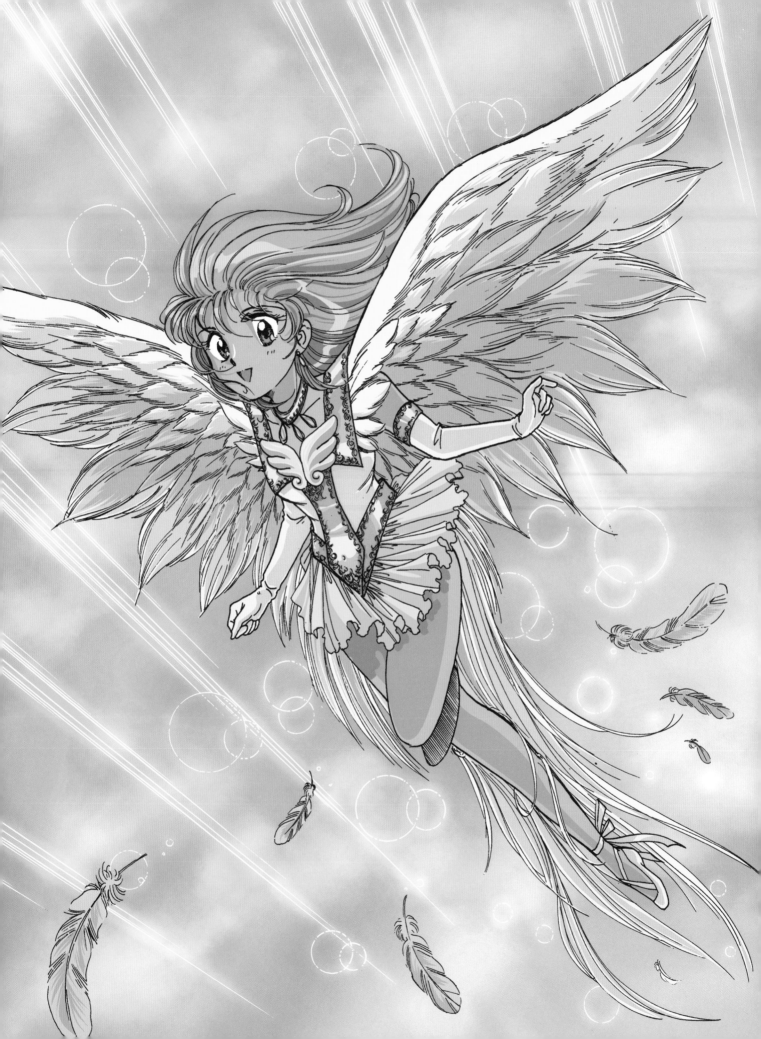

When Vanishing Lines Don't Converge

Sometimes, vanishing points converge so gradually that they don't actually converge on the page but somewhere beyond the edge of the drawing paper. In order to see vanishing lines like this converge, you'd have to tape more pages to one side of your paper! For this example, you'd probably have to add two more pages to the left side of this drawing.

In these cases, you can leave the vanishing lines open, meaning that the space between them reduces gradually but the lines never actually touch You can do this as long as the lines look as though they *would* converge if you followed them long enough, *and*—and this is important—they are not parallel!

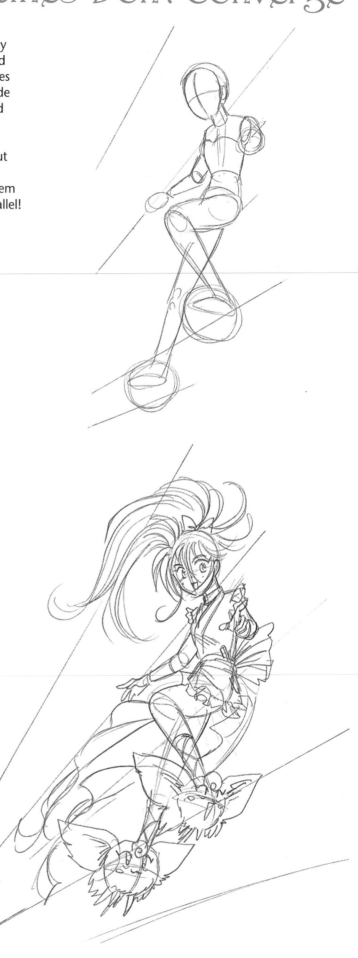

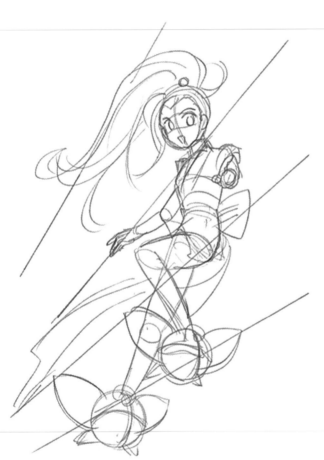

Vanishing Line Tip

Always bracket your character between the top and bottom vanishing lines so that you have "bookended" her with these guidelines. This makes it easier to follow your own sketch marks.

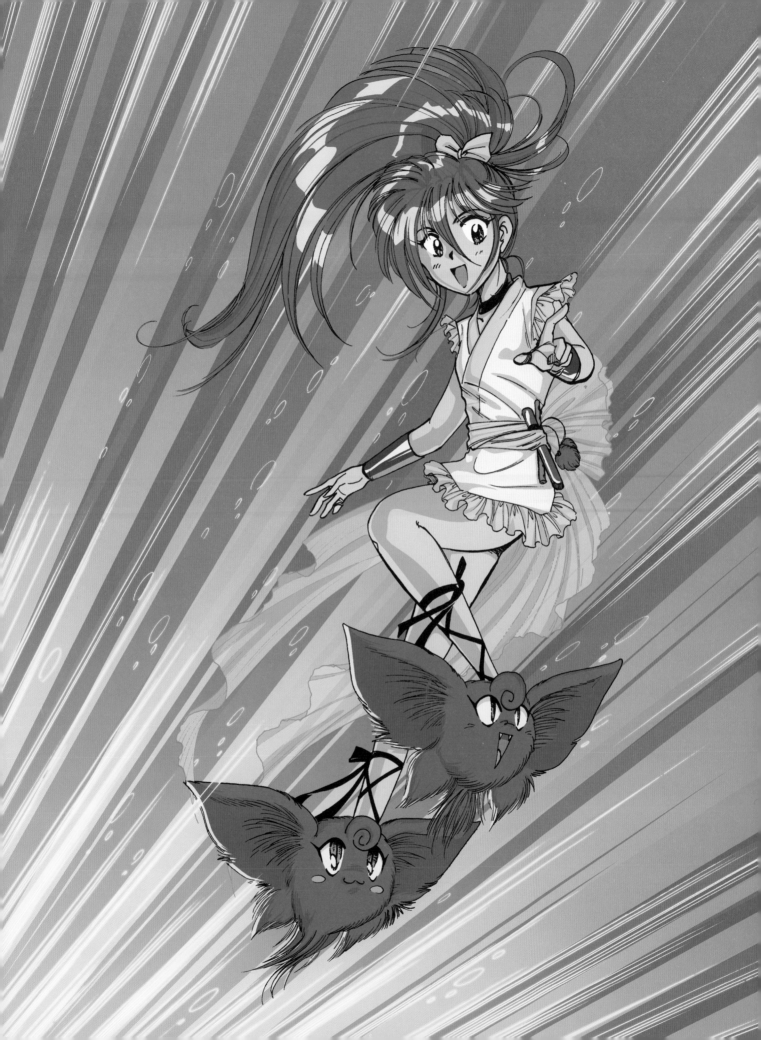

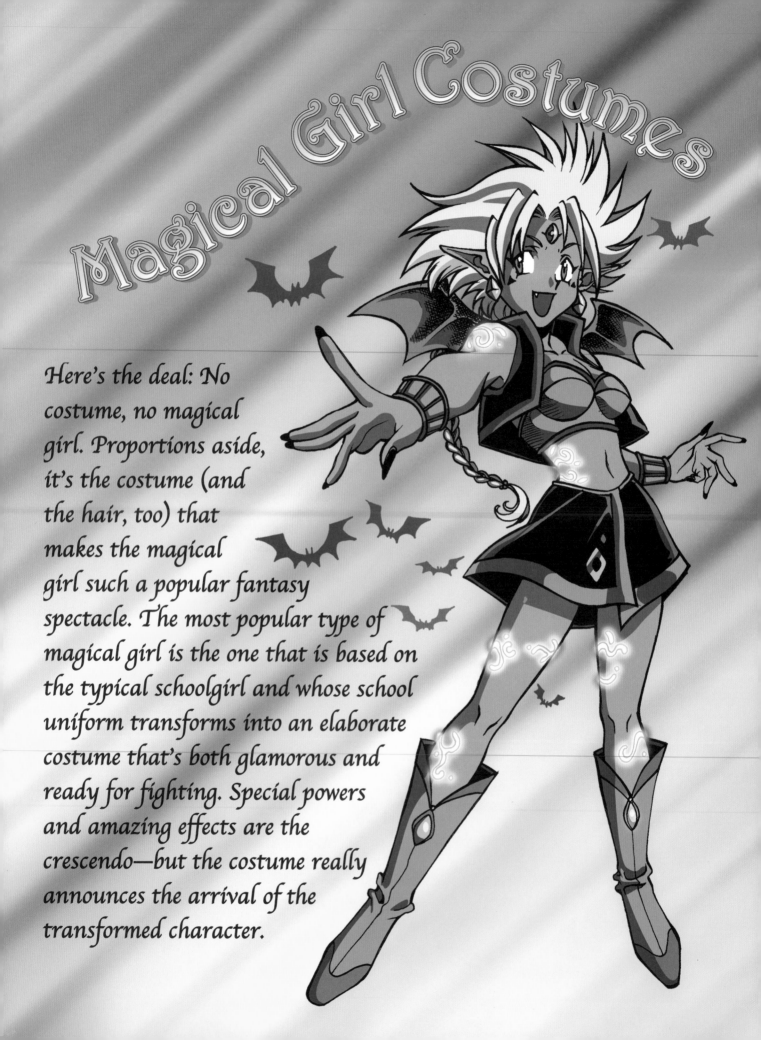

Magical Girl Costumes

Here's the deal: No costume, no magical girl. Proportions aside, it's the costume (and the hair, too) that makes the magical girl such a popular fantasy spectacle. The most popular type of magical girl is the one that is based on the typical schoolgirl and whose school uniform transforms into an elaborate costume that's both glamorous and ready for fighting. Special powers and amazing effects are the crescendo—but the costume really announces the arrival of the transformed character.

Costume Design: What NOT to Do

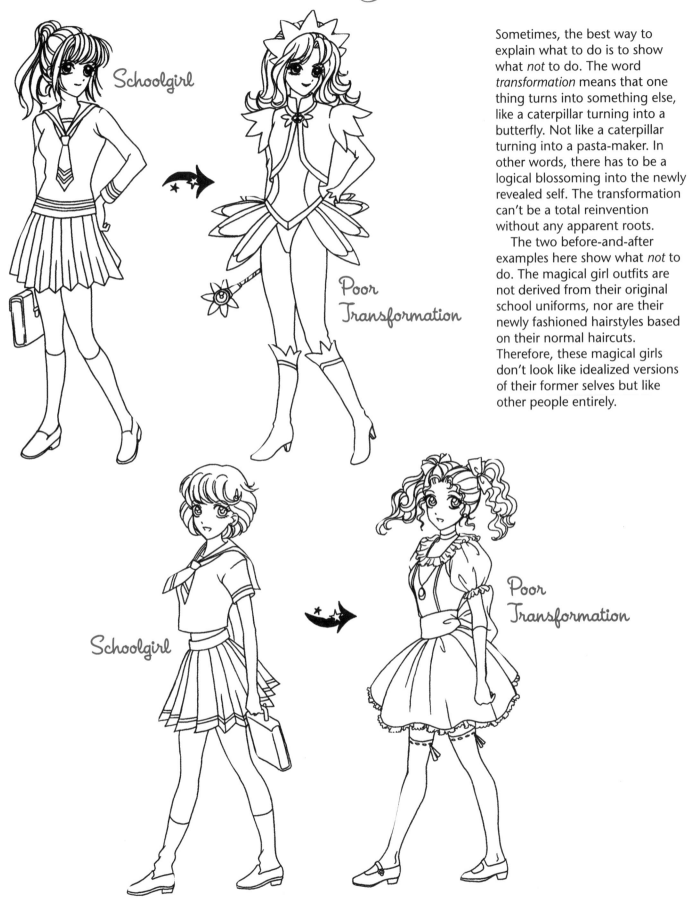

Schoolgirl

Poor Transformation

Schoolgirl

Poor Transformation

Sometimes, the best way to explain what to do is to show what *not* to do. The word *transformation* means that one thing turns into something else, like a caterpillar turning into a butterfly. Not like a caterpillar turning into a pasta-maker. In other words, there has to be a logical blossoming into the newly revealed self. The transformation can't be a total reinvention without any apparent roots.

The two before-and-after examples here show what *not* to do. The magical girl outfits are not derived from their original school uniforms, nor are their newly fashioned hairstyles based on their normal haircuts. Therefore, these magical girls don't look like idealized versions of their former selves but like other people entirely.

The "Magical Tailor"

To see how we get from here to there in a logical progression, let's go step by step from the ordinary to the extraordinary. By making a series of small adjustments, you can see how our "Magical Tailor" weaves his magic.

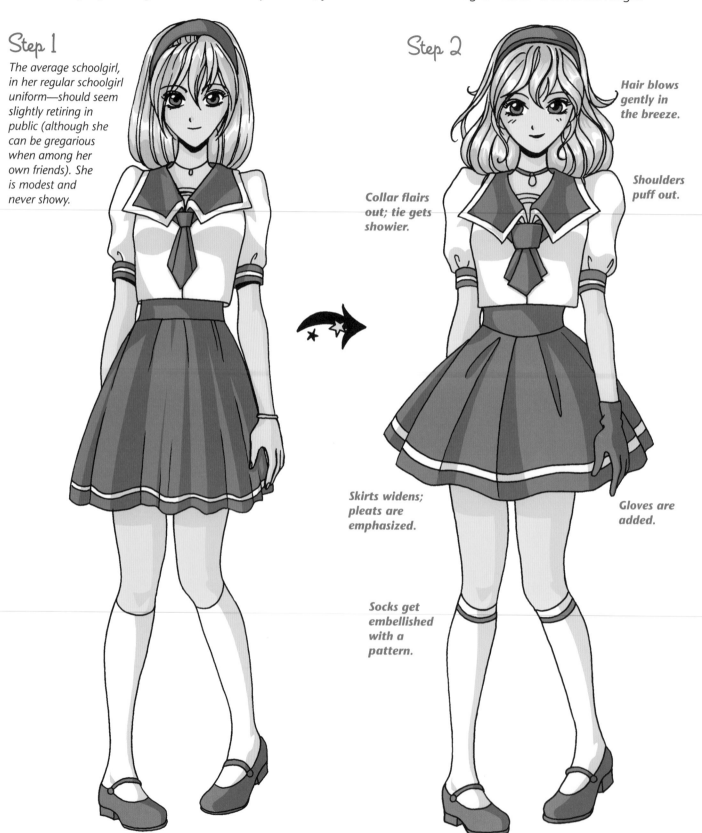

Step 1

The average schoolgirl, in her regular schoolgirl uniform—should seem slightly retiring in public (although she can be gregarious when among her own friends). She is modest and never showy.

Step 2

Hair blows gently in the breeze.

Shoulders puff out.

Collar flairs out; tie gets showier.

Skirts widens; pleats are emphasized.

Gloves are added.

Socks get embellished with a pattern.

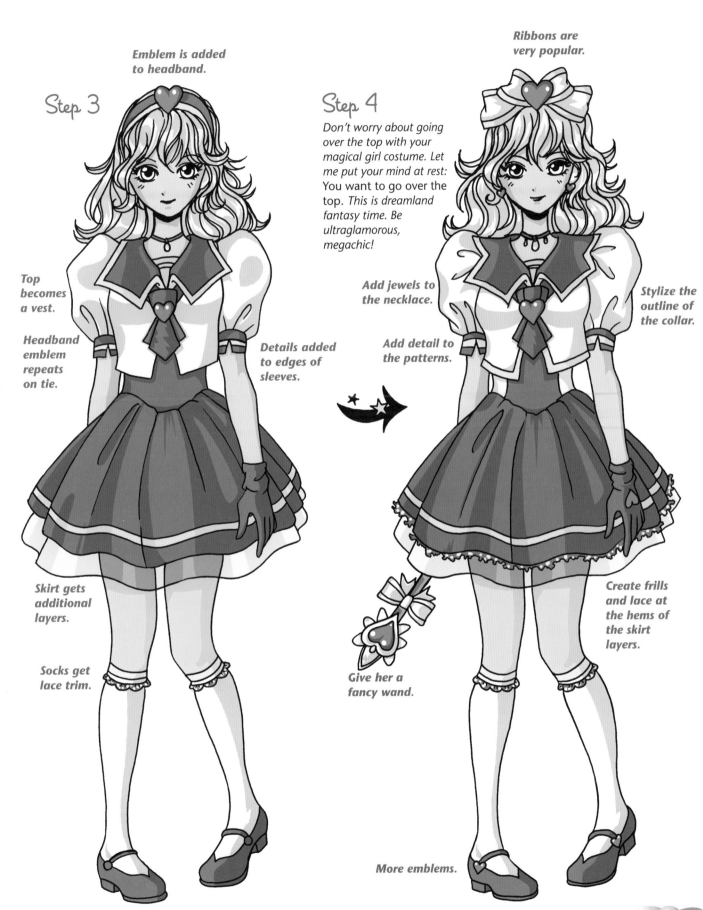

Emblem is added to headband.

Step 3

Top becomes a vest.

Headband emblem repeats on tie.

Details added to edges of sleeves.

Skirt gets additional layers.

Socks get lace trim.

Ribbons are very popular.

Step 4

Don't worry about going over the top with your magical girl costume. Let me put your mind at rest: You want to go over the top. This is dreamland fantasy time. Be ultraglamorous, megachic!

Add jewels to the necklace.

Add detail to the patterns.

Stylize the outline of the collar.

Create frills and lace at the hems of the skirt layers.

Give her a fancy wand.

More emblems.

Instead of inventing a magical girl costume out of thin air, try using the ordinary girl's outfit as the starting point from which to build the fantasy version. If the magical costume is too radically different from the regular, everyday outfit, it won't look like a smooth transition. Remember, the character *transforms* into something; she doesn't suddenly become a whole different person.

So, how do you go about doing that? You look for characteristics in the original clothing that you can highlight and exaggerate to create a fantastic new costume. Take a look at this magical girl's costume, noting the aspects of it that have been held over from the original outfit. See what I mean? The bare bones of the original are there, but they've been greatly enhanced. How? Through magic, of course!

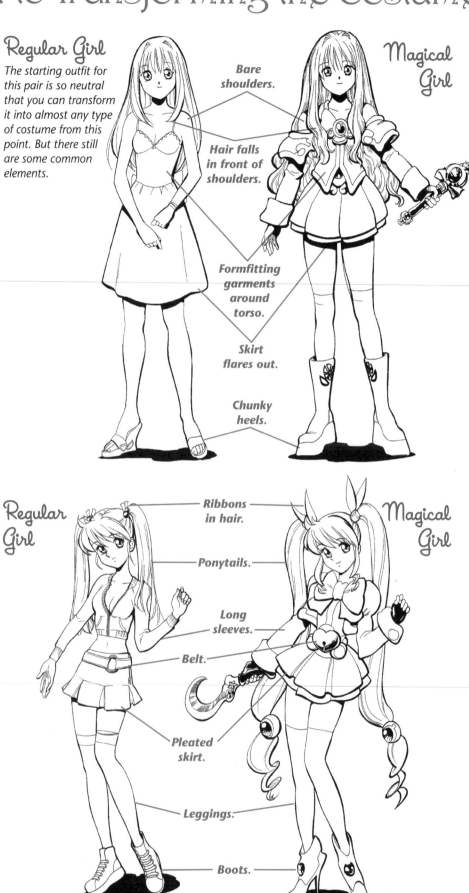

Regular Girl

The starting outfit for this pair is so neutral that you can transform it into almost any type of costume from this point. But there still are some common elements.

Magical Girl

Bare shoulders.

Hair falls in front of shoulders.

Formfitting garments around torso.

Skirt flares out.

Chunky heels.

Regular Girl

Magical Girl

Ribbons in hair.

Ponytails.

Long sleeves.

Belt.

Pleated skirt.

Leggings.

Boots.

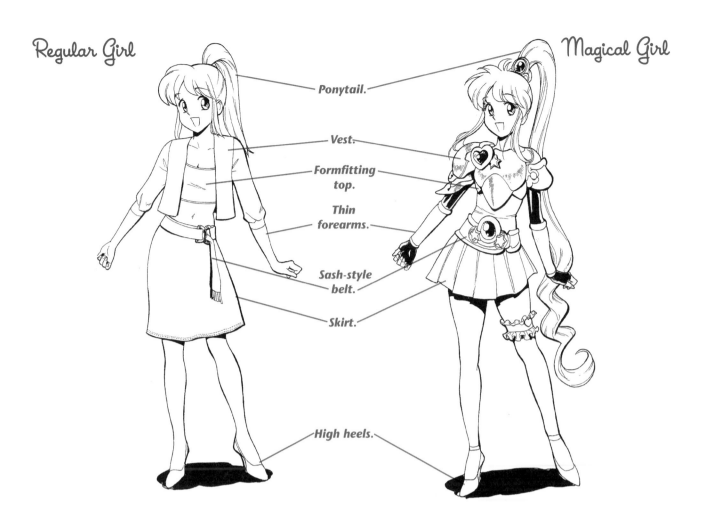

Regular Girl

Magical Girl

Ponytail.

Vest.

Formfitting top.

Thin forearms.

Sash-style belt.

Skirt.

High heels.

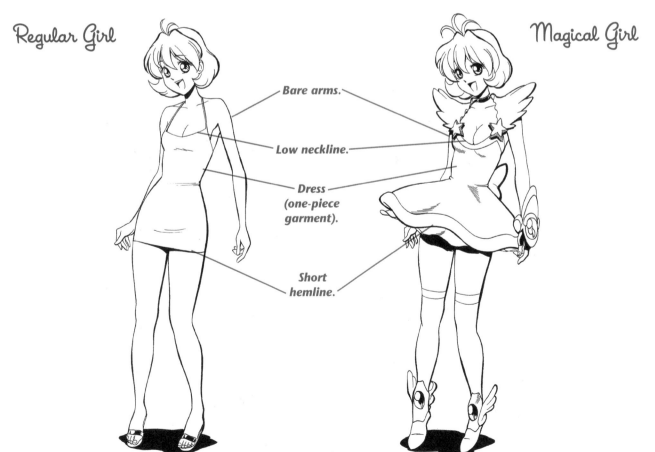

Regular Girl

Magical Girl

Bare arms.

Low neckline.

Dress (one-piece garment).

Short hemline.

Superstylish Gloves

Whether they're shoulder length, midlength, or short, gloves are always a glamorous addition to the magical girl costume. You can add ribbons, buttons, jewels, and lace, and you can even put bracelets and rings on top of gloves.

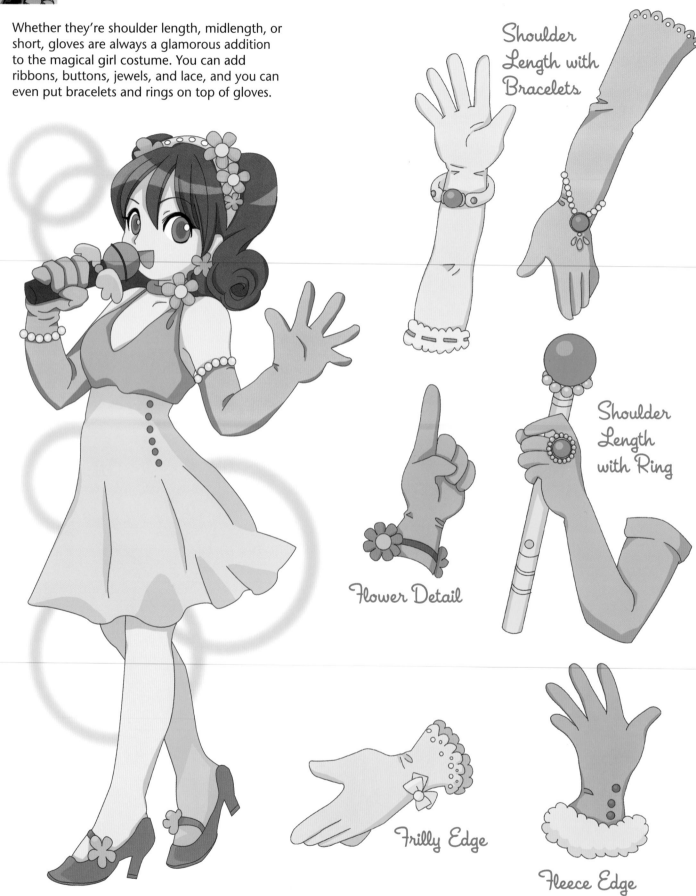

Shoulder Length with Bracelets

Shoulder Length with Ring

Flower Detail

Frilly Edge

Fleece Edge

Chic Footwear

Never let your magical girl go anywhere unless her shoes will make the other girls green with jealousy. Don't worry about comfort. Footwear should have high heels and cool patterns and/or decorations. Remember, your character has just walked into the fantasy shoe store and her credit card has no limit. Don't let her down!

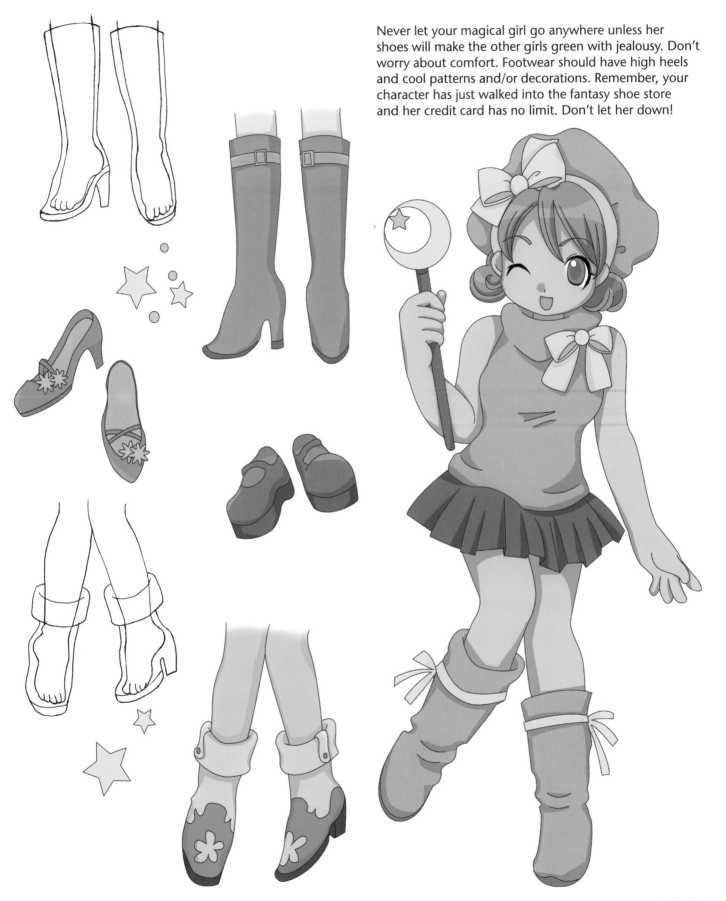

Accessories to Die For

Amulets, necklaces, bejeweled headbands and hair clamps, ribbons, tiaras, and crowns—these are among the most popular accessories for the magical girl costume. Jewels and crystals are a theme throughout many genres of manga, where they possess special powers—and this is especially true of the magical girl category.

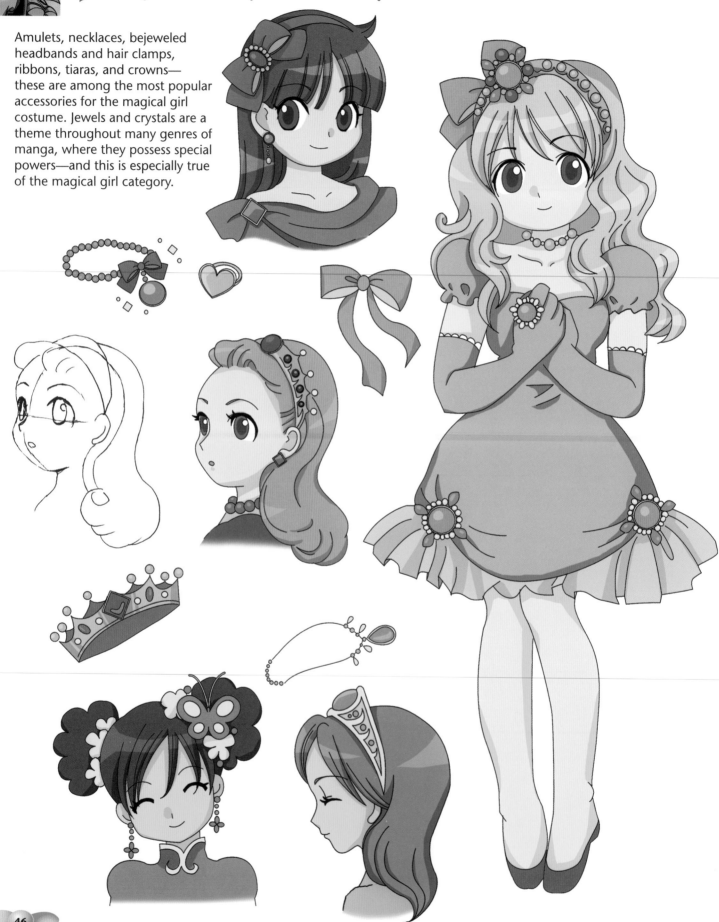

Accessories: Ordinary to Extraordinary!

Whatever a character is carrying with her when she is turned into a magical girl takes on a bewitched charm, as well. And yes, I did say when *she is turned* into a magical girl, meaning that it isn't always something that occurs of her own free will. In fact, the first time it happens, it's a scary experience for her. She doesn't know what's going on. Not only is she changing, but the very cell phone in her hand has suddenly turned into a gold-encrusted piece of jewelry that radiates a special aura. Oh, but don't worry, she'll get used to it quickly—really quickly. Unfortunately, when she returns to normal, her cell phone will also snap back, and she'll got be responsible for all those extra minutes she spent talking to her friends from another dimension. I think those count as overages.

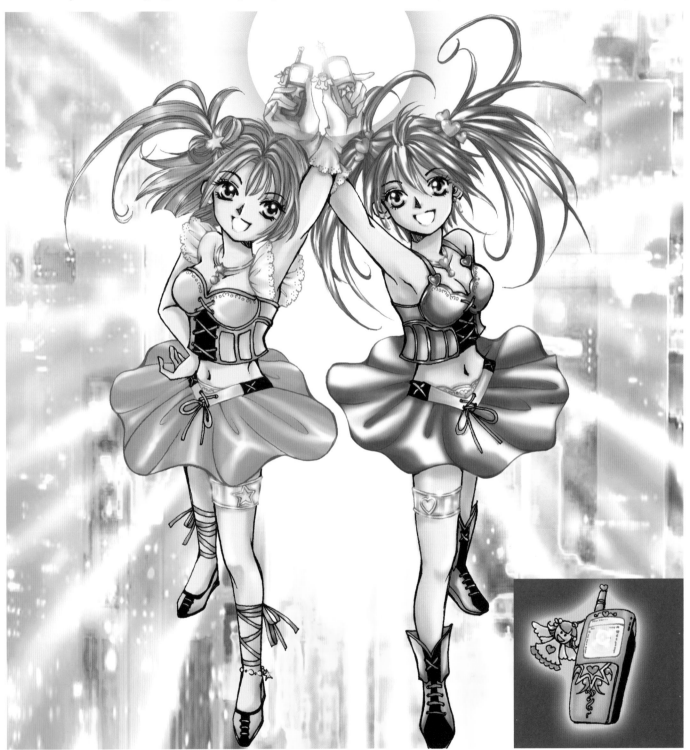

Magical Powers in Ordinary Objects

The possessions that most frequently turn into magical objects are crystals, wands, necklaces, and charms, all of which should emit rays of energy, light, and sparkles. But you can turn any feminine handheld object into a powerful force for good. Just don't let it fall into the wrong hands!

There are three elements required to make a regular object look like a magical one:

• The ability to float or spin.

• The special effects surrounding them, such as lines, swirls, and stars.

• The magical girl's pose: She should be posed so that she appears to have reverence for the object.

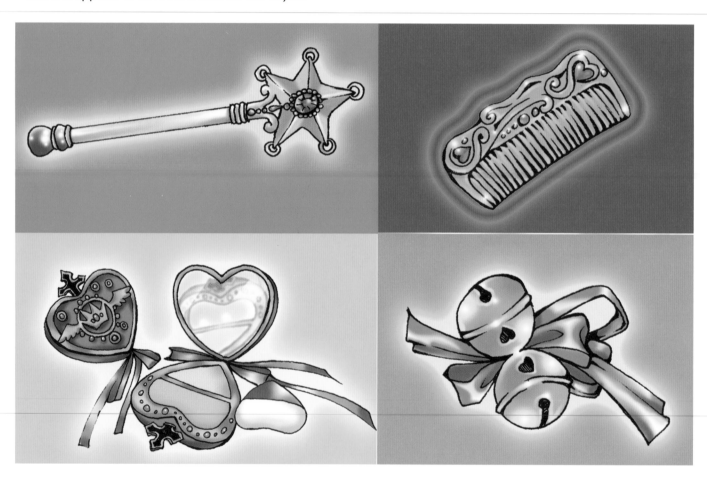

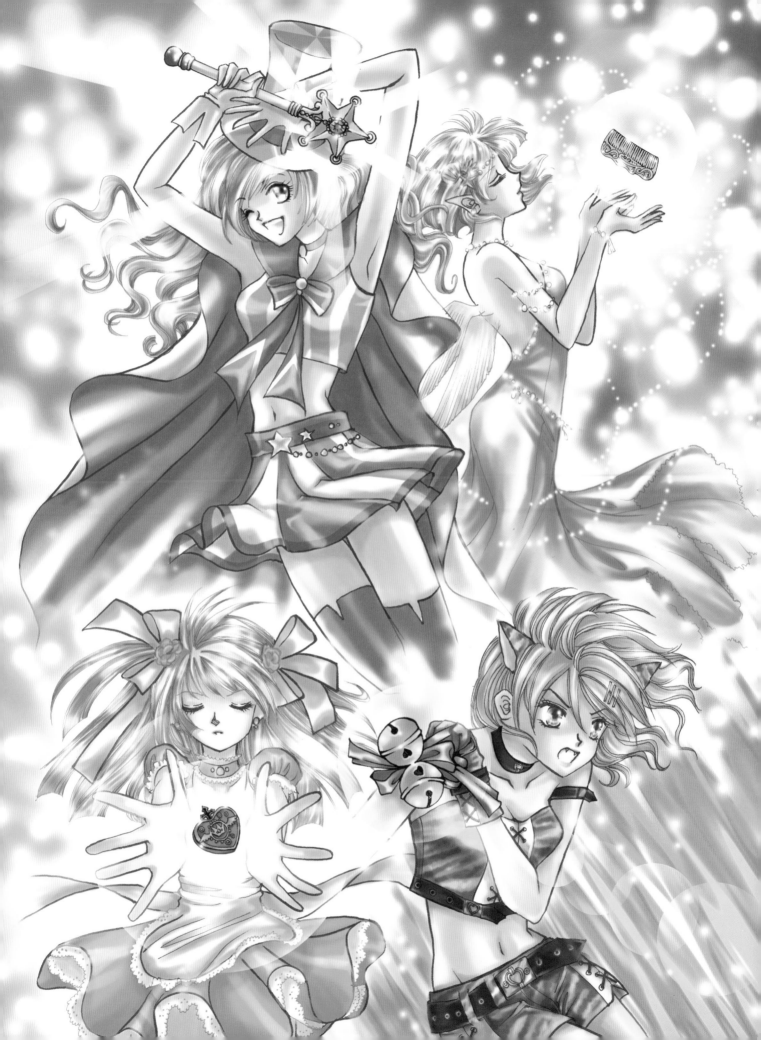

Amazing Wands

Nothing says "You're finished!" to a bad guy like a magical girl's wand. The most popular wand isn't based on the magician's, which is about two to three feet in length. Instead, think of a biblical staff, which can be raised dramatically to ward off evil forces and literally blow back the dark winds that howl. These wands must be ornate yet weaponlike. Although magical girls often wield Excalibur-type swords, these wands themselves are not used to actually strike the opponent—but their rays can be devastating.

There are also more modest wands that are used as decorative devices, almost like fashion accessories. They are short with ornate tops and may glow or cast a shower of sparkles, but they are generally not as powerful as the larger staff-style wands.

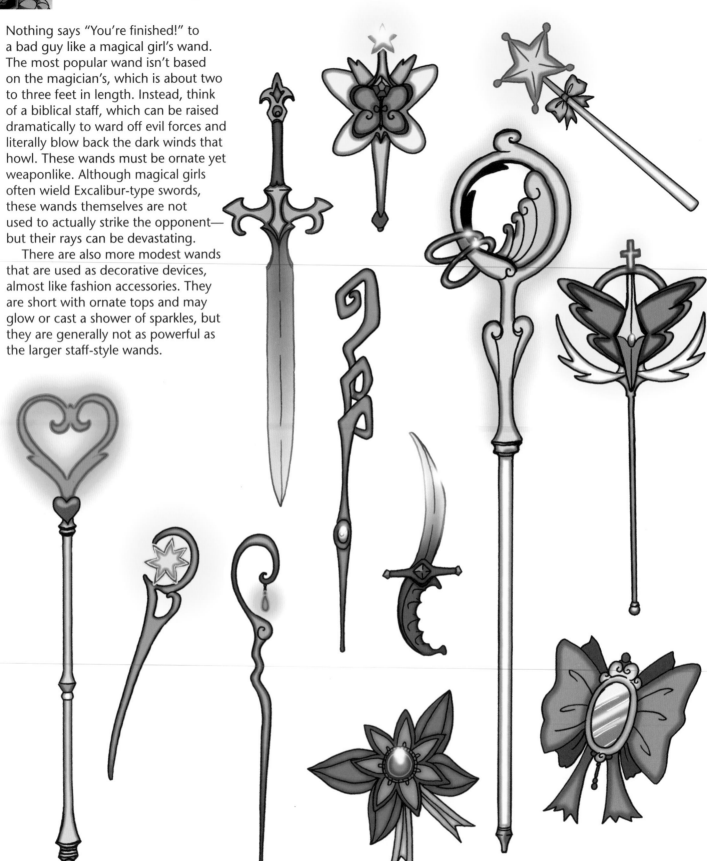

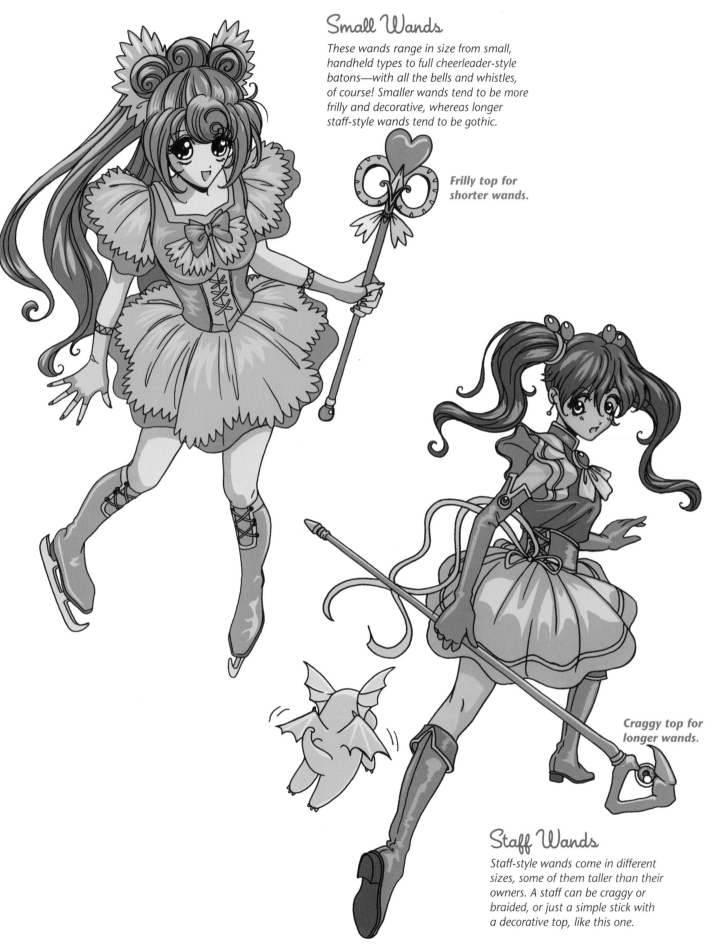

Small Wands

These wands range in size from small, handheld types to full cheerleader-style batons—with all the bells and whistles, of course! Smaller wands tend to be more frilly and decorative, whereas longer staff-style wands tend to be gothic.

Frilly top for shorter wands.

Craggy top for longer wands.

Staff Wands

Staff-style wands come in different sizes, some of them taller than their owners. A staff can be craggy or braided, or just a simple stick with a decorative top, like this one.

A Magical Fighter Girl and Her Sword

A magical girl will sometimes dump the wand for a sword. And then, watch out! She can go after monsters that are twenty stories tall. That sword isn't just any sword, but a weapon imbued with supernatural qualities that can make her all but invincible. The drama happens when she gets hit by the powerful tail of the monster and *drops* the sword. What then? That's when the edge-of-your-seat stuff happens as she must reach her sword before the sharp teeth of the monster reach her!

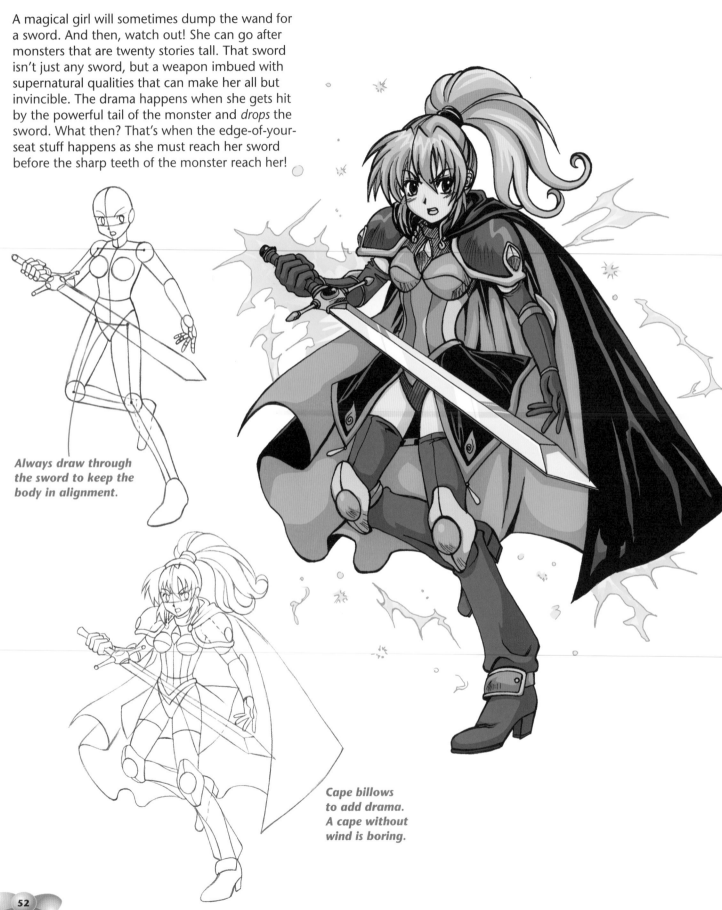

Always draw through the sword to keep the body in alignment.

Cape billows to add drama. A cape without wind is boring.

Windblown Capes and Skirts

I don't care what the weather is like outside—when your character transforms into a magical girl, the wind better be blowing, because the dramatic effect of the wind on the hair and costume is priceless. But you can have it for only three easy payments of $29.95. Oops. Been watching too many infomercials.

When we're talking about the poetic effect of windblown hair, we're not talking about a Category 4 hurricane. We're also not talking about wind coming from all directions. That's a very important note! The billowing breeze is usually directional. If it looks as if it's coming from more than one direction at a time, it's gonna blow everything this way and that—and make her hair a mess, which will make her cry. The wind should blow everything in the same direction.

The next thing to look for is the angle of the wind. "What?" you say. The wind has an angle? Yes! Stop pestering me with these questions and just listen! When the wind blows, you want it to lift the hair and costume—and not just a little but at least at a 45-degree angle. And sometimes, to give it that elegant, fantasy sweep, the wind should lift the hair *almost parallel to the ground*.

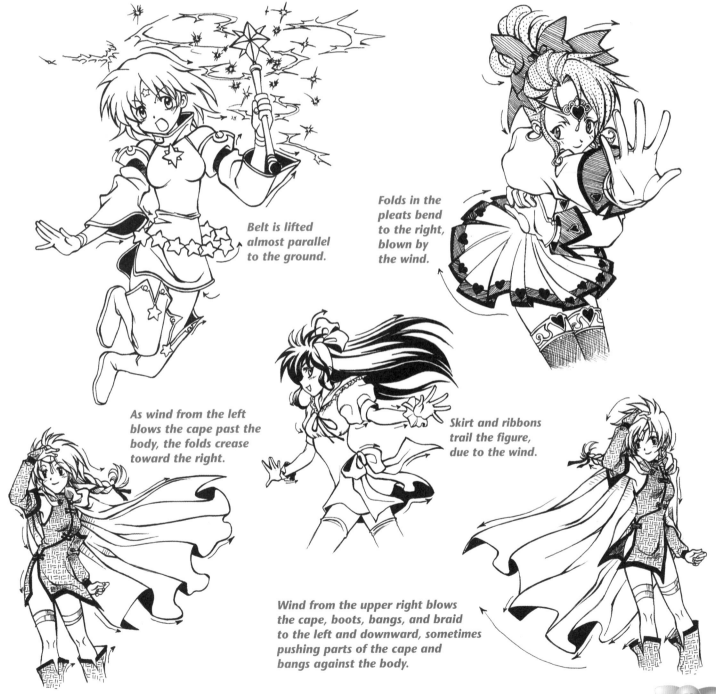

Belt is lifted almost parallel to the ground.

Folds in the pleats bend to the right, blown by the wind.

As wind from the left blows the cape past the body, the folds crease toward the right.

Skirt and ribbons trail the figure, due to the wind.

Wind from the upper right blows the cape, boots, bangs, and braid to the left and downward, sometimes pushing parts of the cape and bangs against the body.

Costume Colors

Think of costume colors as part of the theme of your character's costume. You can vary the colors to suit your character's identity, and the color theme will become synonymous with that identity. To show you how this works, the examples at right use single color themes across a variety of characters. When the color theme changes, you can see how it impacts the look of each character.

These are done with computer coloring programs. Many artists like to use Photoshop. However, artists—even colorists—do "marker comps" first. Marker comps are very rough colorings of black-and-white drawings using color markers. Sometimes, colored pencils are used. Usually, the colorist is not the penciler (who did the drawing), but I've worked with Japanese manga artists who do both because it gives them greater control over their creations.

Primary Colors

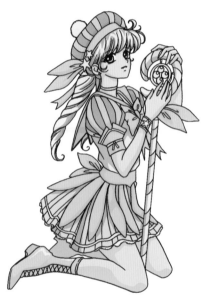

Pastel Colors

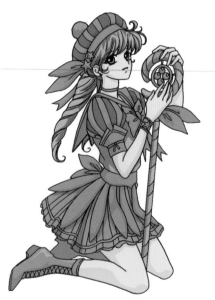

Variations on Single Colors

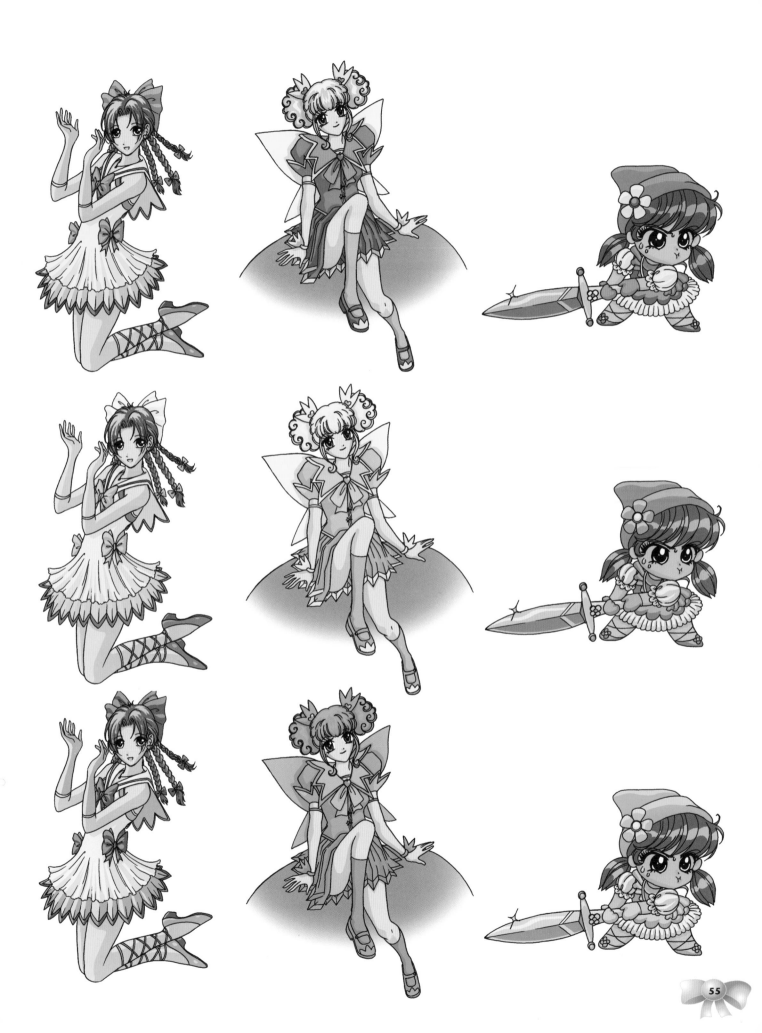

Magical Girl Varieties
The Inside Story from Japan

The schoolgirl-turned-fantasy-fighter is Japan's most popular type of magical girl story, which American manga fans get to see in the form of graphic novels. But what many American readers don't realize is that in Japan, this is a far more diversified genre. The Japanese manga that doesn't get imported has many more types of magical girls, incliuding some who have no particular superpowers at all but who nonetheless magically transform so that they can live out fantasy lives that ordinary girls only dream about. And that's the essence of manga. It's not always about beating up the bad guys. It's also about fantasy and relationships and dreams.

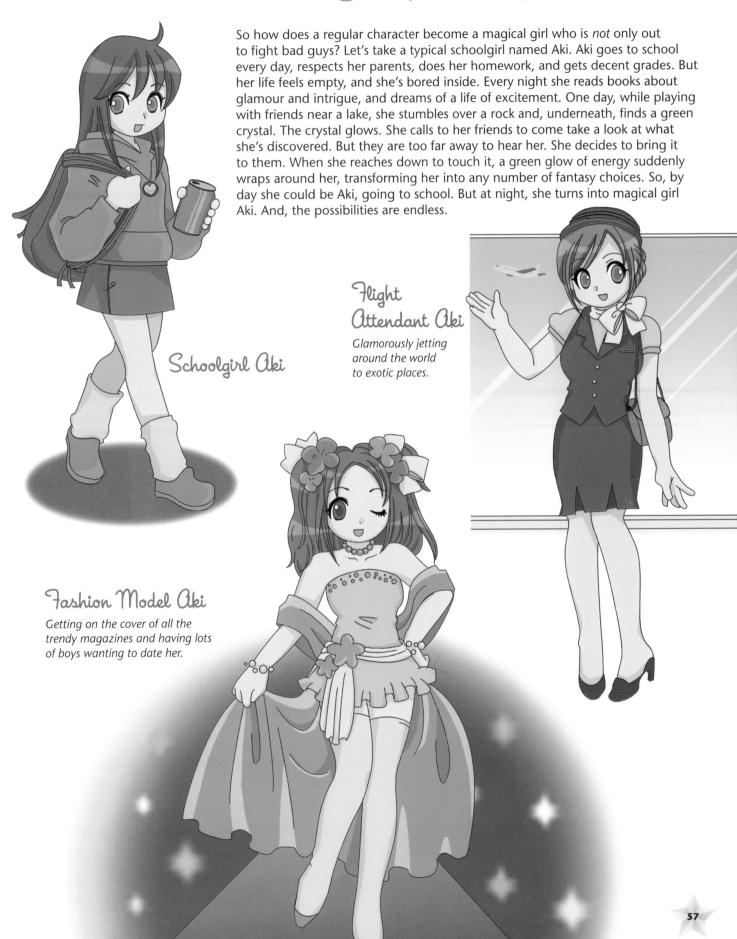

So how does a regular character become a magical girl who is *not* only out to fight bad guys? Let's take a typical schoolgirl named Aki. Aki goes to school every day, respects her parents, does her homework, and gets decent grades. But her life feels empty, and she's bored inside. Every night she reads books about glamour and intrigue, and dreams of a life of excitement. One day, while playing with friends near a lake, she stumbles over a rock and, underneath, finds a green crystal. The crystal glows. She calls to her friends to come take a look at what she's discovered. But they are too far away to hear her. She decides to bring it to them. When she reaches down to touch it, a green glow of energy suddenly wraps around her, transforming her into any number of fantasy choices. So, by day she could be Aki, going to school. But at night, she turns into magical girl Aki. And, the possibilities are endless.

Schoolgirl Aki

Flight Attendant Aki

Glamorously jetting around the world to exotic places.

Fashion Model Aki

Getting on the cover of all the trendy magazines and having lots of boys wanting to date her.

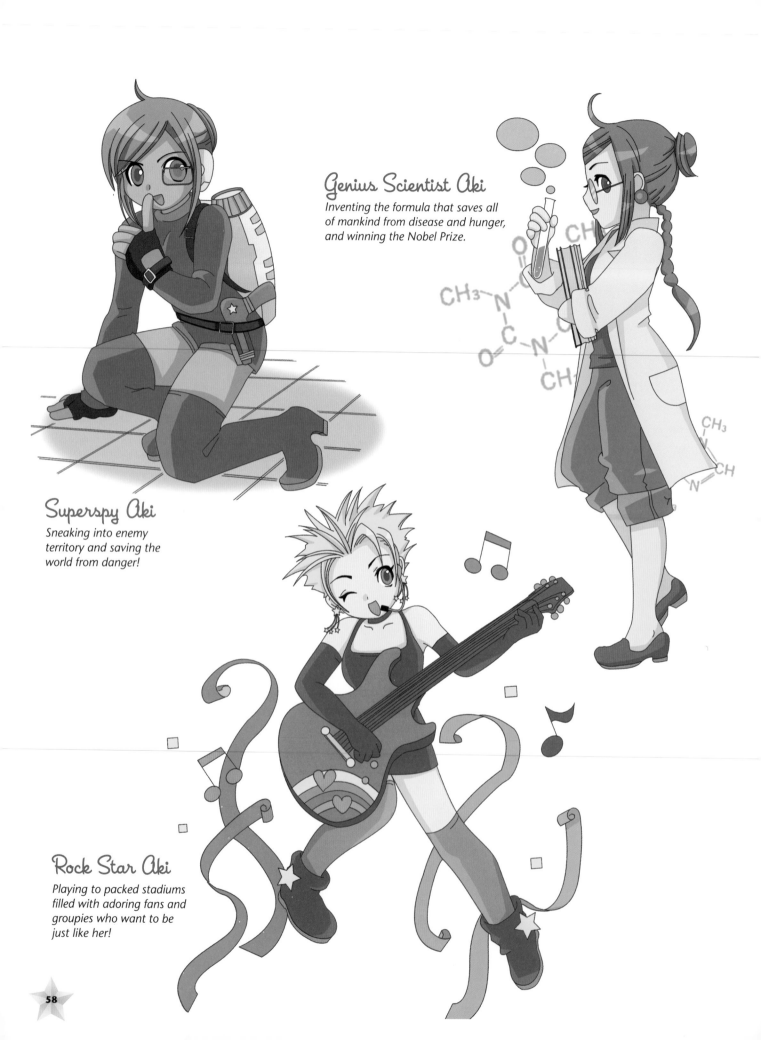

Genius Scientist Aki

Inventing the formula that saves all of mankind from disease and hunger, and winning the Nobel Prize.

Superspy Aki

Sneaking into enemy territory and saving the world from danger!

Rock Star Aki

Playing to packed stadiums filled with adoring fans and groupies who want to be just like her!

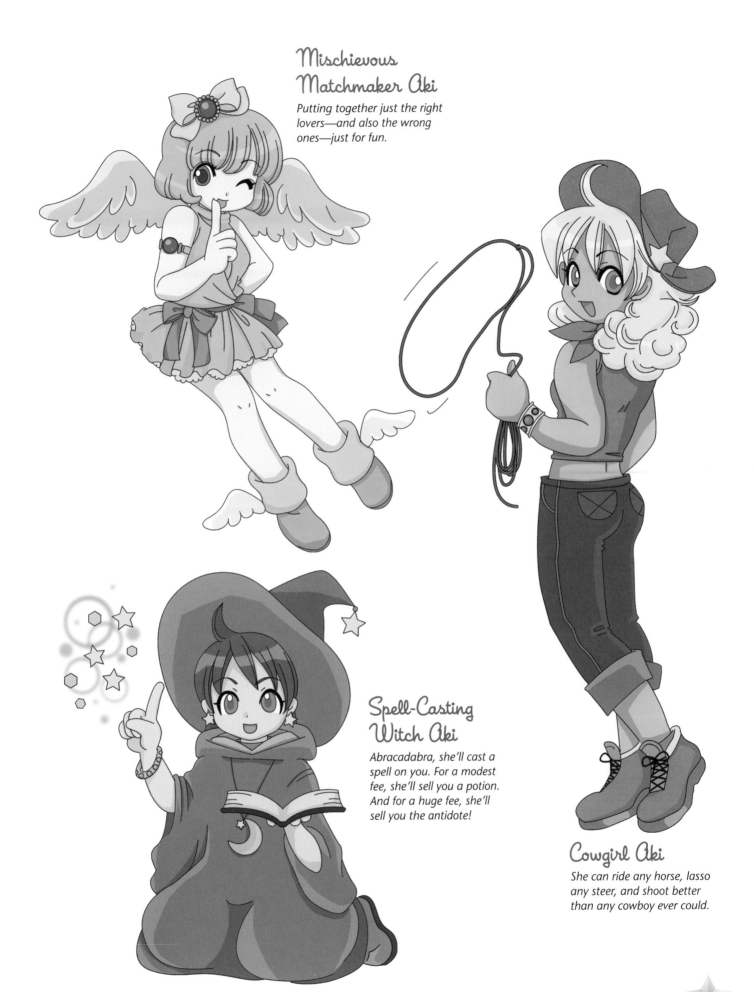

Mischievous Matchmaker Aki

Putting together just the right lovers—and also the wrong ones—just for fun.

Spell-Casting Witch Aki

Abracadabra, she'll cast a spell on you. For a modest fee, she'll sell you a potion. And for a huge fee, she'll sell you the antidote!

Cowgirl Aki

She can ride any horse, lasso any steer, and shoot better than any cowboy ever could.

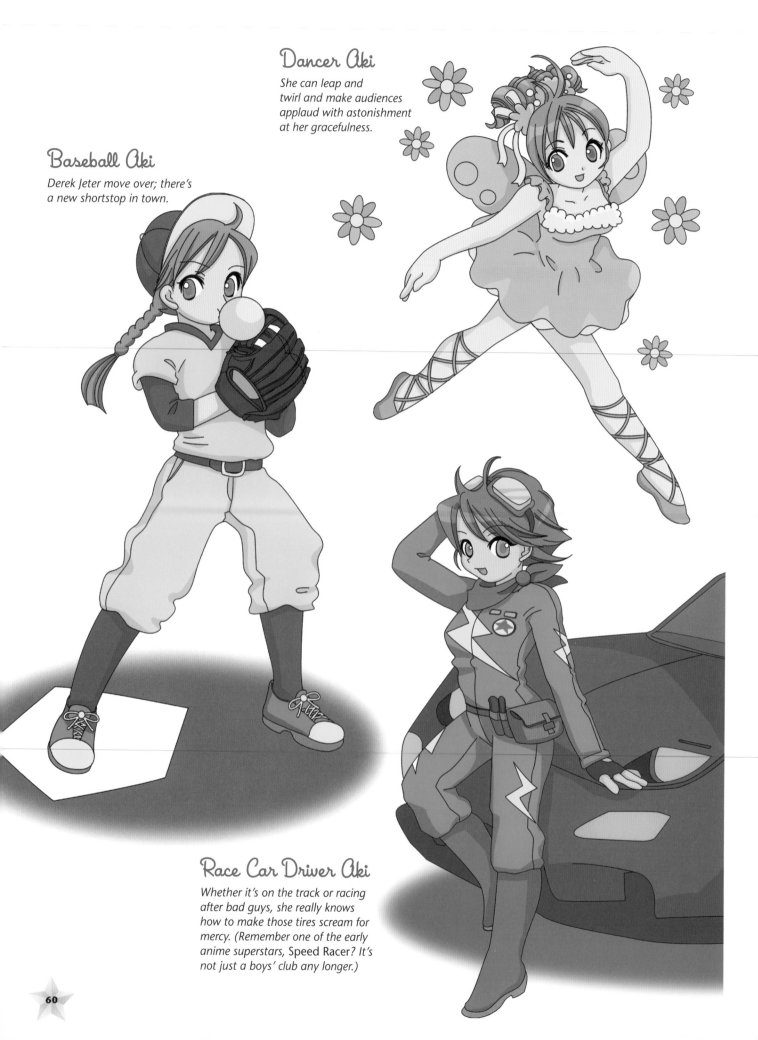

Dancer Aki

She can leap and twirl and make audiences applaud with astonishment at her gracefulness.

Baseball Aki

Derek Jeter move over; there's a new shortstop in town.

Race Car Driver Aki

Whether it's on the track or racing after bad guys, she really knows how to make those tires scream for mercy. (Remember one of the early anime superstars, Speed Racer? It's not just a boys' club any longer.)

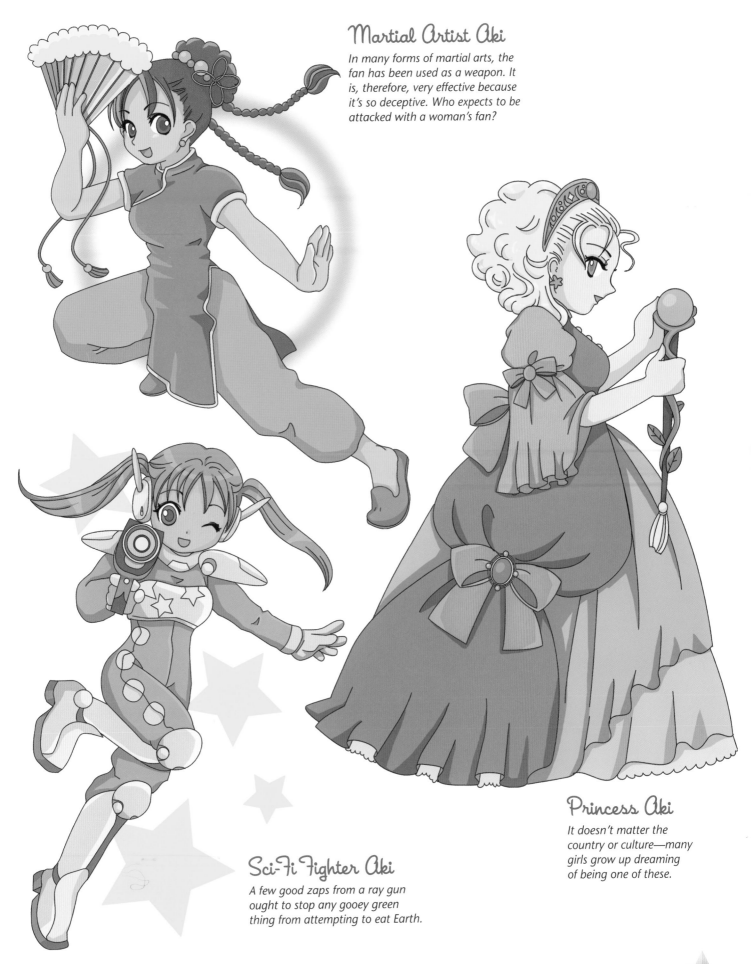

Martial Artist Aki

In many forms of martial arts, the fan has been used as a weapon. It is, therefore, very effective because it's so deceptive. Who expects to be attacked with a woman's fan?

Princess Aki

It doesn't matter the country or culture—many girls grow up dreaming of being one of these.

Sci-Fi Fighter Aki

A few good zaps from a ray gun ought to stop any gooey green thing from attempting to eat Earth.

Chibi-Style Magical Girls

Chibi means *small* in Japanese. Chibi characters appear throughout the manga genres. In the magical girl genre, they appear as supersmall magical girl characters and are some of the cutest gals in the comics world. As with other types of chibi, they're tiny with huge emotions and attitudes. Combine that with magical costumes and magical powers, and you've got the potential for lots of humor—in a teeny, combustible personality.

Chibi are "way out in front" with their expressions. If they feel it, you're going to know about it. And that's funny, because if your chibi is dressed as a princess and she's a little sad, then instead of welling up with a soulful tear, she will bawl uncontrollably. It's a funny look. Check out these over-the-top demonstrations of uninhibited attitude.

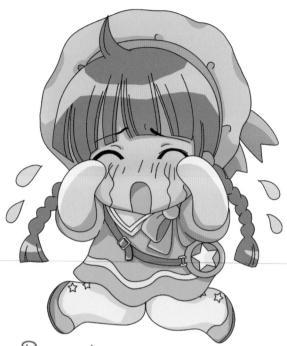

Bwaaaa!

Huge teardrops fly off her face. Streams pour down her cheeks. There's no consoling the poor dear. If you try to give her a hug, she'll probably slug you. The outfit is based on the popular sailor suit, which is a typical school uniform in Japanese public schools.

Omigosh!

The whole body pulls into itself, knees and arms included. If the eyes opened any wider they'd roll right out of her head. Open the mouth, but don't show any teeth.

Just Try It!

Tight mouth, tight arms, both feet planted firmly on the ground. Save your breath. She's not moving.

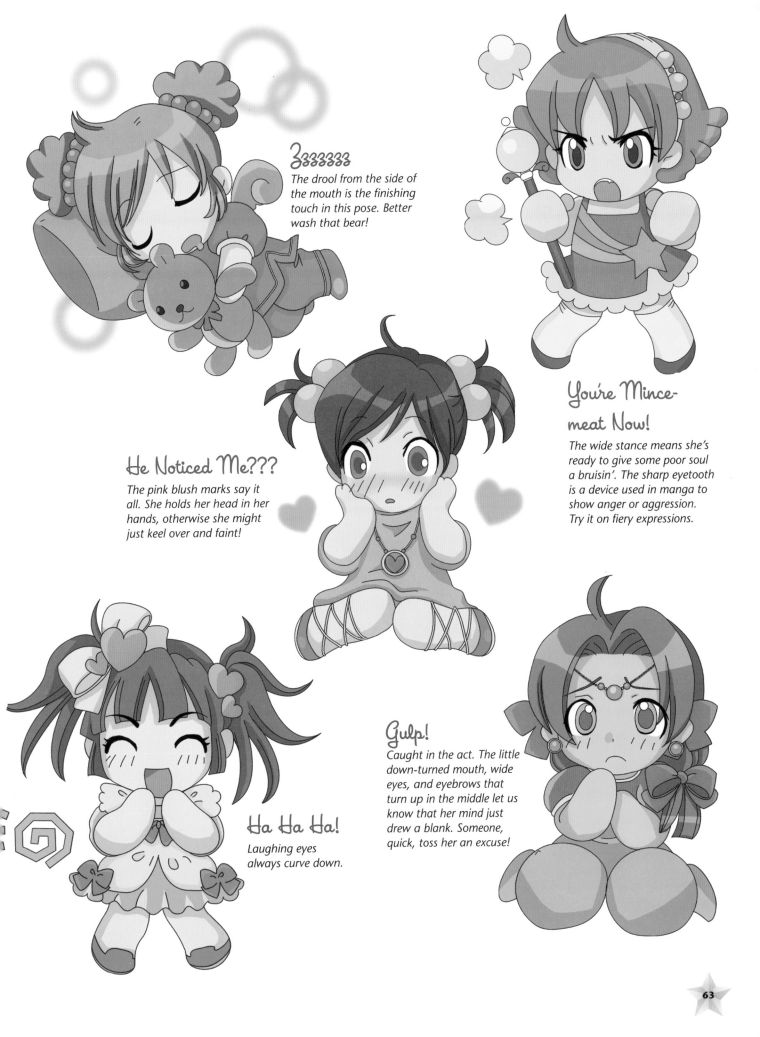

Zzzzzzz

The drool from the side of the mouth is the finishing touch in this pose. Better wash that bear!

You're Mince-meat Now!

The wide stance means she's ready to give some poor soul a bruisin'. The sharp eyetooth is a device used in manga to show anger or aggression. Try it on fiery expressions.

He Noticed Me???

The pink blush marks say it all. She holds her head in her hands, otherwise she might just keel over and faint!

Ha Ha Ha!

Laughing eyes always curve down.

Gulp!

Caught in the act. The little down-turned mouth, wide eyes, and eyebrows that turn up in the middle let us know that her mind just drew a blank. Someone, quick, toss her an excuse!

Magical Boys

The magical boy is a popular character type. He, too, possesses special powers. He may be a classmate of the magical girl. Or perhaps he's someone who lives in the other, magical world and requires the magical girl's help against the demons who are trying to destroy his people—and as such, he has been sent to Earth to bring her back to lead them. They will fight together, and maybe share a secret love from afar.

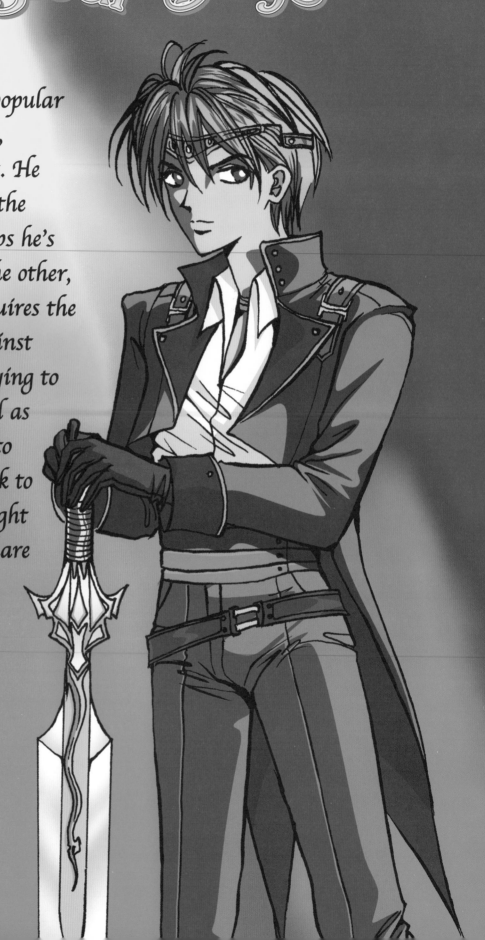

The Magical Boy Face

Like the magical girl, the magical boy is also about 14 to 16 years of age, but he can sometimes appear even a bit older if his features are longer and more elegant (a type of character known as a bishounen, or bishie for short, which in Japanese stands for *pretty boy* and is a standard character type pervasive in many styles of manga).

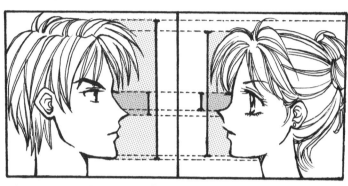

Male vs. Female Facial Proportions

On male characters, there's a higher forehead, more length from the top of the eye to the tip of the nose, and more mass at the bottom of the jaw.

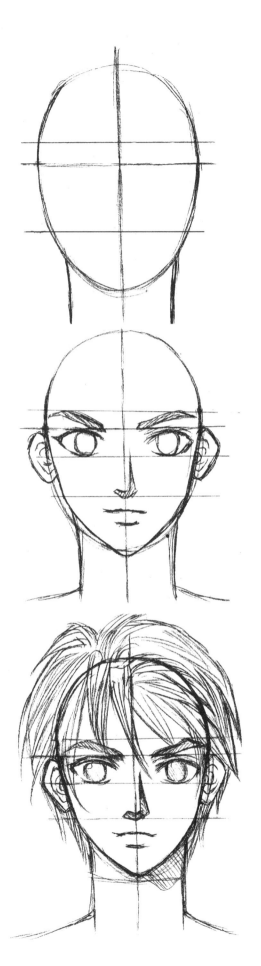

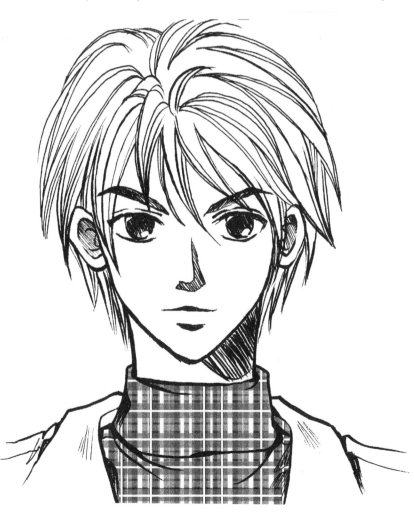

Profile

As you can see from the character design, the magical boy isn't a rugged type—no jock is he. He's earnest, determined, and true. And that's what you want in the magical fighting genre: teens with amazing powers, who nonetheless look vulnerable and outclassed by the enemy. If they looked invincible, there would be no drama. So the magical boy still looks a little on the soft side, but he's got a tiger's fighting spirit in him. And yes, he can be sarcastic and also crack stupid jokes. Hey, what did you expect? He's a boy?

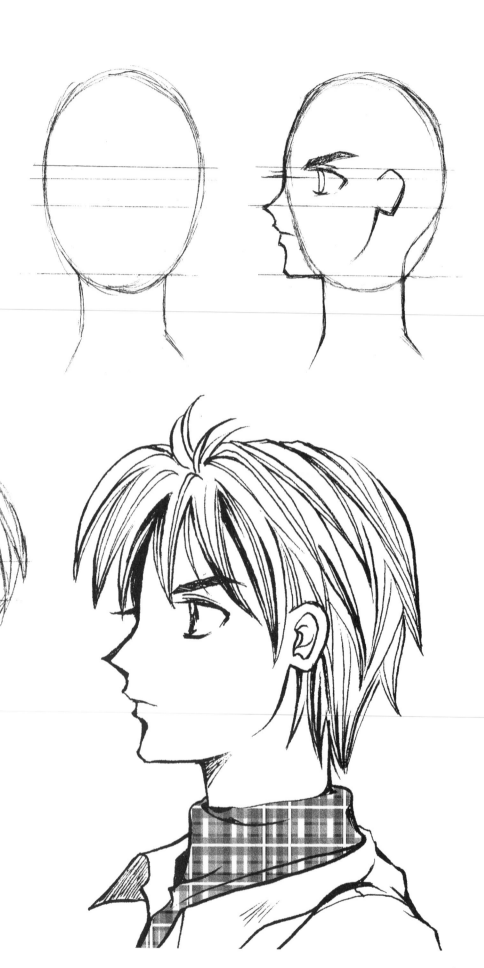

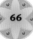

Costume Possibilities

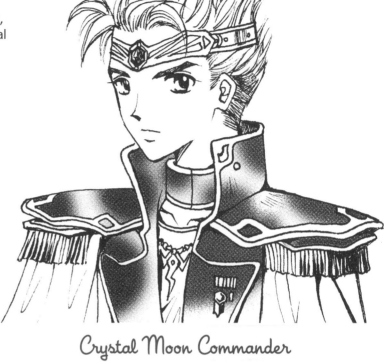

Here's the same character dressed three different ways to create three different magical boys around whom you could build a story. Remember, the origins of the magical boy are important: i.e., where he comes from, what went wrong with his world, and how the magical girl can help save his people from destruction.

Crystal Moon Commander

High collars and squared off shoulder pads create a commanding appearance.

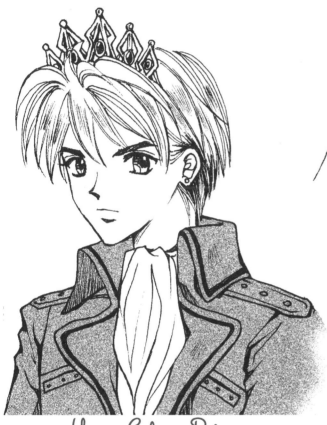

Young Galaxy Prince

A crown and ascot offer a pampered, regal look.

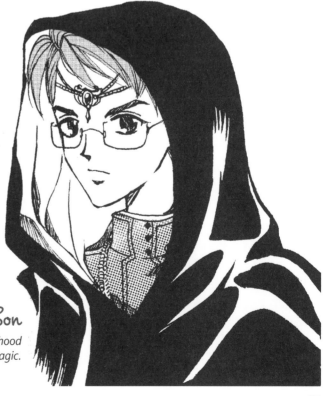

Dark Warlock's Son

A cloak and hood conjure up dark magic.

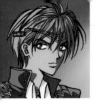

The Magical Boy Body

To start, draw a magical boy as a regular teen, before he transforms into a super version of himself. This chart gives some basic pointers on proportions. When artists think about body proportions, they don't get out the tape measure. Instead, they think in terms of "head lengths." In other words, how many "heads tall" is the character, or how many head lengths is the entire figure? Similiarly, they consider how many heads wide the character is from shoulder to shoulder. And they break down the character into smaller sections, considering how many heads tall just the hip area is (on this diagram, it's three-quarters of a head). Doing this helps the artist keep the character looking the same in a variety of poses because even though the pose changes, the proportions don't.

All people are built differently. So these are *average* proportions. With shorter people, the proportions may be truncated; on lankier characters, they might be elongated. But these proportions make a good guide that fits into the normal range.

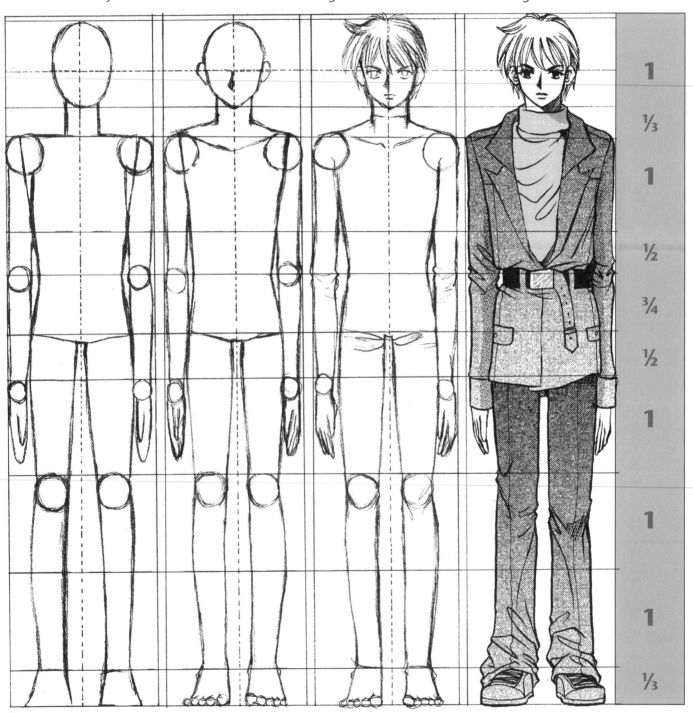

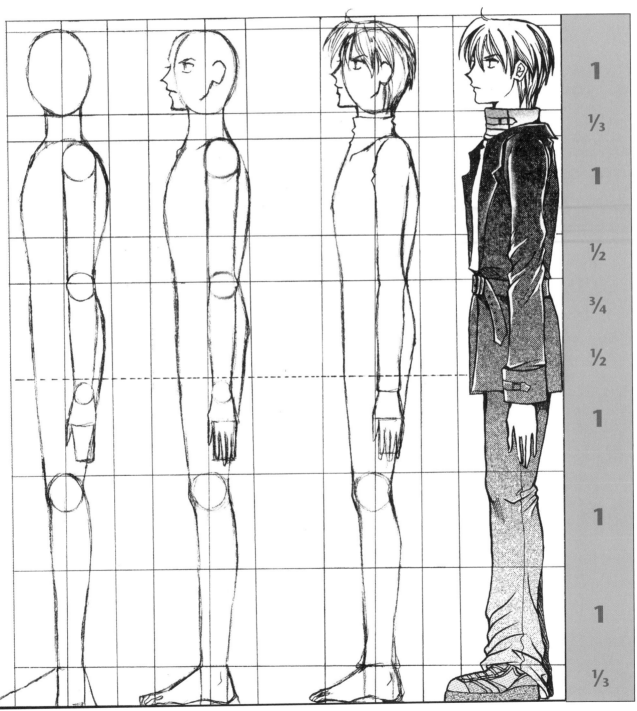

1

⅓

1

½

¾

½

1

1

1

⅓

Magical Boy Types

Just as there are different types of magical girls, there are also different types of magical boys. The figures here and on the next few pages provide some of the many possibilities.

Human (Left)

He's your average high school sophomore who's just been whisked from his bicycle and suddenly transported to another dimension where he has been hailed as the leader. He has been chosen to lead the fight against the legions of darkness that have invaded a peace-loving alien world. His new uniform shows that he is a commander of the highest order. He may not have any idea what he's doing—or what he's up against. Even worse, his new, all-powerful, wicked enemies now view him as the main obstacle to their ultimate domination of the universe. Makes you kinda wish you had a final exam to go to instead.

Elfin (Right)

He's the kind of magical boy who travels from the alien world to Earth to bring back a magical girl to save his people. His elfin ears, sharp nose, pointed eyebrows, and long hair all conspire to give him a faerielike quality. He may travel between the two worlds, but he cannot stay on Earth, even if he falls in love with an Earth girl. His home is somewhere else.

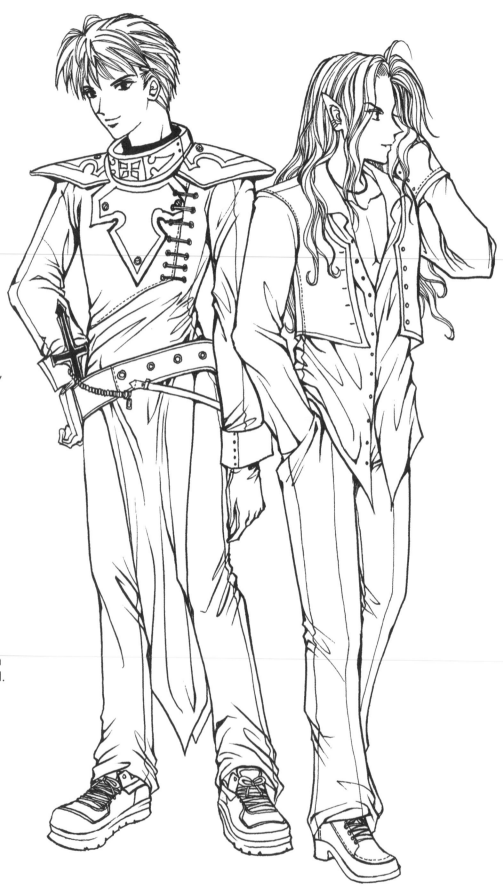

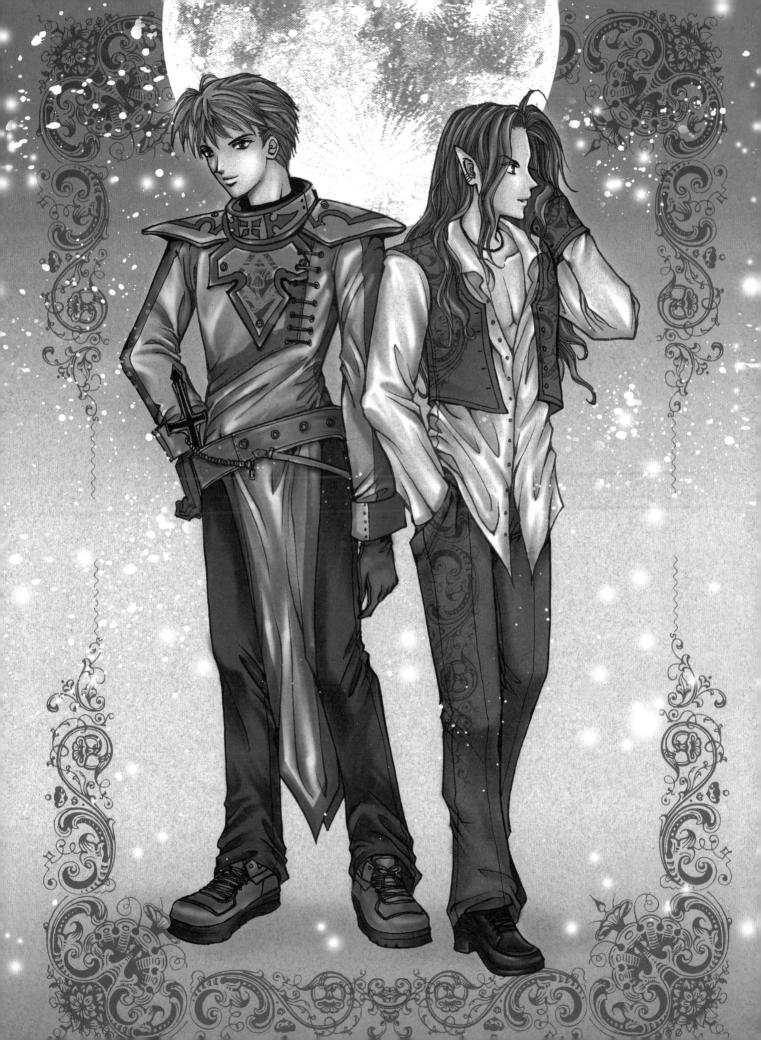

Sword Fighter (Left)

Magical boys can also be fighters of the sword, defenders of the realm, sort of "fantasy knights."

Anthro (Right)

Magical boys can be even more fanciful figures, as well, like *anthros*. *Anthro* is slang for *anthropomorphic*, which describes animals drawn with human attributes (walking upright, for instance). In manga, the term *anthro* refers to humans with animal traits, such as the cat-boy on the right. Anthros are popular enough to warrant their own subcategory in manga. These mysterious creatures can also possess mysterious powers and be part of the magical boy or girl genre.

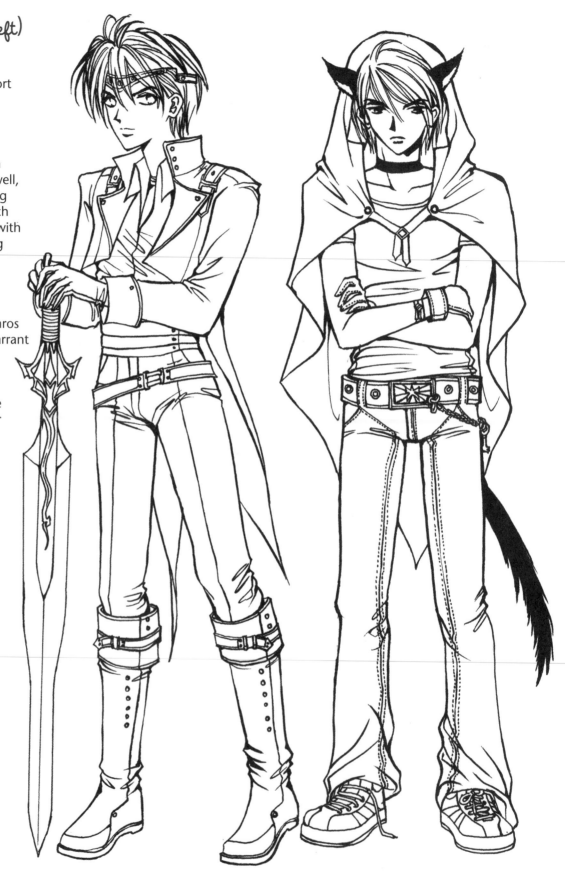

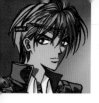

The Power Poses

Here they go—into action to help the magical girl defeat the forces of evil and bring justice to the world. The enemy—whether it be a monster, a giant robot, or a powerful wizard—is always larger in stature than the magical boy, which stacks the odds against our hero. That creates the nail-biting experience the reader secretly desires. It also means that the enemy is going to posses more brute force and generate more special effects. As a result, the magical boy is going to have to use mobility and speed to his advantage. So use lots of action and body movement in his poses.

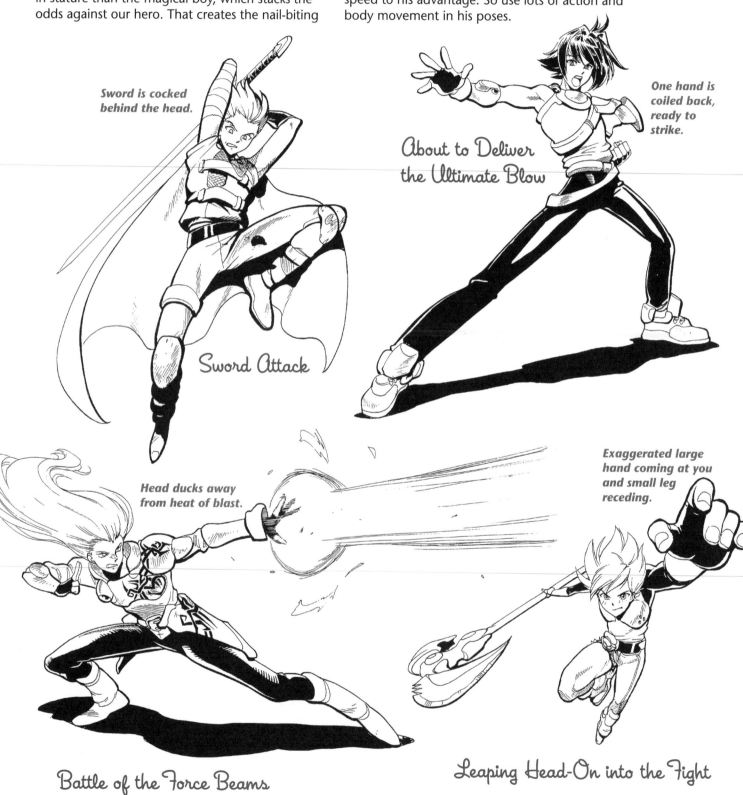

Sword is cocked behind the head.

Sword Attack

About to Deliver the Ultimate Blow

One hand is coiled back, ready to strike.

Head ducks away from heat of blast.

Exaggerated large hand coming at you and small leg receding.

Battle of the Force Beams

Leaping Head-On into the Fight

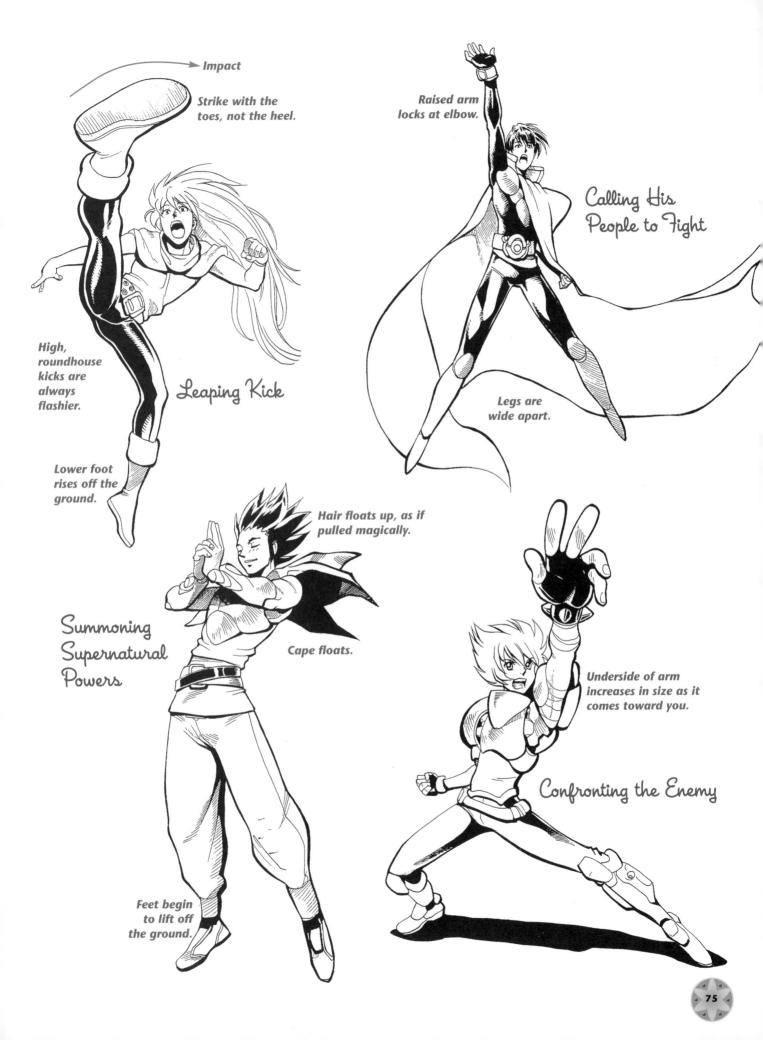

Impact

Strike with the
toes, not the heel.

Raised arm
locks at elbow.

*Calling His
People to Fight*

Leaping Kick

High,
roundhouse
kicks are
always
flashier.

Legs are
wide apart.

Lower foot
rises off the
ground.

Hair floats up, as if
pulled magically.

*Summoning
Supernatural
Powers*

Cape floats.

Underside of arm
increases in size as it
comes toward you.

Confronting the Enemy

Feet begin
to lift off
the ground.

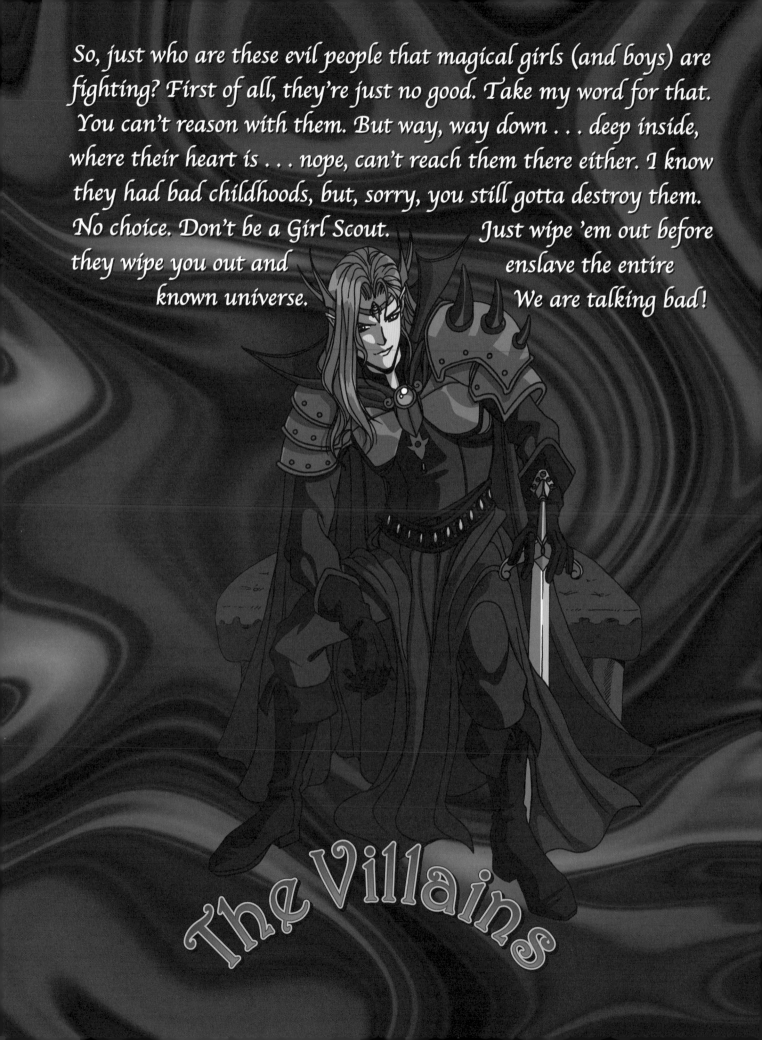

So, just who are these evil people that magical girls (and boys) are fighting? First of all, they're just no good. Take my word for that. You can't reason with them. But way, way down . . . deep inside, where their heart is . . . nope, can't reach them there either. I know they had bad childhoods, but, sorry, you still gotta destroy them. No choice. Don't be a Girl Scout. Just wipe 'em out before they wipe you out and enslave the entire known universe. We are talking bad!

The Villains

Elegant Evil

The evil ones in the magical girl genre are not giant, ugly, creepy crawly, slimy monsters. Far from it. They're elegant, sophisticated, handsome (if they're male), beautiful (if they're female), wicked beings who love their work: making humans suffer. You've seen them not only in manga, but all over popular anime on TV and in film. You hate them for their villainy and treachery.

And strange as it may seem, you can't look at them through the eyes of a manga fan. A manga fan might root against them. Who wouldn't? But as an artist, it's essential that you find a way to actually *like*, even *admire* these hateful personalities. You can't draw characters you despise. That doesn't mean you have to admire them, but you have to give them a dark, appealing charisma. Don't worry. You can do it. Actors do it all the time. They love to play bad guys. It's fun to be bad. Just as it's fun to draw wicked characters. Make them really evil, but—and this is a very important caveat—*they must be charming*!

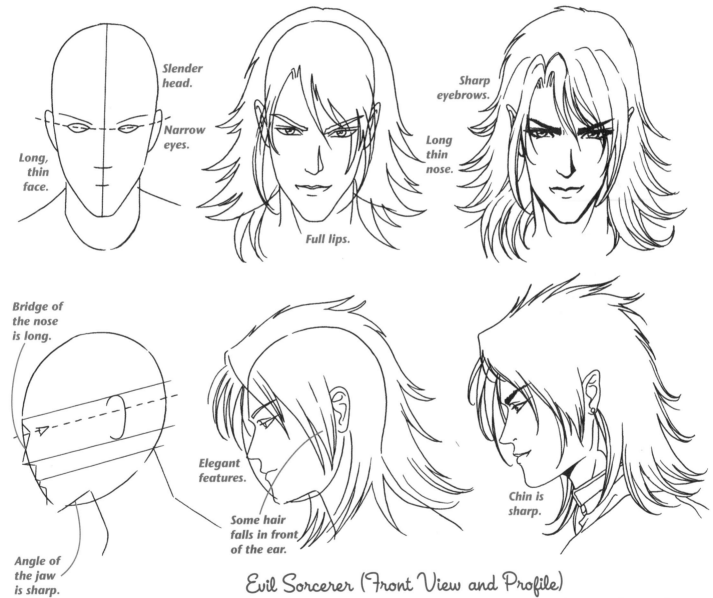

Slender head.

Narrow eyes.

Long, thin face.

Full lips.

Sharp eyebrows.

Long thin nose.

Bridge of the nose is long.

Angle of the jaw is sharp.

Elegant features.

Some hair falls in front of the ear.

Chin is sharp.

Evil Sorcerer (Front View and Profile)

This wicked bishounen character has a long, elegant face. His eyebrows are sharp, and importantly, they rest right on top of the eyes. The hair doesn't spike up as it does on many manga characters, but gently cascades down around his shoulders.

Unlike the magical girls (and boys), the bishounen-style character does not have such a round head. He's clearly older, more mature, more angular. For the profile, it's still easiest to start with an egg shape, but then you've got to go in for some sculpting, chipping away at the front of the face and making sure that the angle underneath the jaw is sharp enough.

Evil Cuts a Dashing Figure

The bishounen evil guy is semigothic, which becomes more apparent when you see his entire body, complete with outfit. He dresses as if he's a dark prince from some faraway kingdom. Let's face it, the guy is vain. He can't pass up a sale at the designer cape shop. It's gotta take him the better part of two hours to get dressed and out of the castle each day. He's almost as pretty as the wicked sorceress (page 82). No wonder she's always ticked off!

His proportions are more realistic than the other characters in the magical girl genre. The villains seem like real adults. And there's a subtle message there: It's the teenagers vs. the adults. Us vs. them. The rebels vs. the authority. It places the reader in the mind-set of the teen characters—a clear vantage point. It's always best, when writing a story, to give your reader a "window" from which to view the world.

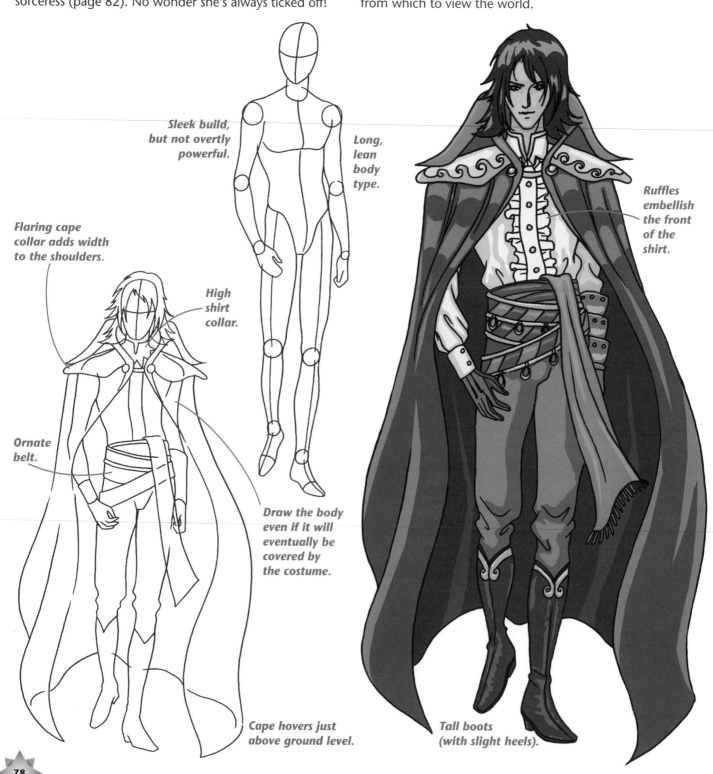

Sleek build, but not overtly powerful.

Long, lean body type.

Flaring cape collar adds width to the shoulders.

High shirt collar.

Ruffles embellish the front of the shirt.

Ornate belt.

Draw the body even if it will eventually be covered by the costume.

Cape hovers just above ground level.

Tall boots (with slight heels).

Walking Cycle: Opposing Legs and Arms

In the magical girl genre, the male villain is evilly seductive. He's an idealized, romantic figure akin to an androgynous vampire, in similar gothic attire.

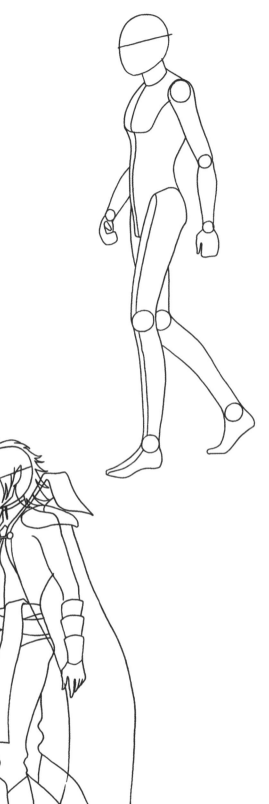

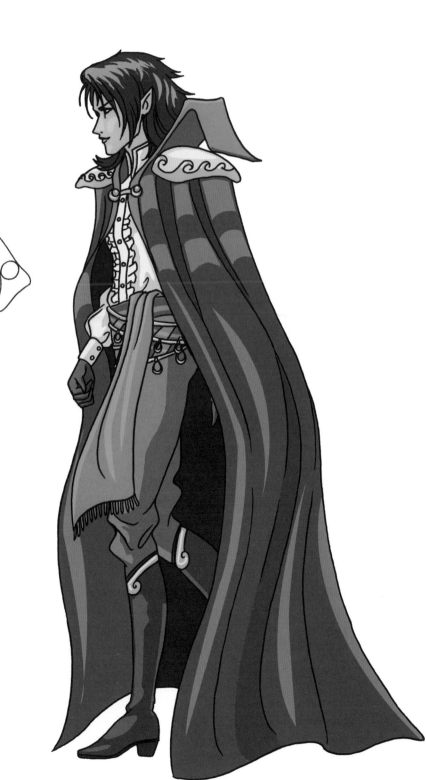

Wicked Enchantress

And you thought the sorcerer was bad? She's the one who's been coaching him! She doesn't even make a pretense of being "on your side." Impatient, cruel, gleefully bad—and those are her good qualities! Any character with black lipstick is up to no good, you can take my word on this one. The extra-heavy eyeliner is also a clue. Her features, though small, are sharp and pointed. Her hairstyle is a little nightmarish, like an apparition in the woods whose clothing and hairdo are continuously rolling in the breeze. You would *not* want to put her in charge of your living trust.

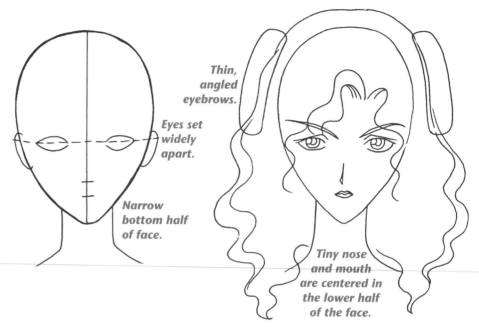

Thin, angled eyebrows.

Eyes set widely apart.

Narrow bottom half of face.

Tiny nose and mouth are centered in the lower half of the face.

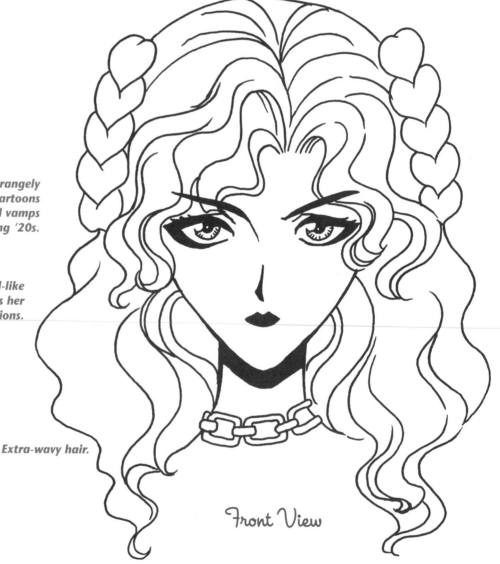

The eyelash is strangely reminiscent of the cartoons of the flappers and vamps of the roaring '20s.

Her little, doll-like face thinly masks her cruel intentions.

Extra-wavy hair.

Front View

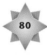

Pronounced chin.

Large eyes, even in profile.

Small overbite.

Lots of detail in the hair and eyes, but no expression lines in the face.

Extreme angle of eyebrows.

Tiny lips.

Profile

Evil Never Looked So Good

Her pose says it all: *I'm here. Prepare to die.* Okay, so it's not the cheeriest greeting in the world, but it does get the point across. I'm sure you noticed right away, unless you're going in for cataract surgery, that this character is extremely curvaceous. She's not planning to fight with her fists. Not now, not ever. In fact, she's not going to get one hair out of place. Not so much as a smudge in her lipstick. It's all in her magical powers—powers that rival those of the magical girl. In fact, the story is a lead-up to the climax, when we get to see whose powers are greater. It's a grand duel, a galactic spectacular, a titanic battle of fireworks between good and evil.

Outward curve.

Narrow, inward curve.

Outward curve.

Back of hand on hip conveys a disdainful attitude.

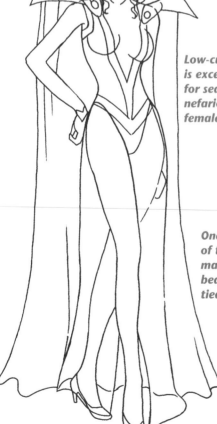

Tall, pointy collar is effective on evil characters.

Low-cut dress is excellent for seductive, nefarious females.

One leg crossing in front of the other in a relaxed manner tells readers, "I can beat you with my hands tied behind my back."

Feet arch down as the high heels push the heel up.

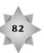

From the Side

From the side you can see that the slightly backward bend of her torso gives her that slinky look; it's a typical posture for villains. Her bare leg gives her some sensuality. Villains are like that. Sure, they want to kill you, but they can't resist flirting while they do it. Good guys are much more forthright in their posture, with the chest held high.

Split dress reveals the leg.

Evil Lord in Armor

The difference between a sorcerer and an evil lord is primarily the armor. When you add armor onto the sorcerer's outfit, he becomes an evil lord. It's not an authentic medieval suit of armor, but a fantasy/armor combo. The medieval and gothic plates, the spikes, and the sword bestow a dark leadership quality on this figure. The evil lord directs an army of sword-swinging followers who obey his every command. It is he who declares war and conquers entire civilizations. And, when he's not fighting on the front lines, he's meeting in a tent behind the scenes with his generals, plotting, planning, and kidnapping whoever can be used as a bargaining chip. He's a schemer and a plotter—and a betrayer.

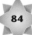

Head gear of a high rank.

Spikes on protective shoulder guards for a gothic look.

Headband adds a fantasy quality to the outfit.

Chest protector.

Arm plates.

Powerful jewel amulet.

Midlength gloves.

Long sword.

Tall boots with cuffs.

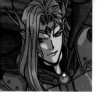

Female Warlord

Yes, my friends, she's a gothic warlord and not a happy camper. What will it take to make her smile? Her team winning the World Series? Shoes from Prada? Losing five pounds without even trying? The annihilation of Earth?

When we're talking about outfitting a female warlord, we're not talking about the kind of costume that would allow her to safely mount a horse and enter a joust. We're talking about making her look so gothic that she could adopt one of the gargoyles perched atop the cathedral at Notre Dame in Paris as a pet. She should move away from the conjuring-spells look, toward the I'm-going-to-set-fire-to-your-village look. Think gloves, boots, and shoulder and knee guards, all of which are protective in battle. Medieval warriors wore hip guards, as well. And yes, sharp wings help. Anything to make her less warm and fuzzy.

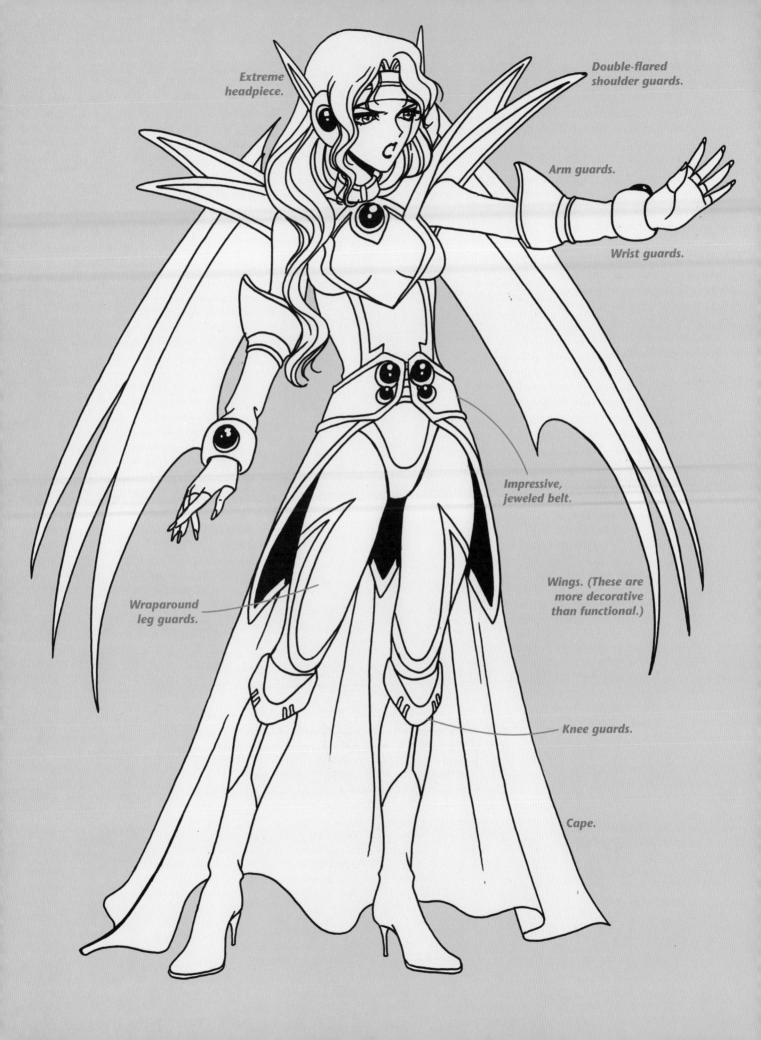

Extreme
headpiece.

Double-flared
shoulder guards.

Arm guards.

Wrist guards.

Impressive,
jeweled belt.

Wraparound
leg guards.

Wings. (These are
more decorative
than functional.)

Knee guards.

Cape.

Lord of the Beasts

The ability to hypnotize—and cast a spell over—vicious, predatory animals is a motif that has been around since the times of the earliest fables. This conceit conveys a message about the power of the character who holds dominion over such fierce beasts. I, personally, can only hypnotize a bichon frise, but it's an extremely aggressive bichon frise. I'm currently working my way up to poodles.

Lions, tigers, wolves, leopards, snakes—any dangerous carnivore makes a good pet for a villain... although, they can be tough to housebreak. Who's going to reprimand a leopard if it has an accident on the carpet? Not me, I can promise you that.

In many manga stories, these beasts are not really animals but humans who have been turned into animals by way of an evil spell. Others are demons in animal form. You can make up your own history for your beast. Either way, these beasts can still "speak" their thoughts to humans of their choice, without anyone else hearing them. A magical girl who faces down these evil foes will sometimes be drowned out by the noise of the inner dialogue going on between the beast and its master as they cackle and plot. The voices can become loud and overwhelming.

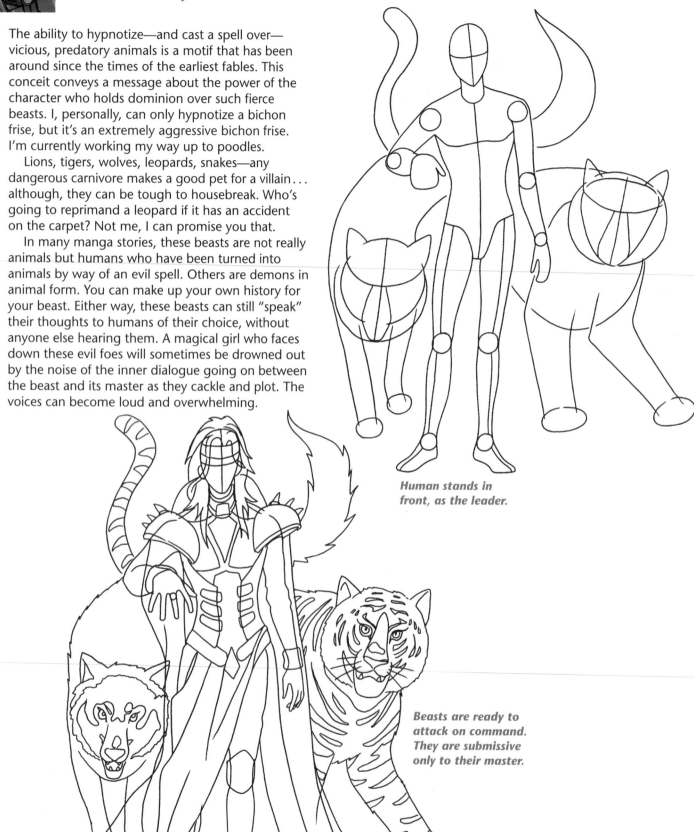

Human stands in front, as the leader.

Beasts are ready to attack on command. They are submissive only to their master.

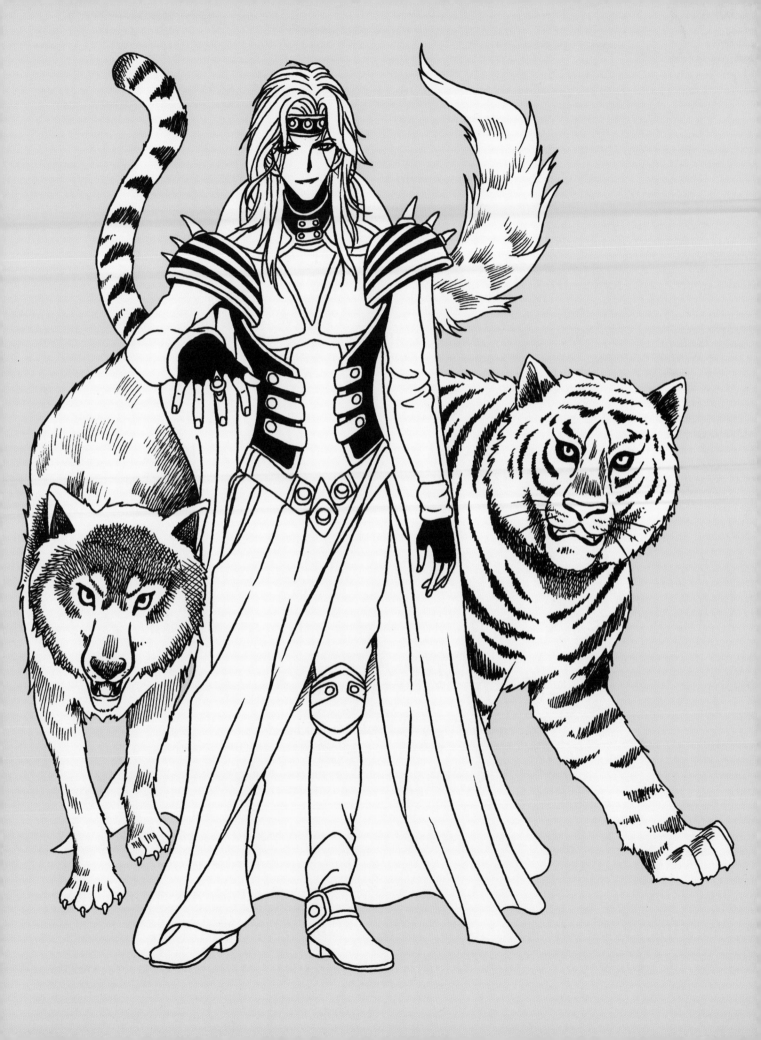

Essential Supporting Characters

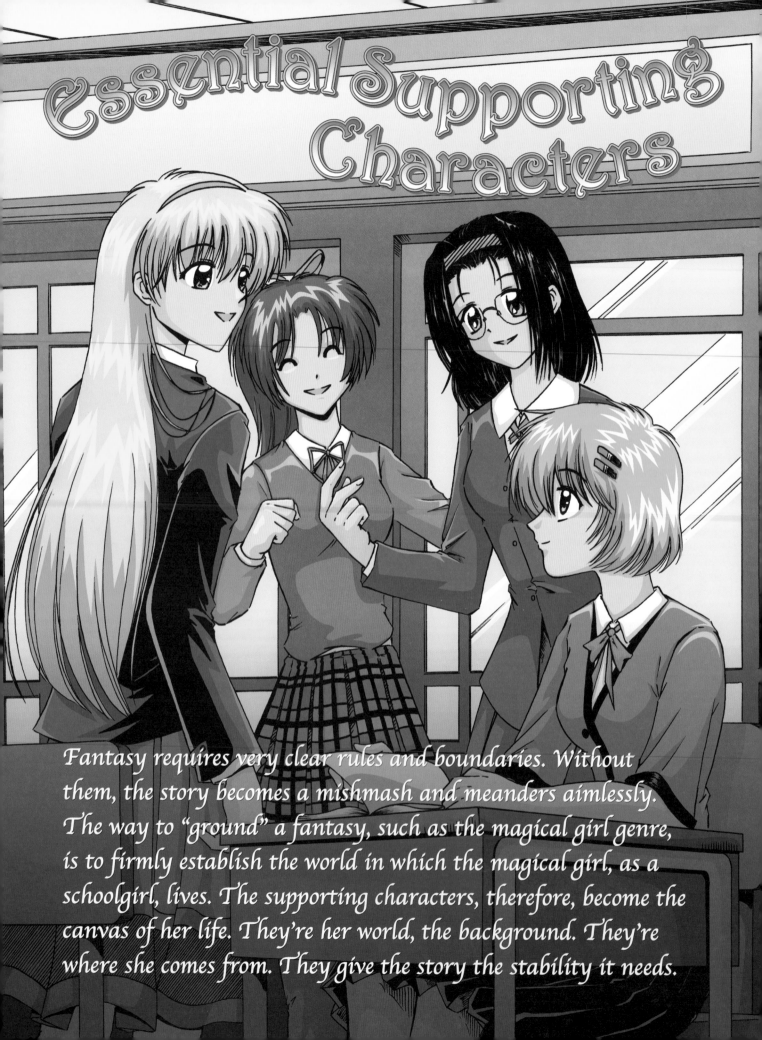

Fantasy requires very clear rules and boundaries. Without them, the story becomes a mishmash and meanders aimlessly. The way to "ground" a fantasy, such as the magical girl genre, is to firmly establish the world in which the magical girl, as a schoolgirl, lives. The supporting characters, therefore, become the canvas of her life. They're her world, the background. They're where she comes from. They give the story the stability it needs.

Best Friends and Confidantes

Everyone has to have a pal, a true-blue friend who can keep a secret, chat endlessly on the phone, and never let you down. When it seems like the whole world is against you and you just can't confide in your parents, you've got to have a best friend you can talk to. This is an essential tool in visual storytelling. Without the best friend, how would the magical girl express her thoughts? If she were to only "speak" in thought balloons, her world would become too insular and self-enclosed. She needs someone to share her secrets with and to challenge her.

The best friend character is typically perky and cute, but doesn't compete with the magical girl in personality.

There may be a really popular girl in their clique, but she won't be the magical girl's best friend. The magical girl will only confide in someone who is down-to-earth like her. In fact, a magical girl's group of friends are all unassuming, fun-loving girls who can share their hopes, dreams, and problems with one another.

And one more thing to keep in mind: Sometimes, when the transforming magic strikes a girl, it will also strike her entire group of girl friends (usually three girls) all at once, turning all three into a *team* of magical girls. So a best friend might just end up being a magical girl fighter, too!

The Japanese School Uniform

These are examples of authentic Japanese school uniforms. You can mix and match any of these sweaters, jackets, skirts, ribbons, and leggings to create new outfits. You can also change the colors and patterns. For example, instead of a plaid skirt, you could use a checkered pattern or zigzag lines and so on. You're the designer.

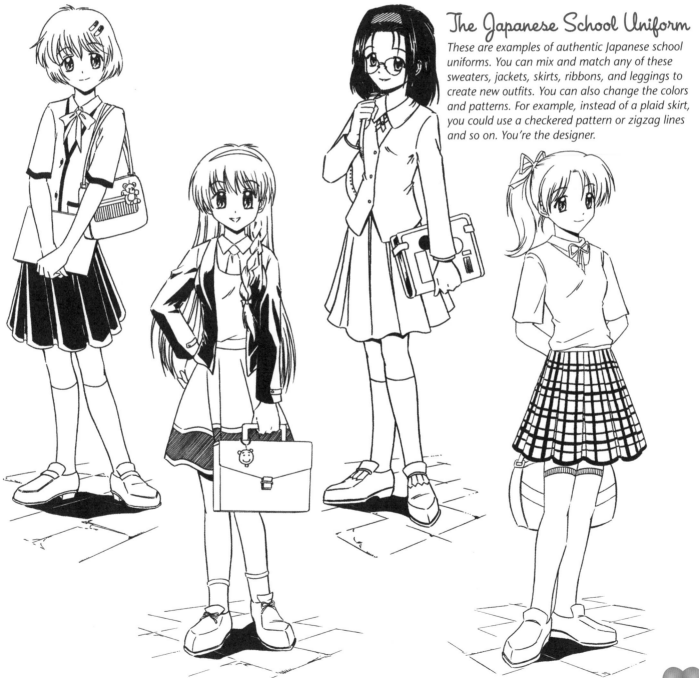

Classic Japanese Schoolgirl Uniform

Of course, you're going to have to draw a variety of schoolgirl outfits for the magical schoolgirl's group of friends, as seen on the previous page. But this is the classic schoolgirl uniform. You don't have to reinvent the wheel in order to come up with your own variations. Try adding different patterns to the skirt. Add oversized buttons and pockets to the sweater. Tight knee-high socks might replace leggings. A series of small changes can add up to a whole new look.

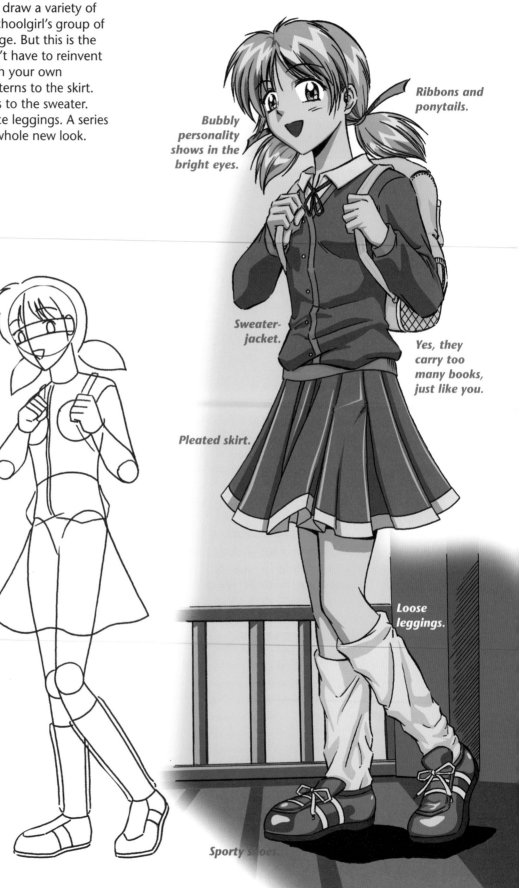

Draw the torso and hips as two distinct sections.

Bubbly personality shows in the bright eyes.

Ribbons and ponytails.

Sweater-jacket.

Yes, they carry too many books, just like you.

Pleated skirt.

Loose leggings.

Sporty shoes.

He's the one who can make the magical schoolgirl blush and forget what she was going to say. She's sure he likes someone else. And why shouldn't he? Every time he sees her, she trips, falls, or spills something on herself due to a case of nerves. When he stops to help her clean it up, she practically bursts into tears of embarrassment. And he can't understand why she never wants to talk to him!

He's a good guy, probably dating the rich snob at the school (see page 94), but only because our magical schoolgirl won't give him a chance. (Humans! It's amazing we've survived this long!) Even though he's a nice-looking character, he's not a bishounen. That's because he has a young teenager's face, not the long, thin, angular face of the more elegant, androgynous, mature bishounen. This character is typically 14 to 16 years of age.

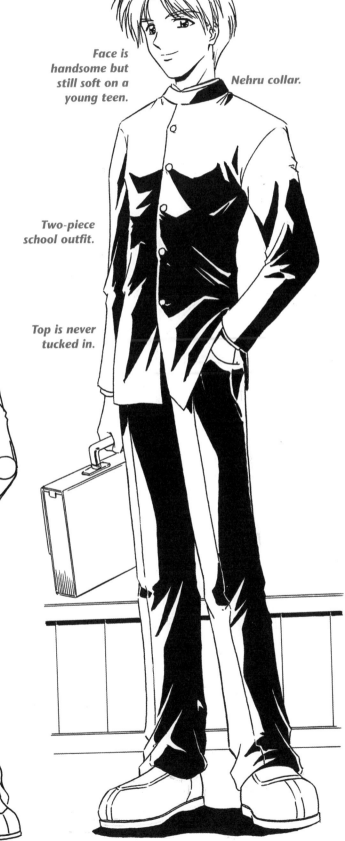

Face is handsome but still soft on a young teen.

Nehru collar.

Two-piece school outfit.

Top is never tucked in.

The Rich Snob

Okay, so she's pretty, but does she have to be so obvious about it? And the way she spends her daddy's money on clothes, you'd think she had no other hobbies, except criticizing the mismatched outfits other girls wear. But don't try to stand up to her. She has a razor-sharp tongue, and she's not afraid to use it. She's tight with a few other chic females who make up a closed clique that draws admiring looks from all the boys—and major-league resentment from all the other girls.

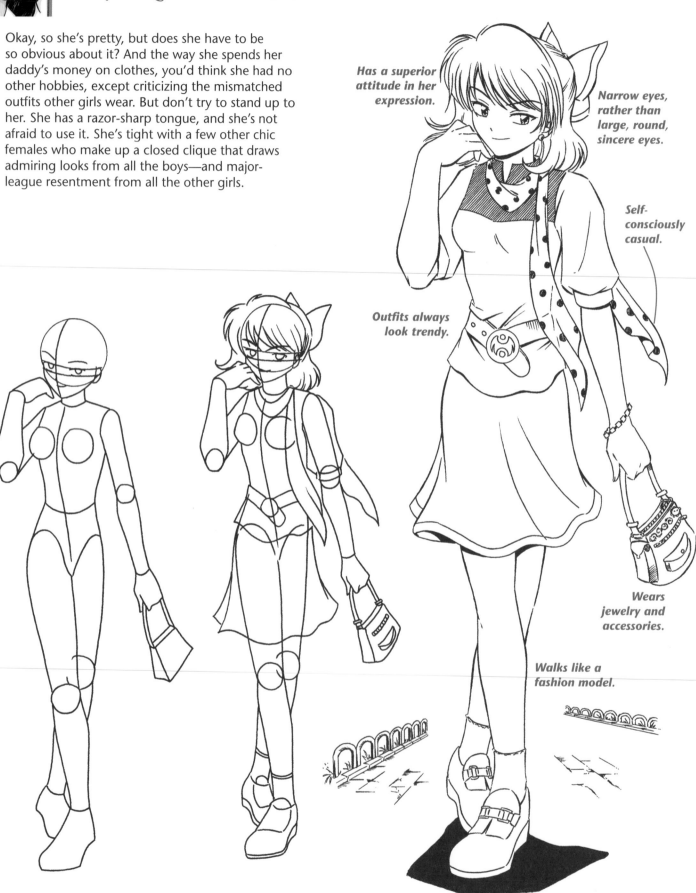

Has a superior attitude in her expression.

Narrow eyes, rather than large, round, sincere eyes.

Self-consciously casual.

Outfits always look trendy.

Wears jewelry and accessories.

Walks like a fashion model.

Magical Girl's Kid Brother

Family is always an important backdrop in magical girl stories. And the humorous sidekick in the family is often the kid brother. He's the little daredevil of the family, getting into trouble, taking the pratfalls. He might snoop around, suspecting that something's not quite right about his big sister, getting close to finding out what her secret is but always falling on his face as he tails her on his skateboard. He's short in stature and a bit of a string bean.

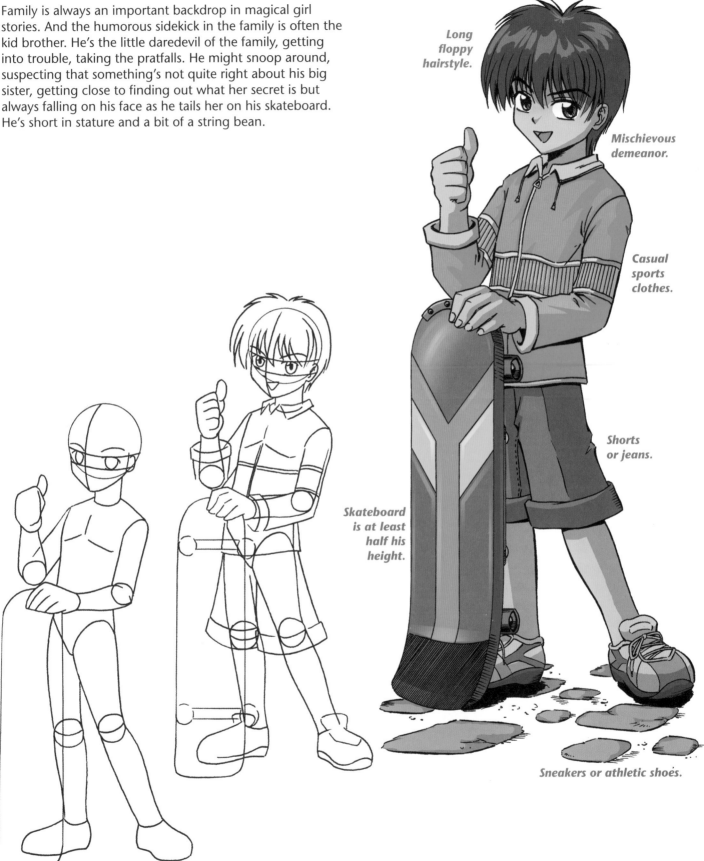

Long floppy hairstyle.

Mischievous demeanor.

Casual sports clothes.

Shorts or jeans.

Skateboard is at least half his height.

Sneakers or athletic shoes.

Dad

Just as the *Father Knows Best* 1950s-style sitcom dad was always cheerful on his way to work each morning, so too is the magical girl's father. He's Mr. Oblivious, never even remotely aware that his teenage daughter has to deal with real-life problems or that the teenage years might pose particular difficulties or that, as a girl suddenly given immense powers and the responsibility to save the world, his daughter might be a little . . . um . . . stressed. Of course, she's keeping all of this a secret from her family, but still, she's got a lot going on. However, there's nothing that a brownie and a cold glass of milk won't fix, according to dad.

Older characters have closer cropped hair.

Glasses are a sign of maturity.

Obvious smile with closed eyes says it all!

Jacket falls in front of torso.

Work, work, work. . . .

Mom has never heard of the women's movement. To her, Betty Crocker is a feminist. She is always busy around the house. All this commotion leaves the magical girl feeling alone in the midst of her family. And that's on purpose. It's a situation that the average teen can relate to. You've got your entire family around you, but no one understands. The only ones who "get you" are your friends. And even still, sometimes, you feel alone. That's the plight of the magical girl. And that's why she's such a popular icon. All teens can relate to her.

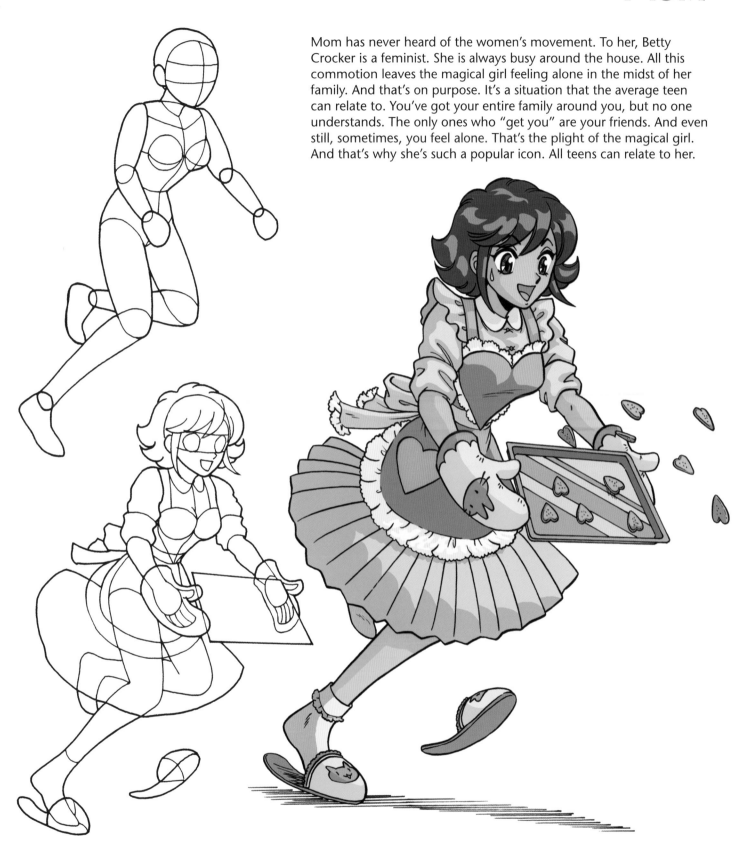

The Mean Teacher

Are there any nice teachers? Sorry, but I speak from a boy's perspective. In my experience, teachers do not like boys. Boys have too much energy. They don't like to sit for long stretches at a time. They like to crack jokes and mouth off. Well, what did teachers expect when they got into the profession? We're boys! This is what we do! We can't help it. It's a chromosome thing.

But the same kind of teacher is generally fond of girls, who get their homework in on time and like to be called on in class. Unfortunately, battling demons in other dimensions doesn't leave a magical girl with lots of time for algebra assignments. So the magical girl may have her chance to see a side of the teacher that the boys have to face every day.

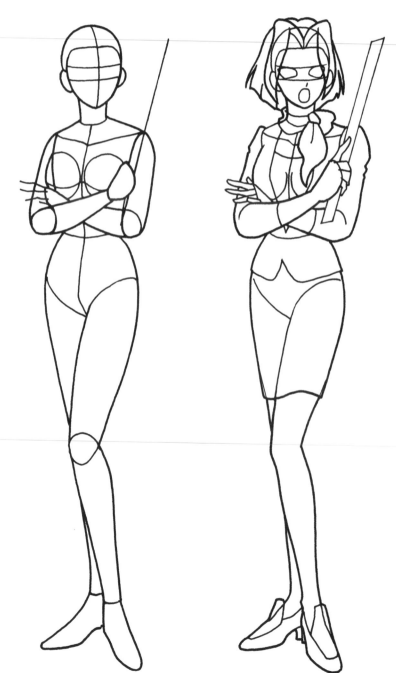

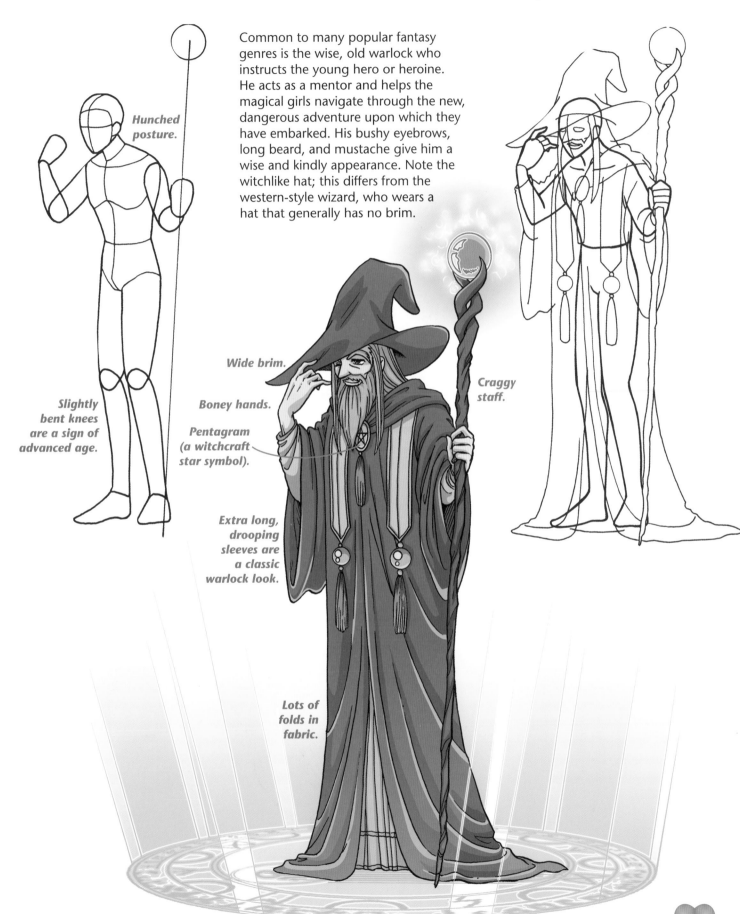

Hunched posture.

Common to many popular fantasy genres is the wise, old warlock who instructs the young hero or heroine. He acts as a mentor and helps the magical girls navigate through the new, dangerous adventure upon which they have embarked. His bushy eyebrows, long beard, and mustache give him a wise and kindly appearance. Note the witchlike hat; this differs from the western-style wizard, who wears a hat that generally has no brim.

Slightly bent knees are a sign of advanced age.

Wide brim.

Boney hands.

Pentagram (a witchcraft star symbol).

Craggy staff.

Extra long, drooping sleeves are a classic warlock look.

Lots of folds in fabric.

Magical Mascots

These cuddly little fantasy monsters, rascals really, are pals of the magical girl. They're mascots, buddies, magical friends. They hop along for the ride. Magical girls usually encounter them once they enter the "other world" where they have been sent to save the people from the evil lord. These chipper little critters are not afraid of going to dangerous places with her. In fact, they'll even throw themselves into harms way to protect her. Yes, they've even been known to give their lives for their magical friends. A tear or two has been shed over the loss of these brave little companions. There is no finer friend than a tiny manga monster.

Designing Your Own Manga Mascots

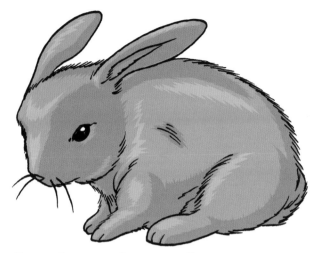

They're irresistibly cute, there's no denying that. But can you teach someone to draw something irresistible? Is there a class in drawing *irresistibility*? Well, believe it or not, you *can* learn how to make something irresistible. The secret is twofold. So, we'll start with the first element—the basis for all of these little manga monsters: animals. That's right, cute little animals. And if you want to make them extra cute: baby animals. By using baby animals as your starting point, you can easily build a manga monster that tugs on the heartstrings of the reader. All you have to do is create a cartoon of the animal with some manga features and styling.

Real Bunny Starting Point

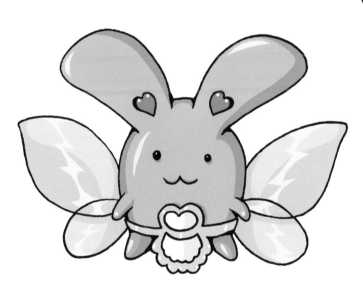

Cute Manga Bunny Critter #1
The entire body is one shape, just a little puffball.

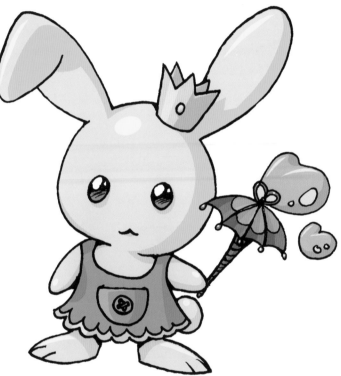

Cute Manga Bunny Critter #2
The head and body are two different sections, but of equal size. Note the nice manga eyes, with shines.

When Mascots Cross Worlds

Although these fun-loving, courageous, hyper rascals live in the "other dimension," they do sometimes pop back into the magical girl's "real world"—with hilarious results. For example, it's very difficult to explain to your science teacher what a flying ball of blue fluff is doing hovering next to your desk, eating all of your Cheese Crunchies out of your backpack. So these manga monsters are humorous characters who, nonetheless, are prepared to fight to the death to protect their friends.

Real Cat Starting Point

Cute Manga Cat Creature

Notice that the manga version is a kitten. Baby animals are much cuter. Add a fantasy swirl off the forehead and a fantasy tail, as well as markings on the cheeks. You don't have to destroy the form in order to turn it into a creature. You only have to make it seem like it belongs just this side of the fantasy realm.

Real Puppy Starting Point

Cute Manga Puppy Creature

The face has become rounder and younger-looking, with manga eyes. And the entire form is now ultrasimplified. That star marking on the forehead tells us that this is a fantasy creature. The body has been changed so that it no longer looks like a regular dog (note the weird leg formation).

Real Turtle Starting Point

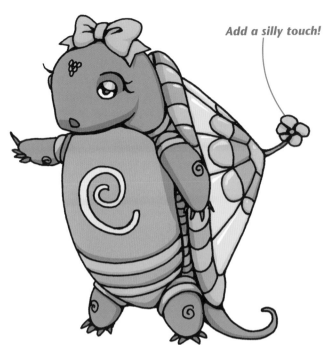

Add a silly touch!

Cute Manga Turtle Creature

Ever see a turtle walk on two legs? Or have eyelashes? Me neither. Walking on two legs gives the turtle-creature extraordinary speed. Does the mile in just under a week and a half.

Real Mouse Starting Point

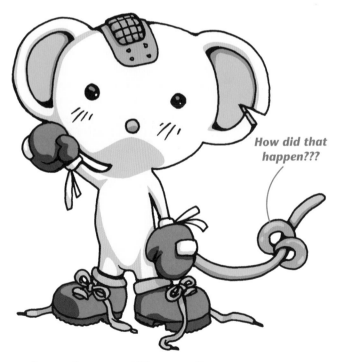

How did that happen???

Cute Manga Mouse Creature

Who wants to go three rounds with Squeaky the Tornado? Winner gets a week's supply of cheddar.

Ordinary vs. Superfantasy

Using animals as the basis for your cute manga mascots is only the first step. You can, as you progress, use anything you want as your starting point. Although animal-based monsters are the surest way to achieve a cuddly looking character, there have been many funny monsters based on plants and even inanimate objects. You can also make up shapes from your imagination.

But whatever you start with, your finished drawing must be in the realm of the fantasy kingdom. And that's where the second element to designing magical mascots comes in. They've got to be part of the magical world of magical girls. We've got to believe that the mascot can zip in and out of different dimensions. If there's too little in the way of a fantasy style, your mascot's just going to look like a very weird pet. It needs to have an *enchanting*

charm. Remember that term. It's important that you aim for that in your drawings.

Let's take a look at a bunch of manga mascots drawn two ways to show the contrast. The first versions show how a beginner might attempt them. Nothing wrong with that. In fact, they are pretty good first tries. But they're not the types of characters that are ever going to be memorable or be favorites among readers. They just don't have enough magic, enough sparkle, enough *enchanting charm*. The second examples show the same characters drawn with classic, fantasy-based motifs and styling. The characters are also adjusted to better fit the genre. Sometimes, all it takes is a simple adjustment of the posture. Other times, more fantasy decorations are included, or costumes are added.

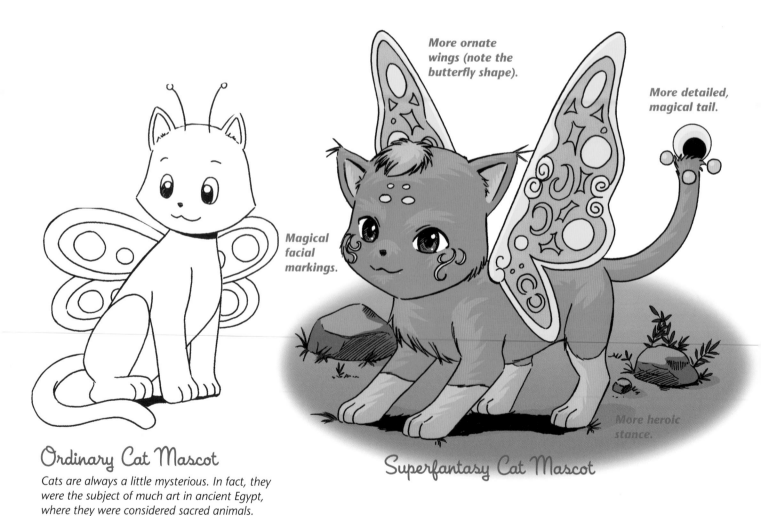

More ornate wings (note the butterfly shape).

More detailed, magical tail.

Magical facial markings.

More heroic stance.

Ordinary Cat Mascot

Cats are always a little mysterious. In fact, they were the subject of much art in ancient Egypt, where they were considered sacred animals.

Superfantasy Cat Mascot

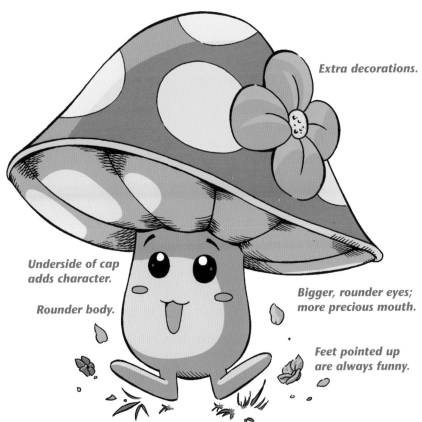

Extra decorations.

Underside of cap adds character.

Rounder body.

Bigger, rounder eyes; more precious mouth.

Feet pointed up are always funny.

Ordinary Surprise Friend

Sometimes a friend can pop out of nowhere to help guide a magical girl on her way or lift her spirits when she's in the doldrums. Luckily for her, this little guy avoided becoming part of a Caesar salad long enough to point her in the right direction. He can suddenly sprout from the ground and offer a suggestion.

Superfantasy Surprise Friend

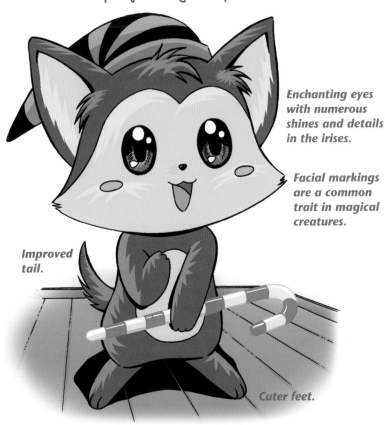

Enchanting eyes with numerous shines and details in the irises.

Facial markings are a common trait in magical creatures.

Improved tail.

Cuter feet.

Ordinary Christmas Kitty

One big step in transforming your creature into a fantasy-based being is to give it an upright, human posture. When you further enhance your mascot by dressing it in a holiday outfit, it becomes charming—the perfect buddy to have at your side. Another holiday that offers many potential outfits is Halloween.

Superfantasy Christmas Kitty

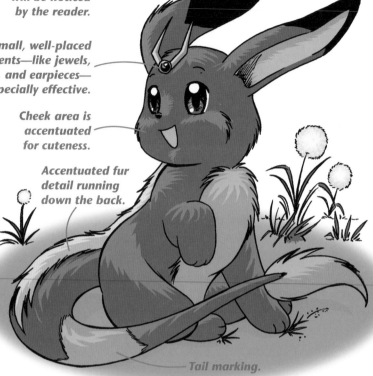

**Unusual markings
will be noticed
by the reader.**

**Small, well-placed
ornaments—like jewels,
tiaras, and earpieces—
are especially effective.**

**Cheek area is
accentuated
for cuteness.**

**Accentuated fur
detail running
down the back.**

Tail marking.

Ordinary Rabbit Helper

This little forest helper can scamper about, tell the magical girl a secret that will aid her quest, and hop away just as quickly as it appeared. The challenge with all of these creations is in designing them to look like the original animal—but yet different enough so that it will look bewitched. You only need a few well-placed elements to convey the idea that it's not a real rabbit. However, if given a choice between having too many fantasy "bells and whistles" or having it look too much like a rabbit, I would err on the side of having it look too much like a rabbit. The reason is simply because the "cute" factor of the rabbit is too appealing to tamper with. And by choosing a fantasy-based color—for example, making the rabbit pink or blue—you're already taking it out of the realm of realism.

Superfantasy Rabbit Helper

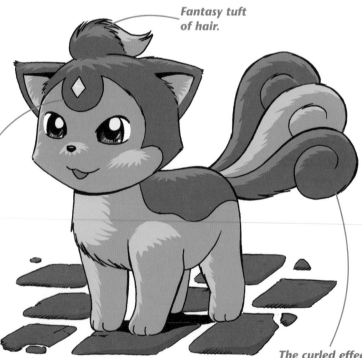

**Fantasy tuft
of hair.**

**Markings
frame
the jewel.**

Ordinary Three-Tailed Cat

You can often repeat a feature on an animal to create the fantasy idea. On this little hairball, it's the tail, but you could invent a character with extra ears, noses, or even eyes.

Superfantasy
Three-Tailed Cat

**The curled effect
at the end is a
pleasing way to
emphasize the
novel tail.**

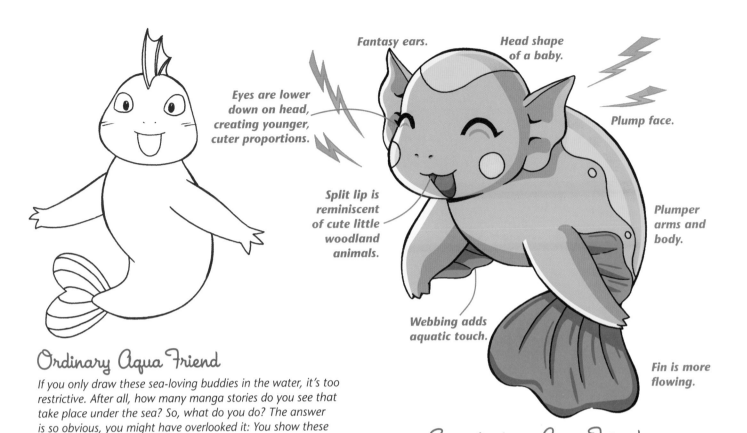

Fantasy ears.

Head shape of a baby.

Eyes are lower down on head, creating younger, cuter proportions.

Plump face.

Split lip is reminiscent of cute little woodland animals.

Plumper arms and body.

Webbing adds aquatic touch.

Fin is more flowing.

Ordinary Aqua Friend

If you only draw these sea-loving buddies in the water, it's too restrictive. After all, how many manga stories do you see that take place under the sea? So, what do you do? The answer is so obvious, you might have overlooked it: You show these water types "swimming" in the air. Does that sound awkward? It isn't, actually. It's a very cool look, and it works great on aquatic fantasy characters. This plump little guy should be able to throw lightning bolts as his special power. But I'm spilling the beans prematurely. We're going to get into the special powers of manga mascots in a couple of pages.

Superfantasy Aqua Friend

Third "eye" emblem design.

Folded ears look friendly.

Fantasy feather design; not realistic.

Clouds act as the ground.

Foxlike tail.

Ordinary Flying Pup

Better have a very long leash, because when he sees an airplane fly past, he loves to chase after it! Wings are always a good, solid standby when you're trying to come up with a fantasy characteristic to tack onto an animal. But one word of caution: Don't make the wings the typical, realistic, feathered angel wings that you would see in a Rubens painting. That would make the dog look like an angel dog—in other words, to be blunt, a dead dog. Don't want that. Give the pup fantasy wings, with curls and exaggerated feathery shapes.

Superfantasy Flying Pup

Ordinary Wolf Pup

It doesn't really matter what type of animal you start with, even if it is, potentially, a threatening type, like a wolf. Just turn it into a baby with big eyes and a tiny nose. Who can resist that? Baby lions and baby grizzly bears are incredibly adorable, even if their parents send shivers down your spine.

Moon motif is from the world of wizards and witches.

Special effects magic.

Rings "float" mysteriously around the tail without touching it.

Superfantasy Wolf Pup

Ordinary Goofy Cat-A-Roo

Yes, you can have a sidekick whose main attribute is that he's just plain silly. Although he tries hard to help, the only thing he manages to do is to slow down the magical girl in her quest to save the day. But he's so darn earnest, you gotta love him. This guy is usually a little hyper: Wind him up and watch him go! Yes, he's aware that he's only made things worse by his efforts. But he promises that he'll redouble his efforts next time, which is exactly what you want him not to do!

Droopy ears.

Slightly crossed eyes.

Thin neck.

Funny little pouch.

Skinny legs.

Long, thin feet.

Superfantasy Goofy Cat-A-Roo

Ordinary Water-Thudder

It's tempting, when you draw a character that has a naturally round outline, like a whale, to just leave it at that. Just draw a simple football or blimp, and start working on the cute features of the face. Well sure, that's okay, and you can invent some good characters like that. But if you want to bring out the cuteness of the character and make it so adorable that your friends will compliment you and your enemies will be so jealous that they'll wish they were never born, then I'd suggest doing a little extra work on the *far* side of the outline of the face. Make sure that the orbit of the eye curves *in* slightly and the cheek area below it curves *out* slightly. Also, the horizontal marking across the face gives the subtle suggestion of a nose, without the need for nostrils or any added definition.

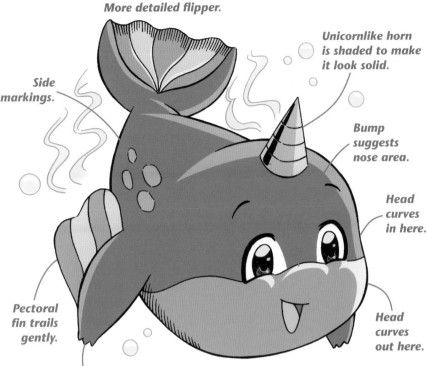

More detailed flipper.

Side markings.

Unicornlike horn is shaded to make it look solid.

Bump suggests nose area.

Head curves in here.

Pectoral fin trails gently.

Head curves out here.

A touch of fingers adds a fantasy element on a creature that would ordinarily only have flippers.

Superfantasy Water-Thudder

Ordinary Enchanted Fox

It's not every day that you see a fox with four ears. So no whispering behind his back, 'cause he'll hear you! The head is always a good place to put jewels, emblems, markings, or horns. You can do it very economically because the reader can't avoid noticing them due to the fact that the reader is almost always looking at the character's head. If you were to place special markings somewhere else on the character—for example, on the stomach—then you wouldn't see them in this pose. Just don't add too many, or you'll clutter up the face.

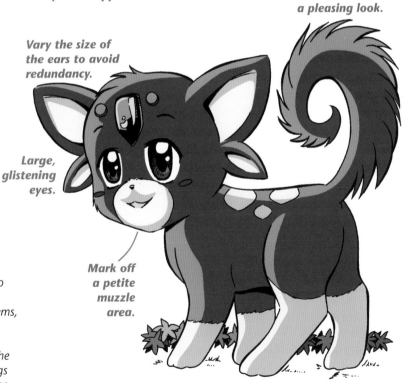

Curl the tail for a pleasing look.

Vary the size of the ears to avoid redundancy.

Large, glistening eyes.

Mark off a petite muzzle area.

Superfantasy Enchanted Fox

Special Mascot Powers

As we've seen, these little creatures are more than just buddies; they're humorous sidekicks. One of the principles of humor is placing two incongruous things together. And that's what happens with the special powers: We give these tiny, harmless-looking creatures oversized powers. It's always a visual surprise to see such explosive force coming from such tiny containers!

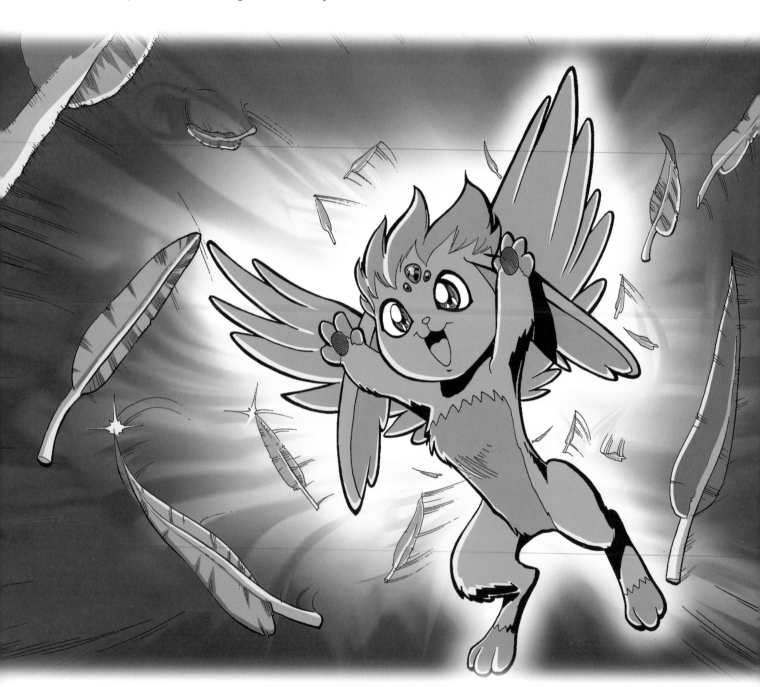

Blinding Burst

Too bright to see. This mascot temporarily blinds the magical girl's enemies.

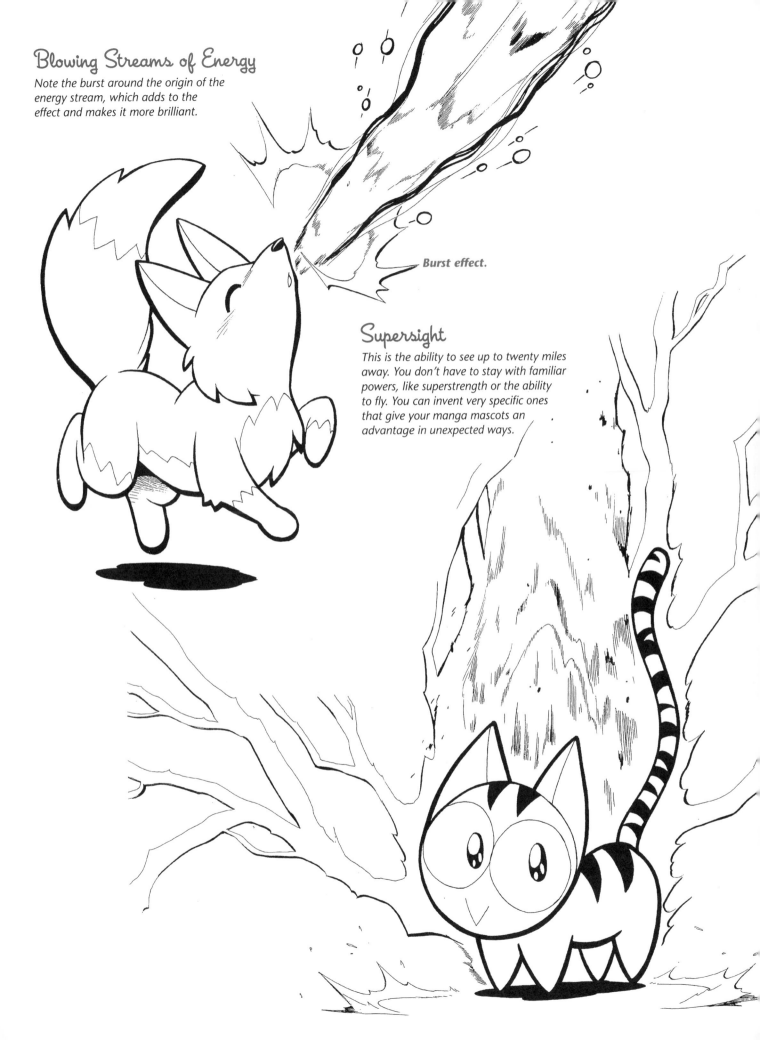

Blowing Streams of Energy

Note the burst around the origin of the energy stream, which adds to the effect and makes it more brilliant.

Burst effect.

Supersight

This is the ability to see up to twenty miles away. You don't have to stay with familiar powers, like superstrength or the ability to fly. You can invent very specific ones that give your manga mascots an advantage in unexpected ways.

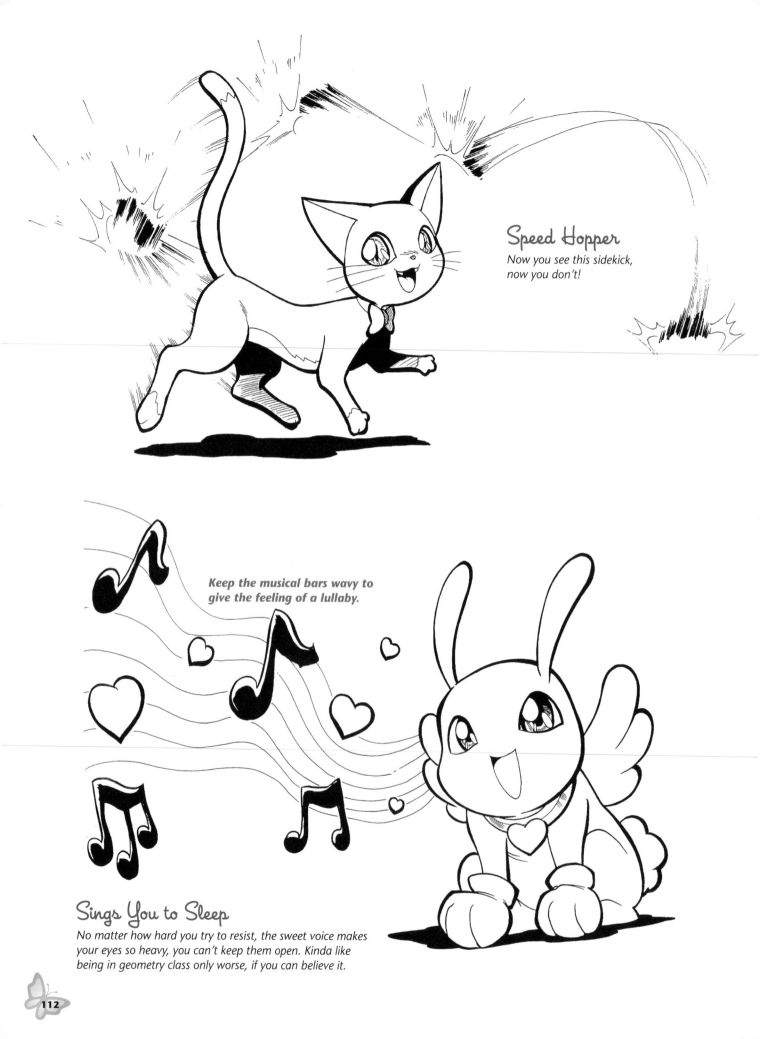

Speed Hopper

Now you see this sidekick, now you don't!

Keep the musical bars wavy to give the feeling of a lullaby.

Sings You to Sleep

No matter how hard you try to resist, the sweet voice makes your eyes so heavy, you can't keep them open. Kinda like being in geometry class only worse, if you can believe it.

Combining Mascot Powers

When you put several of these magical friends together in a single scene and let them loose with their impressive powers, watch out! It should look like a hurricane hit the page.

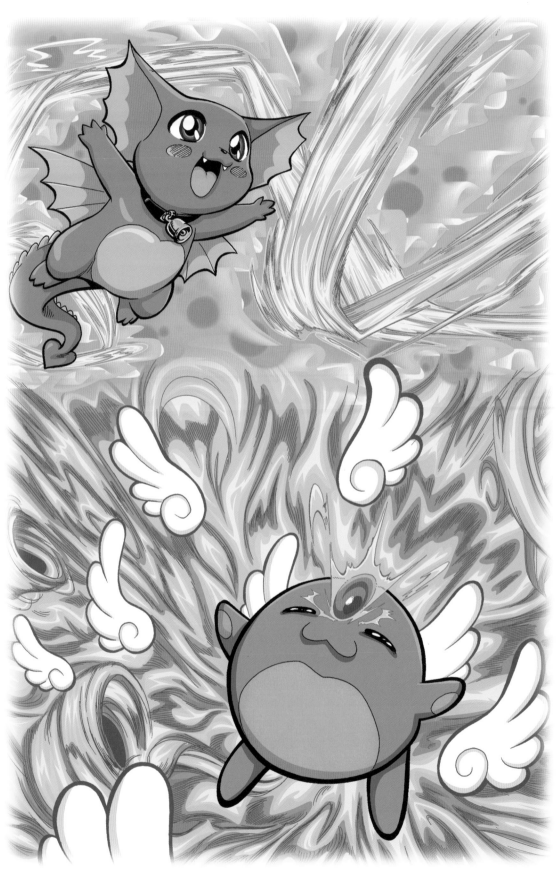

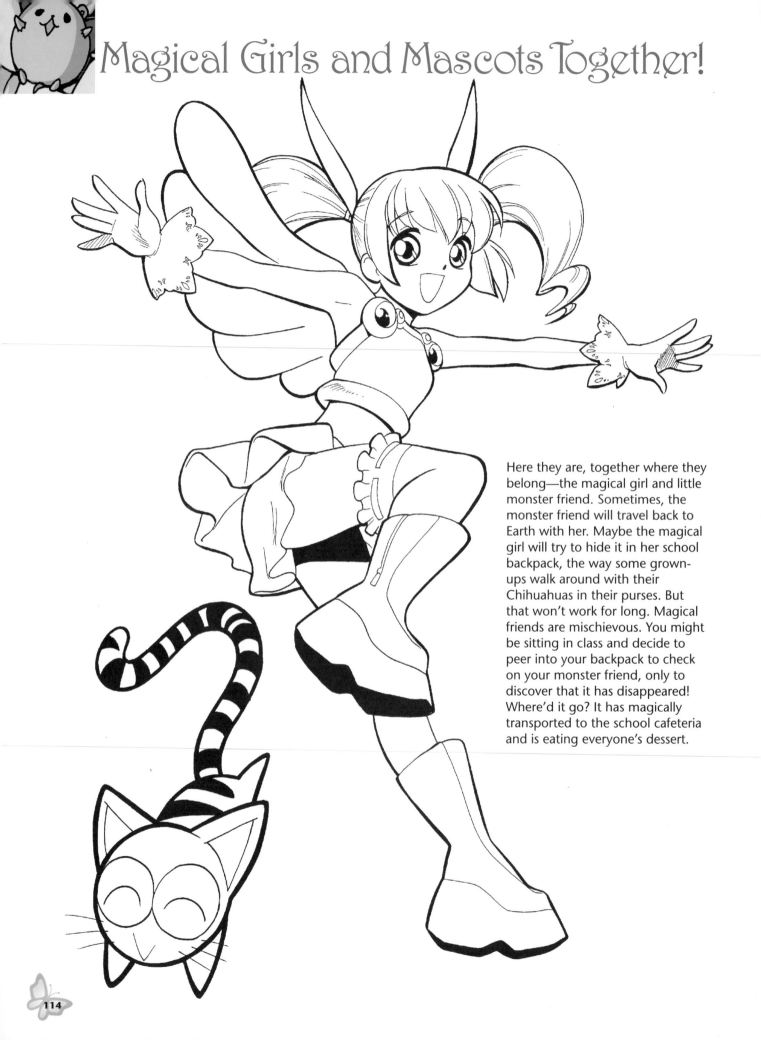

Magical Girls and Mascots Together!

Here they are, together where they belong—the magical girl and little monster friend. Sometimes, the monster friend will travel back to Earth with her. Maybe the magical girl will try to hide it in her school backpack, the way some grownups walk around with their Chihuahuas in their purses. But that won't work for long. Magical friends are mischievous. You might be sitting in class and decide to peer into your backpack to check on your monster friend, only to discover that it has disappeared! Where'd it go? It has magically transported to the school cafeteria and is eating everyone's dessert.

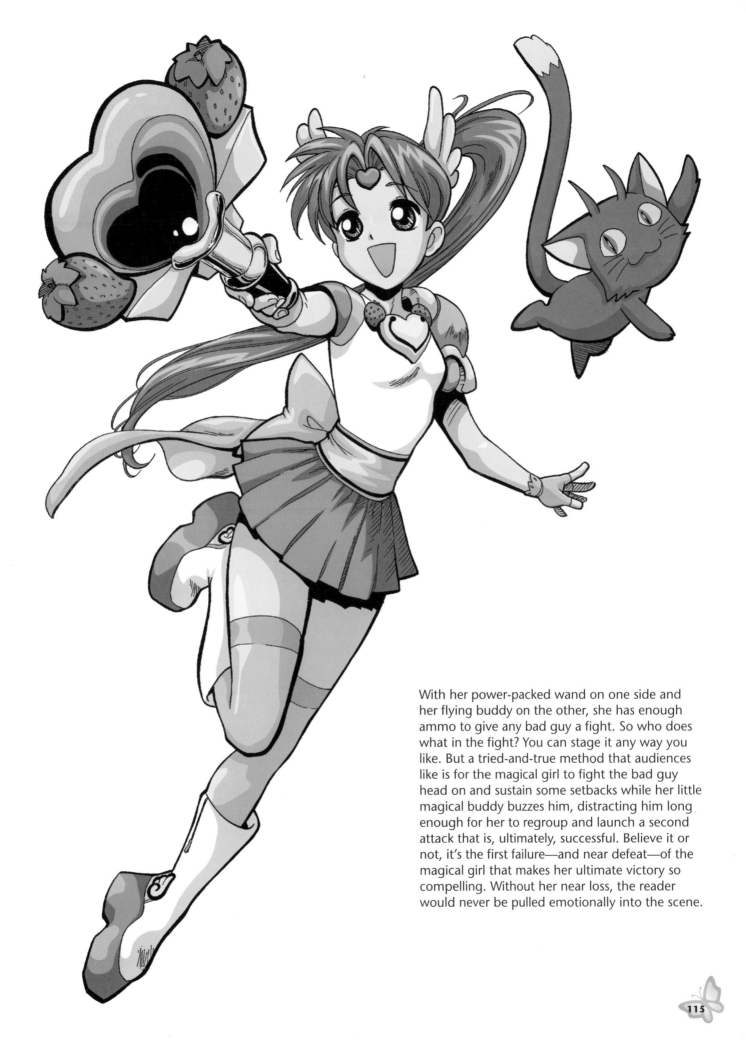

With her power-packed wand on one side and her flying buddy on the other, she has enough ammo to give any bad guy a fight. So who does what in the fight? You can stage it any way you like. But a tried-and-true method that audiences like is for the magical girl to fight the bad guy head on and sustain some setbacks while her little magical buddy buzzes him, distracting him long enough for her to regroup and launch a second attack that is, ultimately, successful. Believe it or not, it's the first failure—and near defeat—of the magical girl that makes her ultimate victory so compelling. Without her near loss, the reader would never be pulled emotionally into the scene.

Magical Fighter Teams

The magic that transforms the average schoolgirl often transforms more than just one person—it transforms her group of friends. This is, in a loose analogous way, the Japanese version of the American Team Action Fighters, all costumed, who fight on the side of justice. But these girls are more than just fighting for the same cause, they're also best friends.

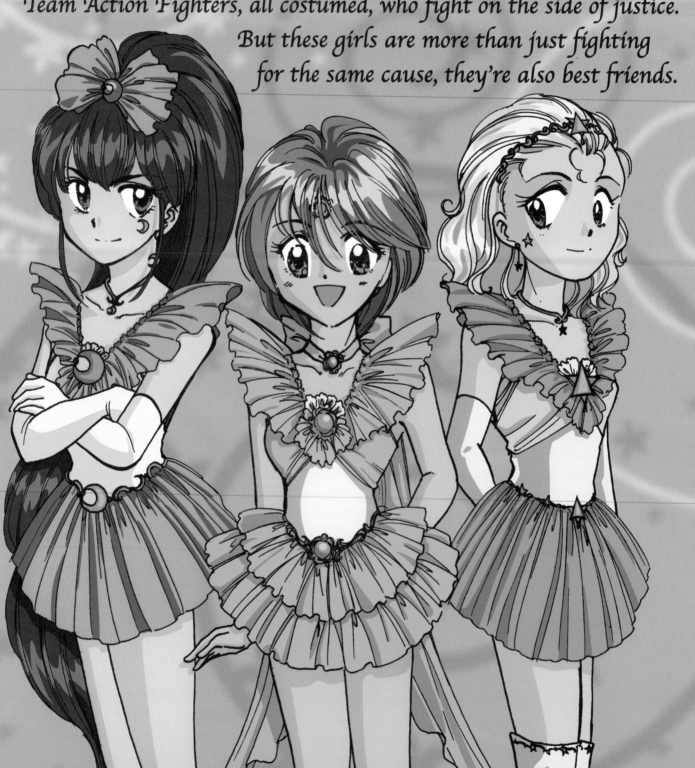

Varying the Height

When you're working with three girls, rather than one, it's important to create more than just a unifying visual theme, but *differences*, as well. You don't want them to blend together to such an extent that they lose their individual personalities.

One commonly overlooked way to do this that you should *always* employ when drawing a group of girls is by varying the height of the characters.

Varying the heights forces the eye to travel up and down while scanning the image, which makes the eye slow down and take more time to soak in the image. When the characters are all the same height, the eye tends to skim the image quickly, as one whole clump, without looking at each girl individually, which is a disadvantage for the artist, who has worked hard to draw each figure.

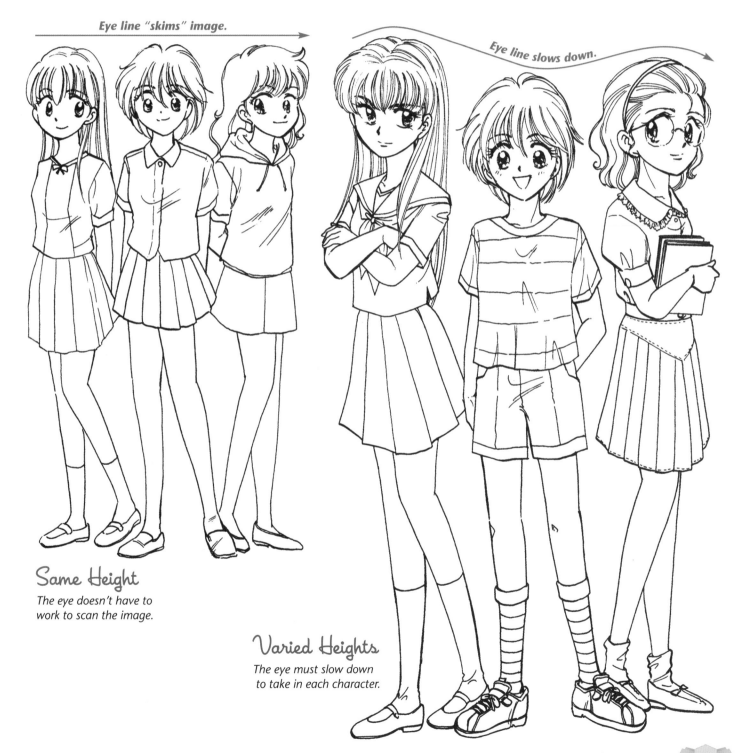

Eye line "skims" image.

Eye line slows down.

Same Height
The eye doesn't have to work to scan the image.

Varied Heights
The eye must slow down to take in each character.

Varying the Costumes

Of course, you'll give the magical girls outstanding costumes. But will you give them each different costumes? Well before you answer, let me present the issue in more detail. You need to give each girl her own, individual identity. If you give each character the same costume, they will all look like clones. But if the costumes look too different, the characters won't look like part of a team. So the answer is: No, you don't give them each totally different costumes. You give them all *similar* costumes—but with just enough differences to make them look like individuals. The differences in the design of the costumes may be subtle, but with the addition of color, you can highlight the differences one notch further.

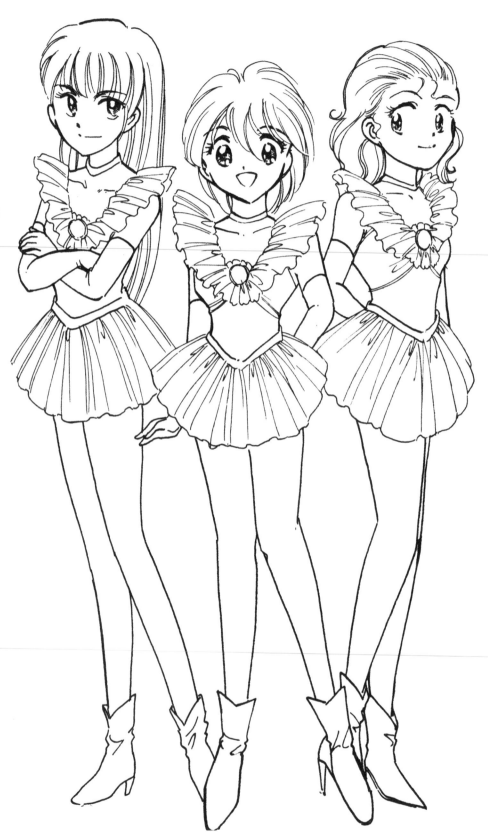

Same Costumes

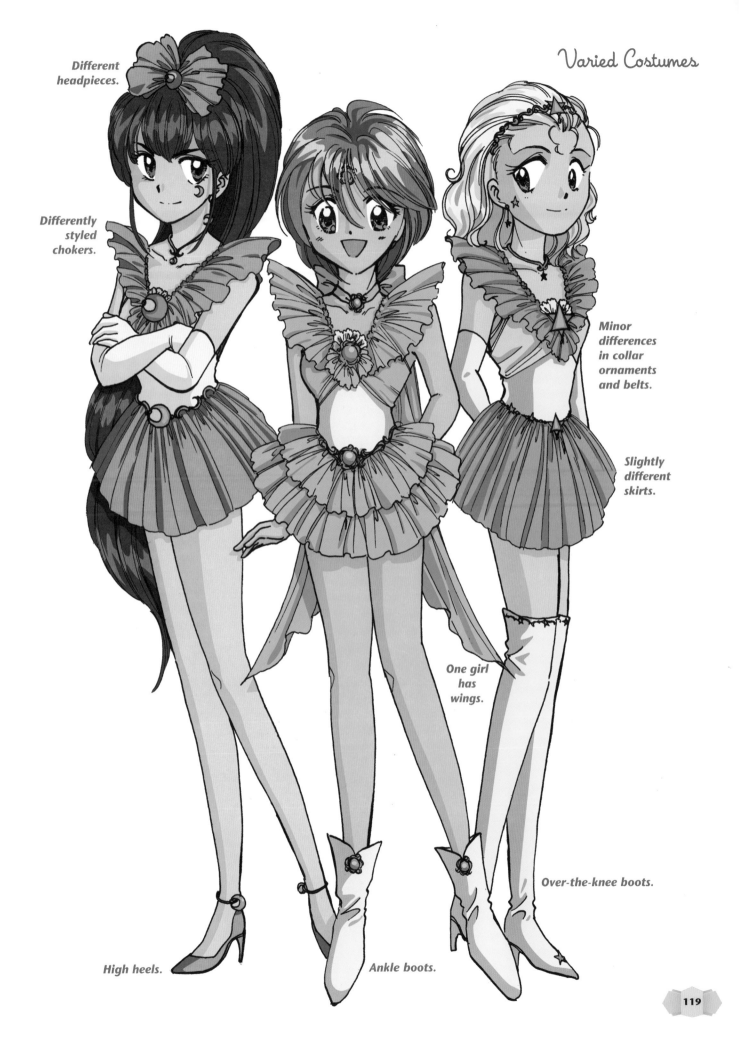

Different headpieces.

Differently styled chokers.

Minor differences in collar ornaments and belts.

Slightly different skirts.

One girl has wings.

Over-the-knee boots.

High heels.

Ankle boots.

Staging Team Action Poses

The last step in creating a team is all about staging and matching each personality to a fighting style. You could show your magical girl team standing stiffly, or you could show your team in motion, ready to take on the bad guys. You don't want the team members standing in a single row, side by side. That's boring. It's more exciting if they look as if they're coming at you. But you have to be careful that the figures don't overlap one another too much. You want the reader to have a clear view of each character. Try arranging them with the highest figure

as the one in the center and the other two below her and to the sides.

Just as there are different hairstyles for different personalities, so too are there different types of magical girl fighters. Choose the personality type that best fits the fighting style. For example, the bubbly personality is best suited to be the fighter with the special effects. The introverted personality is best as a fighter who possesses mysterious powers. And the leader of the group takes the fight to the bad guys.

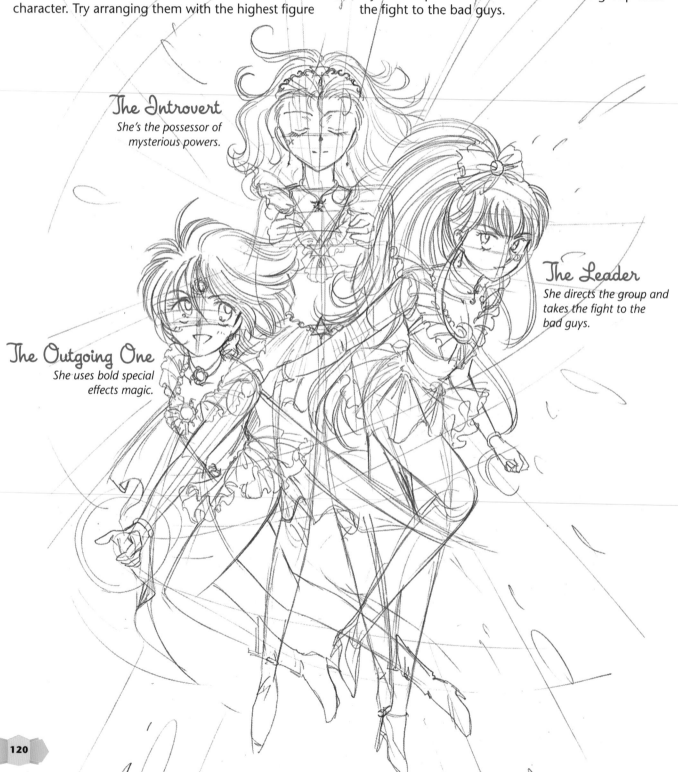

The Introvert
She's the possessor of mysterious powers.

The Leader
She directs the group and takes the fight to the bad guys.

The Outgoing One
She uses bold special effects magic.

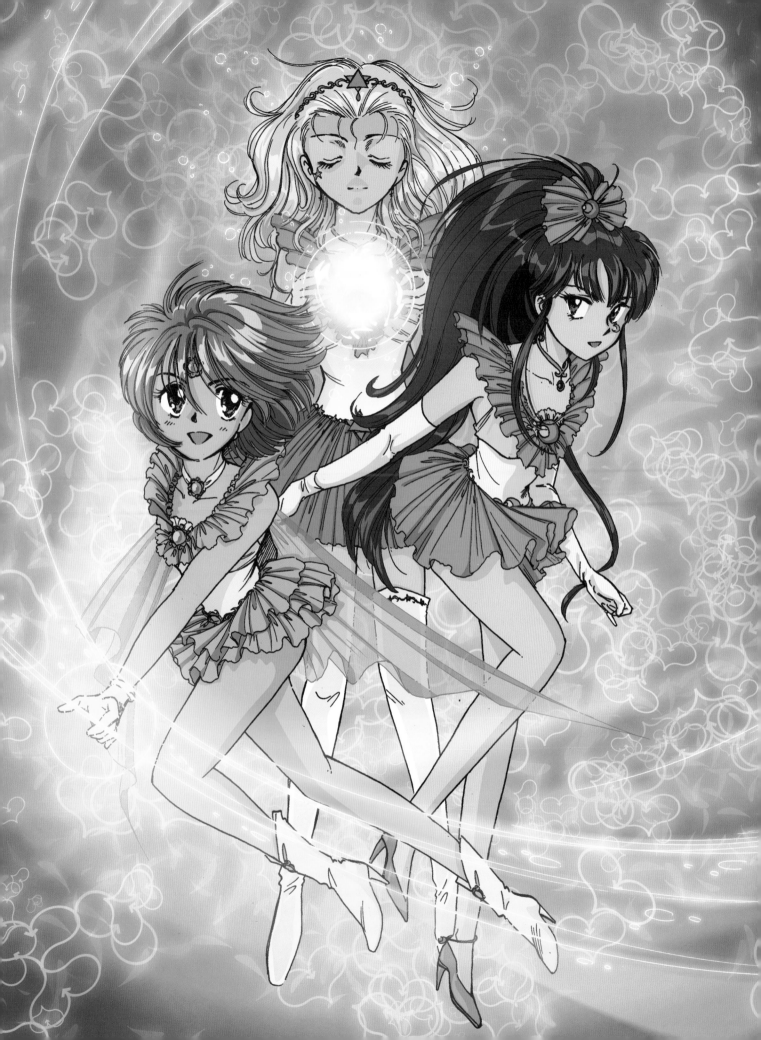

Choreographing Team Fight Scenes

What's the most important moment of an effective fight scene?

 A. the attack
 B. the group huddle
 C. the special effects
 D. the near defeat
 E. the monster's expression

Time's up. What did you guess—A? That's what I would have guessed. That makes the most sense, naturally. I mean, you've got to have an attack, right? If you guessed A, get down and give me ten push-ups and a lap around the track. You're *wrong*! Same with all you readers who picked B, C, and E. The correct answer is D. Yep, that understated, lonely little answer hidden toward the bottom of the stack is the correct one. The near defeat is the key to a good fight scene.

 The near defeat comes right after an attack that *should* work but doesn't. It's the "uh-oh" moment of the fight, when the girls realize that they might not have enough of what it takes to win. It's the *necessary* point in the scene when the audience goes, "Oh heck, *now* what do they do?" That's the point you've got to bring your reader to. Without that, you're just going in a straight line toward victory, and that spells B-O-R-I-N-G. With the setback, the reader suddenly wakes up and realizes, *Hey, these gals could actually lose!*

 Let's follow the action the way a professional manga artist might lay it out in a scene between a band of magical girls and a fire monster.

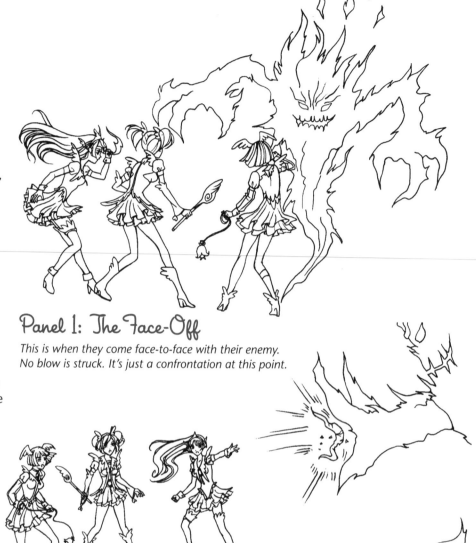

Panel 1: The Face-Off

This is when they come face-to-face with their enemy. No blow is struck. It's just a confrontation at this point.

Panel 2: Lead Girl Takes Her Best Shot

The first magical girl throws her magical boomerang into the heart of the fiery beast. This is her most effective weapon, and it never fails—until now! This is a real setback! Gulp!

Panel 3: The Reaction Shot (the Huddle)

Again to underline the setback, we have a reaction shot, as the girls look to one another, bewildered. Hmmm, this could mean trouble. What are they going to do now?

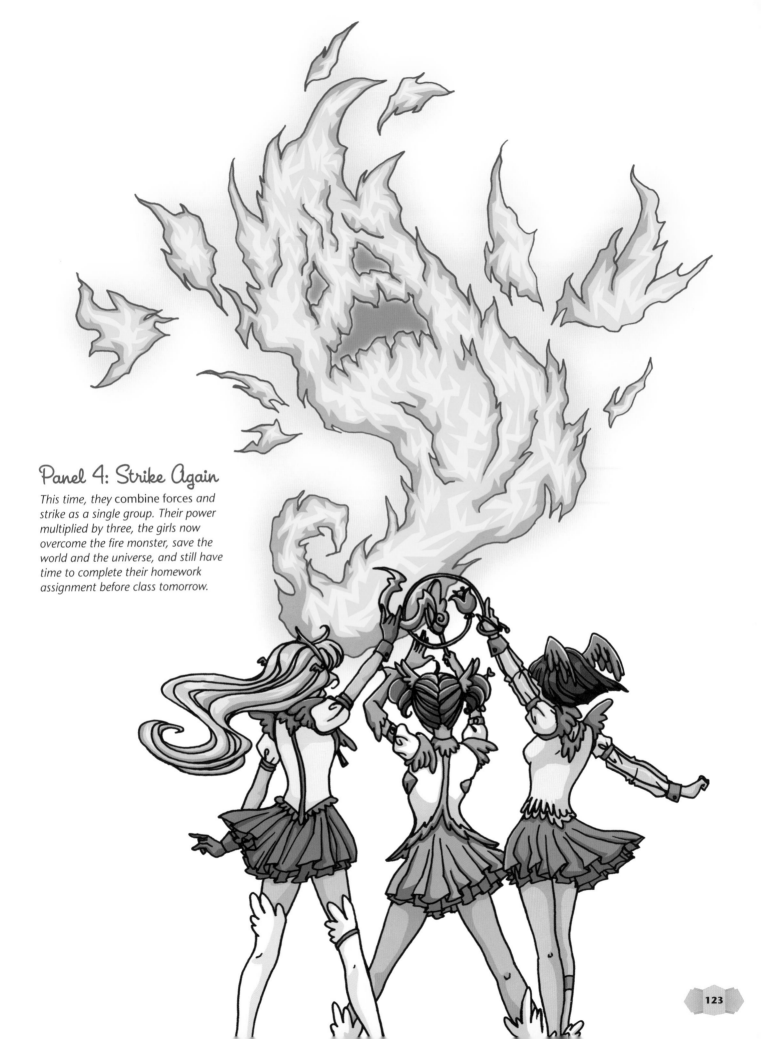

Panel 4: Strike Again

This time, they combine forces and strike as a single group. Their power multiplied by three, the girls now overcome the fire monster, save the world and the universe, and still have time to complete their homework assignment before class tomorrow.

The Best Angle for an Action Shot

Before you start to draw your figure, do some very quick, rough sketches—I'm talking fifteen-second sketches—of your character in a variety of poses to decide which is the most dynamic position. Don't invest anything emotionally in any one, single pose. Add no detail. Don't get attached. This will help you make a totally dispassionate decision. If you don't like any of the choices you've made, toss 'em and start over. Once you find a pose that's promising, *then* start exploring its possibilities and work it up.

Here's a typical action that you'll no doubt have a reason to draw at some point in your magical girl comics. The magical girl has taken just about all the abuse she cares to take . . . now you've gone and ticked her off. Out comes the wand, and she lets you have it! Let's examine the three most likely ways a beginner might draw this pose. (None of them are wrong, per se, but there are reasons why they might not be your absolute best choice.) And then we'll see what we can do about it.

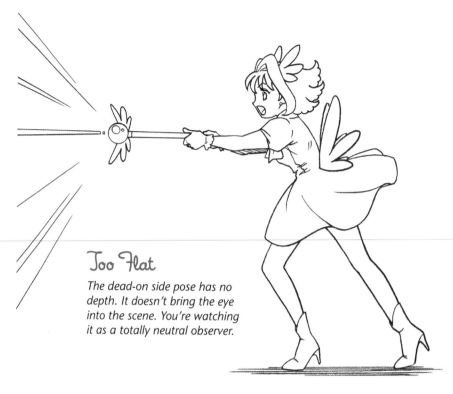

Too Flat

The dead-on side pose has no depth. It doesn't bring the eye into the scene. You're watching it as a totally neutral observer.

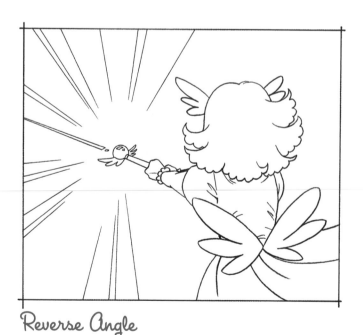

Reverse Angle

A reverse angle describes viewing the action from over the shoulder of the character. The drawback with this pose is that the biggest, most impressive object in the picture is the girl's back.

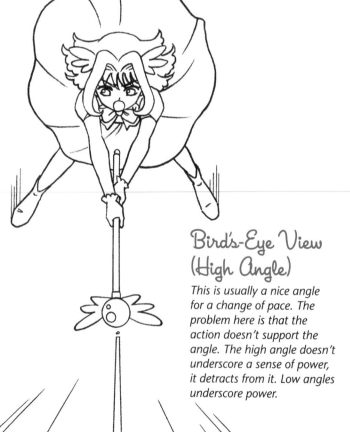

Bird's-Eye View (High Angle)

This is usually a nice angle for a change of pace. The problem here is that the action doesn't support the angle. The high angle doesn't underscore a sense of power, it detracts from it. Low angles underscore power.

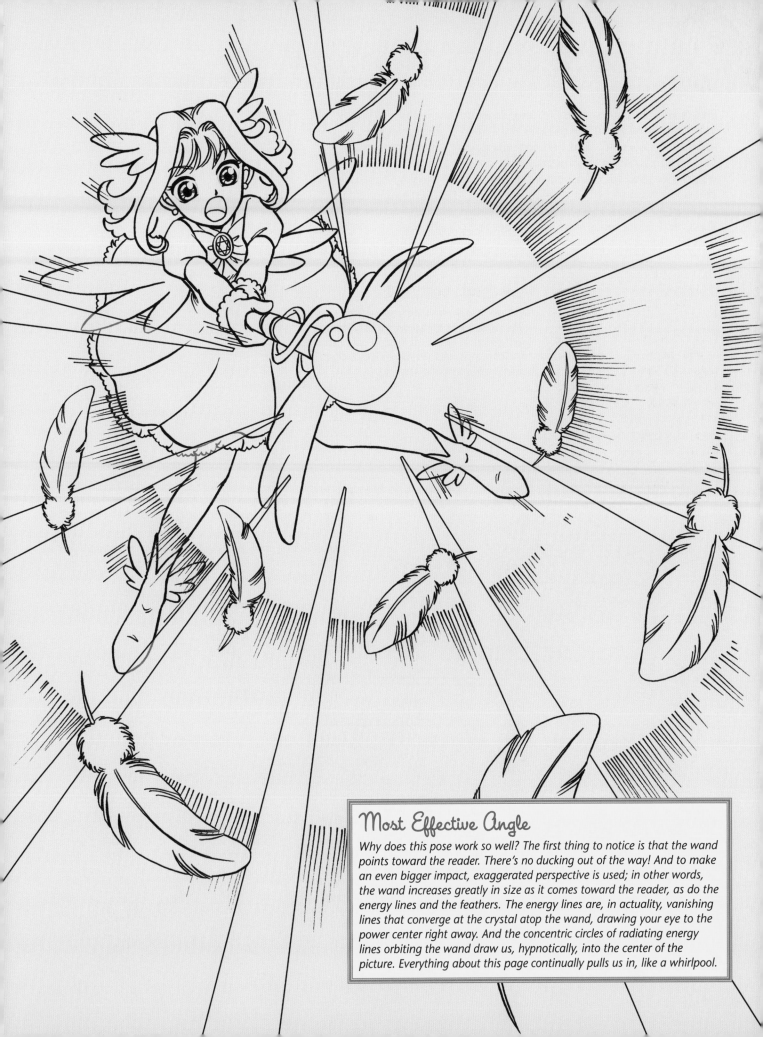

Most Effective Angle

Why does this pose work so well? The first thing to notice is that the wand points toward the reader. There's no ducking out of the way! And to make an even bigger impact, exaggerated perspective is used; in other words, the wand increases greatly in size as it comes toward the reader, as do the energy lines and the feathers. The energy lines are, in actuality, vanishing lines that converge at the crystal atop the wand, drawing your eye to the power center right away. And the concentric circles of radiating energy lines orbiting the wand draw us, hypnotically, into the center of the picture. Everything about this page continually pulls us in, like a whirlpool.

Diving Out of Harm's Way

Here's another comparison of poses. Does this scene remind you of anything? How about the old Westerns when a gunfighter shoots at another guy, who dives behind some cover? Yes, the costumes and settings change, but the plot lines vary little. Instead of bullets, it's laser beams. But you still have to jump out of the way because you don't want to get hit by either of them! This is a "money shot" (Hollywood lingo translation: it's an audience favorite)—so use it! If you're doing a sequential fight scene, try to work it in.

Not Bad, but . . .

This works well. But there's something a little static about the scene. I mean, you've got your main character leaping out of the way of a blast, and yet there's still room to build it into more of a moment.

A Good Idea Taken Too Far

Okay, okay, I said to make a bigger moment out of it, but don't go nuts! Forced perspective is a great technique. But you've still got to be able to see what's going on. And unfortunately, here you can't.

Long Shot, Looking Down

When you take a longer view of two characters, it's called an establishing shot. An establishing shot is very useful for two specific purposes: to set up the beginning of a story and to reestablish where you are in the middle of a scene (if you've had so many close-ups and action shots that the reader may have gotten a bit lost). However, to cut to an establishing shot in the middle of an action scene is deadly. It saps all the energy from the moment.
Can you feel it? The suspense is suddenly lost. This is where your reader puts the book down and goes to the fridge. Don't let that happen.

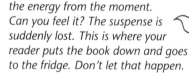

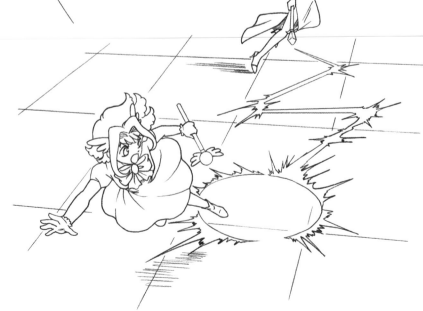

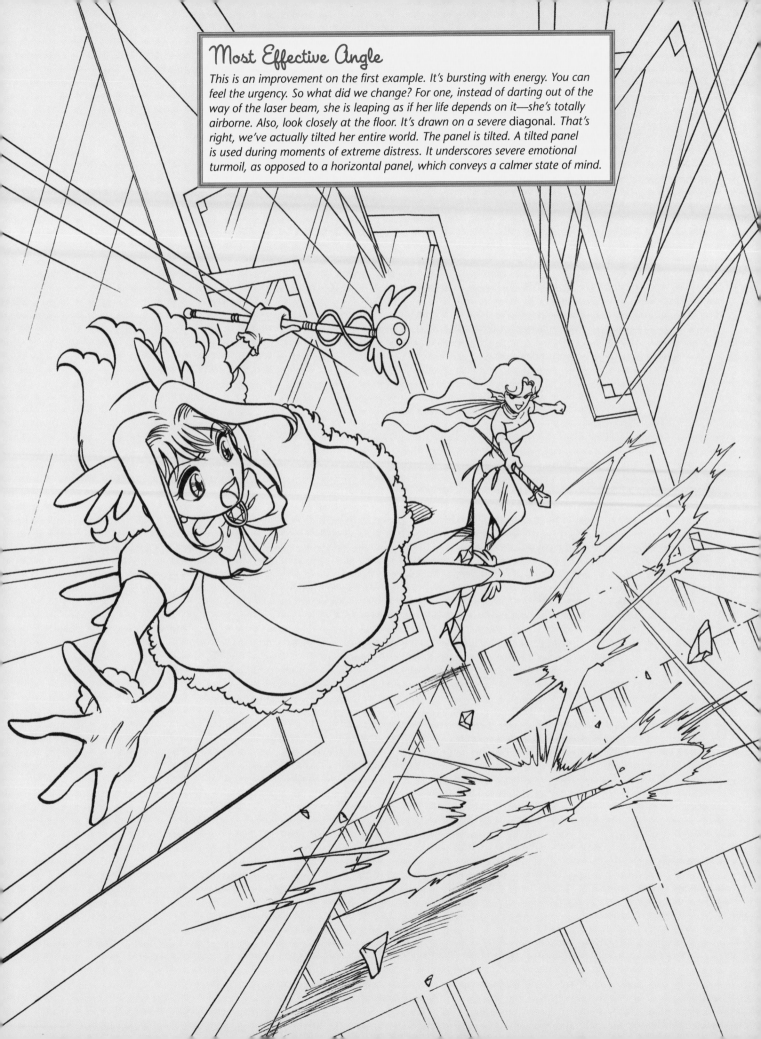

Most Effective Angle

This is an improvement on the first example. It's bursting with energy. You can feel the urgency. So what did we change? For one, instead of darting out of the way of the laser beam, she is leaping as if her life depends on it—she's totally airborne. Also, look closely at the floor. It's drawn on a severe diagonal. That's right, we've actually tilted her entire world. The panel is tilted. A tilted panel is used during moments of extreme distress. It underscores severe emotional turmoil, as opposed to a horizontal panel, which conveys a calmer state of mind.

Clashing Weapons

Ah yes, the moment we've all been waiting for: It's a tense instant—at least, it should be—because she cannot hold it for long against her physically more powerful opponent. And readers know it, which adds the classic suspense elements of the ticking clock: How much longer can she keep it up?

Too Much Distance

This is a typical beginner's mistake. Concentrating on making the figures look correct at the expense of the action. Figures in fight scenes do not keep so much distance from each other. There's one exception to this: when you're showing a reaction shot in a fight scene. So for example, if someone is punched halfway across a room, you can show that person crashing into a wall twenty feet away. Otherwise, figures in fight scenes should be positioned in close to each other, to heighten the struggle.

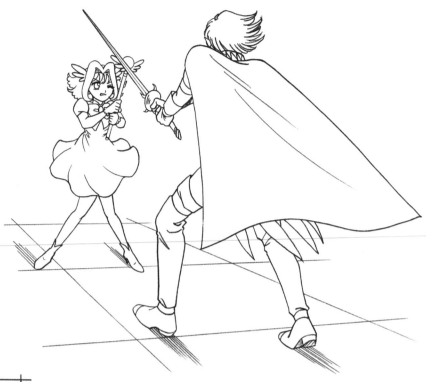

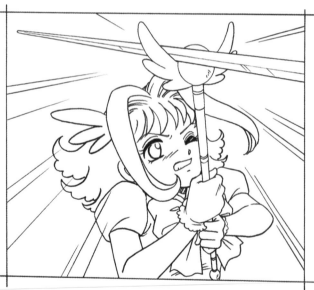

Great Shot, Bad Timing

This is a great shot to cut into after you first show a two-shot (a shot with two people in it).

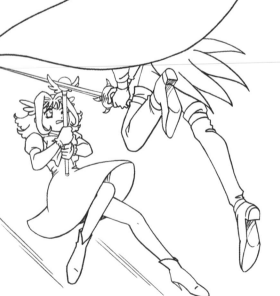

Too Far Away

Nice angles, nice everything, but when you're drawing action scenes in comics, you've got to be in the reader's face. And this is not.

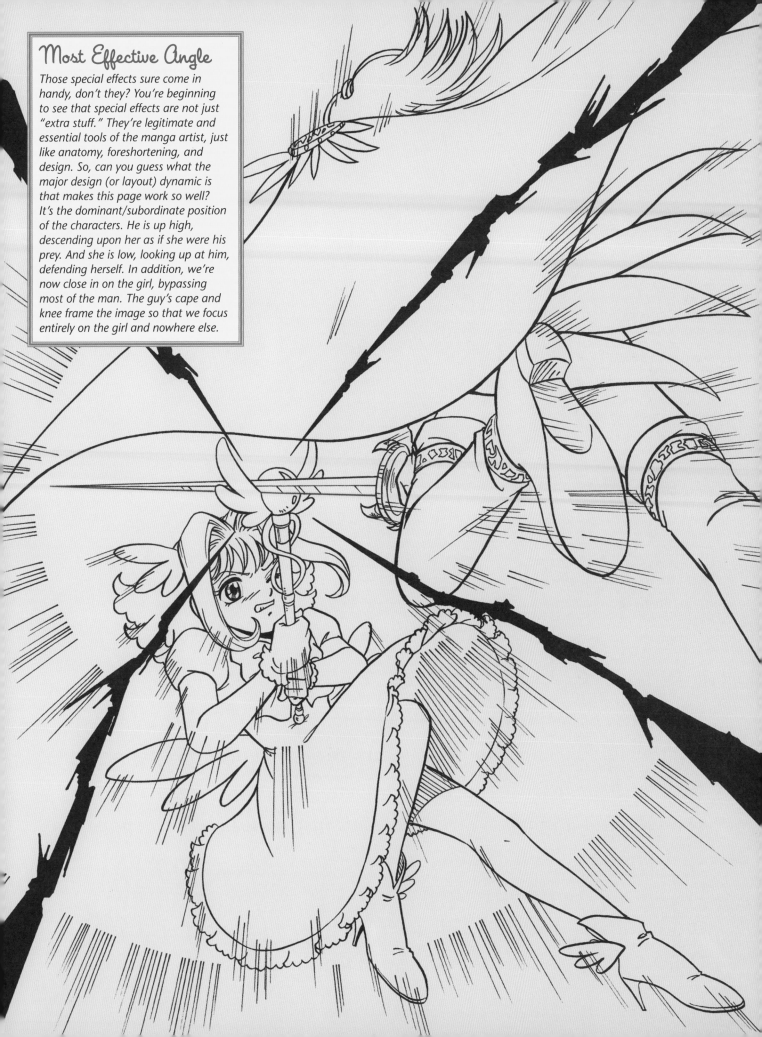

Most Effective Angle

Those special effects sure come in handy, don't they? You're beginning to see that special effects are not just "extra stuff." They're legitimate and essential tools of the manga artist, just like anatomy, foreshortening, and design. So, can you guess what the major design (or layout) dynamic is that makes this page work so well? It's the dominant/subordinate position of the characters. He is up high, descending upon her as if she were his prey. And she is low, looking up at him, defending herself. In addition, we're now close in on the girl, bypassing most of the man. The guy's cape and knee frame the image so that we focus entirely on the girl and nowhere else.

Magical Transformations

Here's the part you've all been waiting for. It's the most wondrous, enchanting phenomenon that occurs in the magical girl genre. It's the transformation scene: when a normal schoolgirl miraculously changes into a magical girl. It doesn't just happen with a snap of the fingers. It's a dreamy, surreal process that envelops the ordinary girl with all sorts of magical effects and glitter. It's beautiful and amazing. You don't want it to happen too quickly. The reader wants to take in the moment, like riding a rainbow.

Creating a Typical Transformation

Before we get to the actual technique of creating the transformation (in stages from beginning to middle to end), let's see how a transformation might occur in a typical manga story. Here, we come upon an ordinary schoolgirl on her way home one day. Suddenly, demons appear out of the sky. They seem, at first, to be frightening. Everyone is running from them, including the adults. Our schoolgirl tears down the block and then . . .

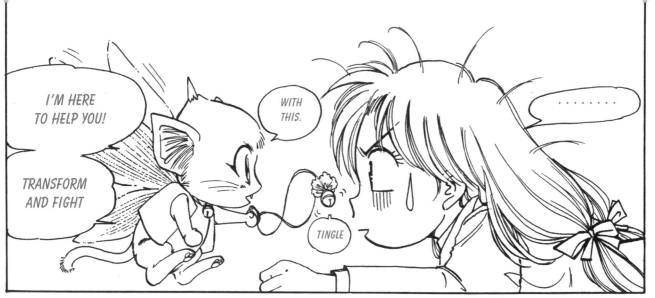

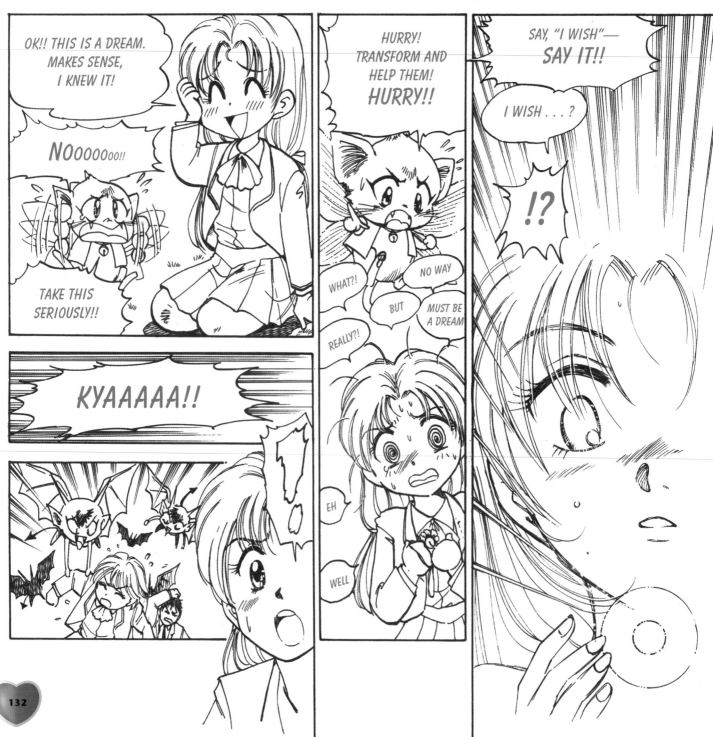

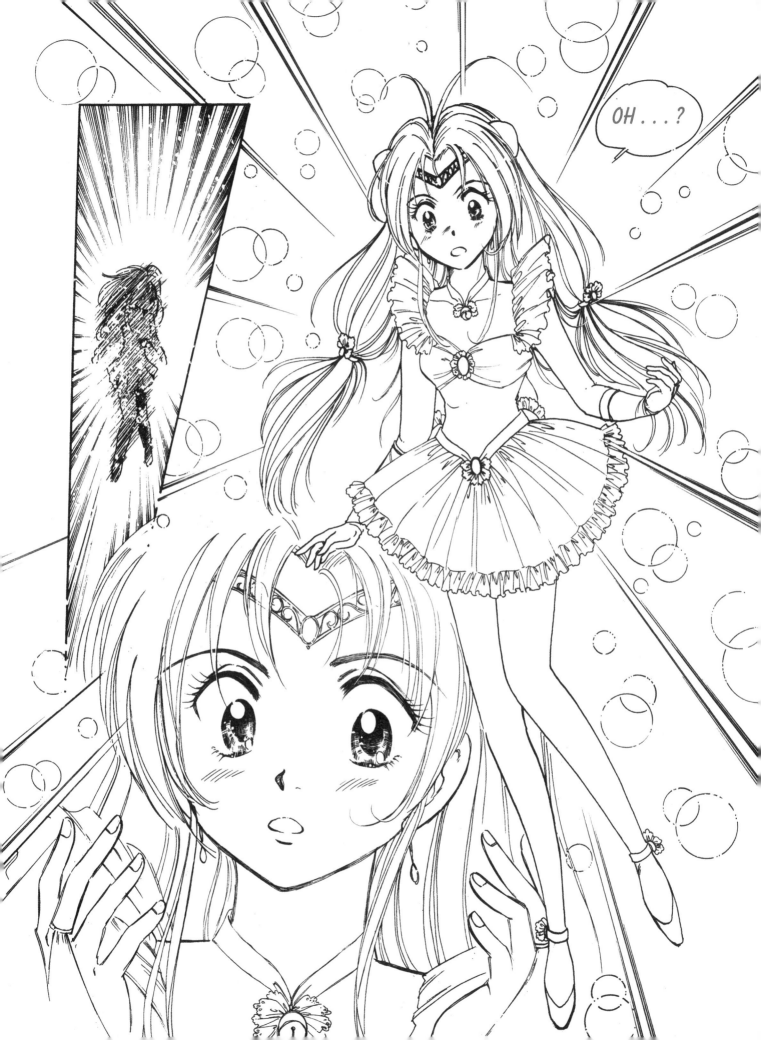

The Transformation Step by Step

The wand can ignite the transformation.

Now let's take a look at the actual basic steps involved in transforming from a regular girl into a magical girl. These steps may go in sequence, or they may be combined:

1. Magic begins to appear.

2. Costume begins to change.

3. Magical effects become a torrent of swirls.

4. New costume becomes elaborate.

5. Magical effects change shape as new costume solidifies.

6. Magical effects dissipate.

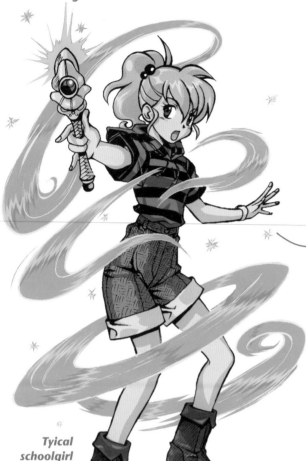

Magic sparkles are necessary. Without them the swirling effect would look like wind.

Character is posed to cover nudity. Swirls and flowing hair also conceal body.

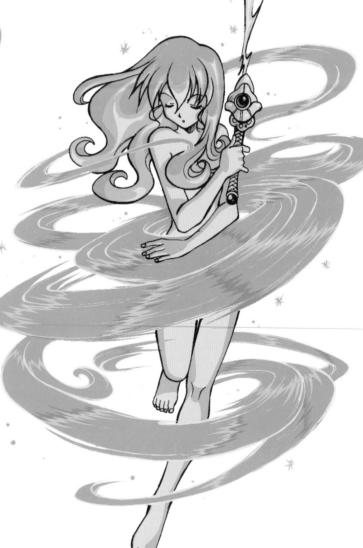

Tyical schoolgirl outfit.

Step 1: Regular Schoolgirl

She calls on the magic to transform her. At this point, like a thunderstorm on its way, there's just the rumble of magic in the air.

Swirls orbit the character.

Step 2: The Transformation Begins

The magic becomes a tornado swirling around the character as the old "her" is swept away. It's common for the magical girl to become nude when the transformation occurs. So position the special effects and the character to cover up, in order to retain modesty.

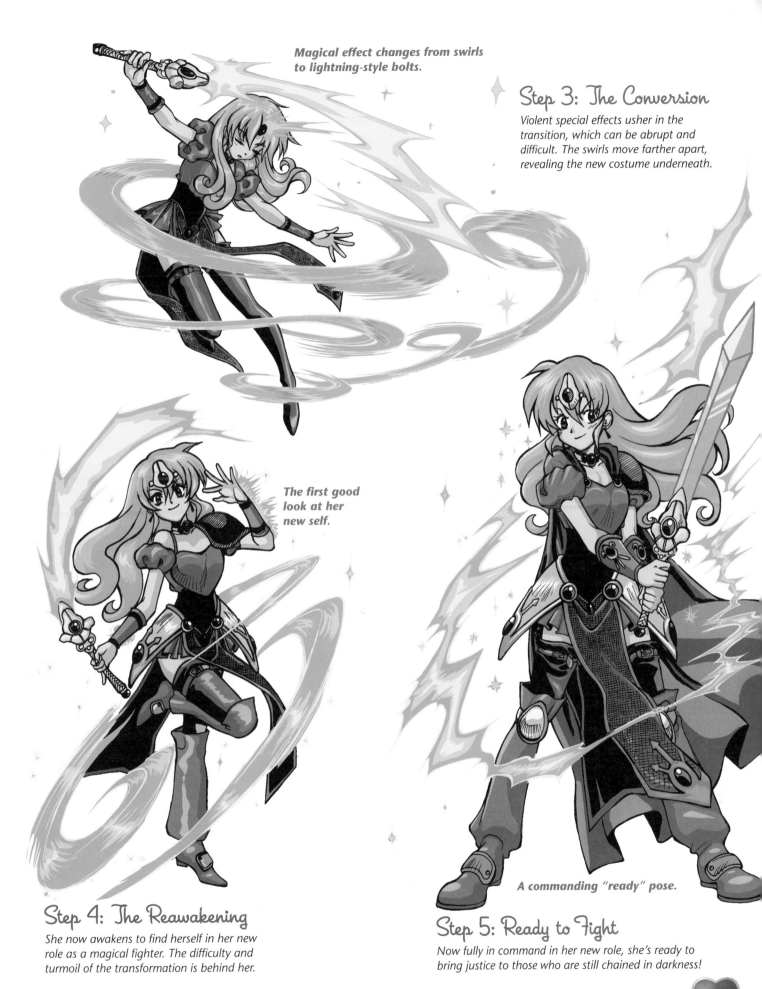

Magical effect changes from swirls to lightning-style bolts.

Step 3: The Conversion

Violent special effects usher in the transition, which can be abrupt and difficult. The swirls move farther apart, revealing the new costume underneath.

The first good look at her new self.

Step 4: The Reawakening

She now awakens to find herself in her new role as a magical fighter. The difficulty and turmoil of the transformation is behind her.

A commanding "ready" pose.

Step 5: Ready to Fight

Now fully in command in her new role, she's ready to bring justice to those who are still chained in darkness!

Transforming Magical Helpers

Often, the little magical mascots or helpers are on an urgent mission to bring a magical girl back to their world to save them from a dark lord. These little helpers can be quite persistent. They, too, can transform. And their transformation is sometimes just as astonishing as that of the magical girl. What starts out as a sweet, faerielike mascot, for example, can turn into a more aggressive creature in another dimension.

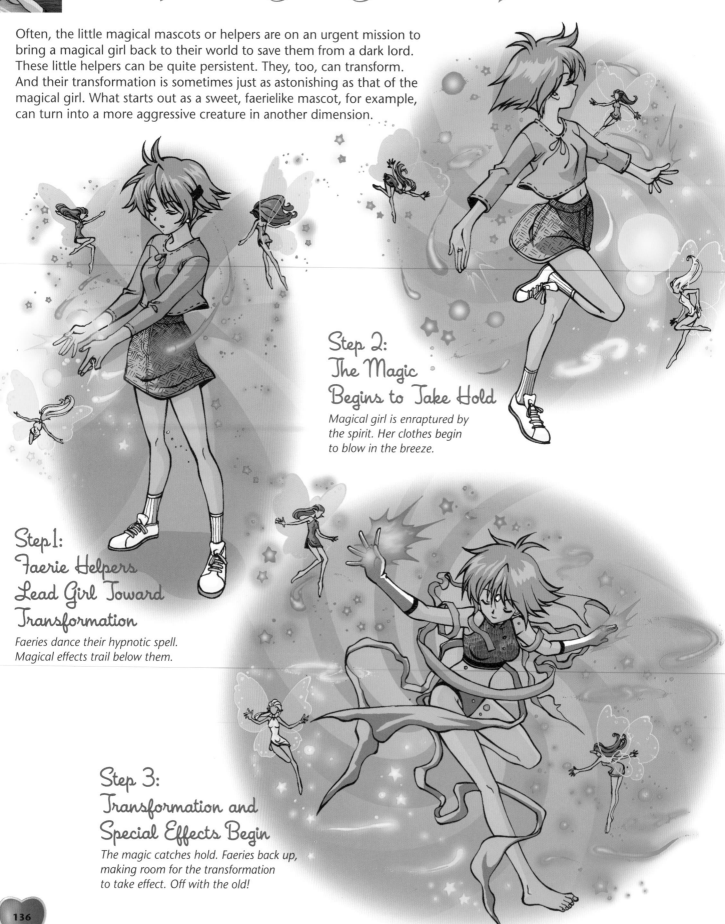

Step 2:
The Magic
Begins to Take Hold

Magical girl is enraptured by the spirit. Her clothes begin to blow in the breeze.

Step 1:
Faerie Helpers
Lead Girl Toward
Transformation

Faeries dance their hypnotic spell. Magical effects trail below them.

Step 3:
Transformation and
Special Effects Begin

The magic catches hold. Faeries back up, making room for the transformation to take effect. Off with the old!

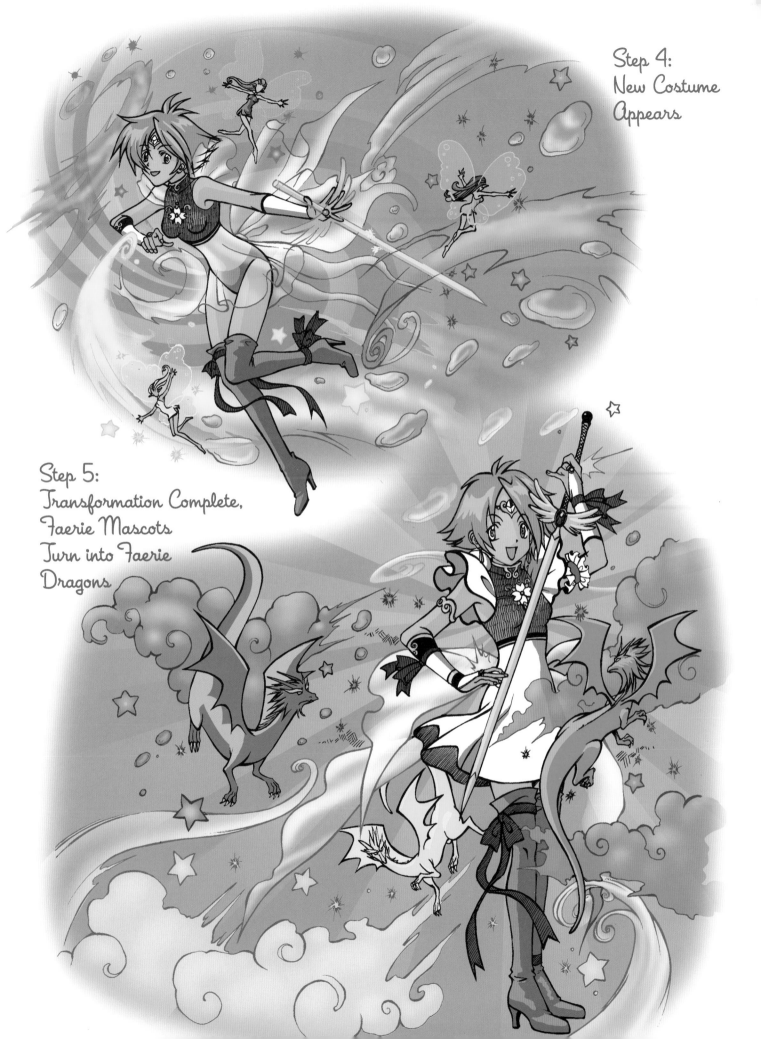

Step 4:
New Costume
Appears

Step 5:
Transformation Complete,
Faerie Mascots
Turn into Faerie
Dragons

Posing with Special Effects

In addition to creating cool transformations, you'll also want to combine fantastic magical effects with eye-catching poses. This really puts the icing on the cake. Start by sketching the outline of the body. Next, add the details of the face, as well as other details, like fingers and toes. Then, draw the costumes. The special effects always go last. (I know, I know . . . it's hard to wait to draw the fun stuff!) Although you may start off drawing the figure tentatively, once you've got your basic construction the way you want it, you should strive to finish your drawing with bold, confident strokes.

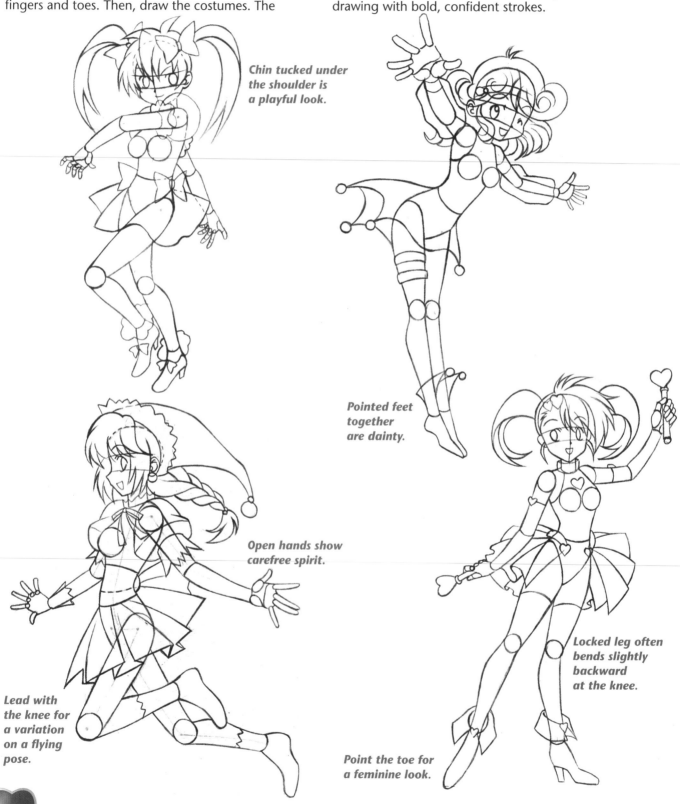

Chin tucked under the shoulder is a playful look.

Pointed feet together are dainty.

Open hands show carefree spirit.

Lead with the knee for a variation on a flying pose.

Locked leg often bends slightly backward at the knee.

Point the toe for a feminine look.

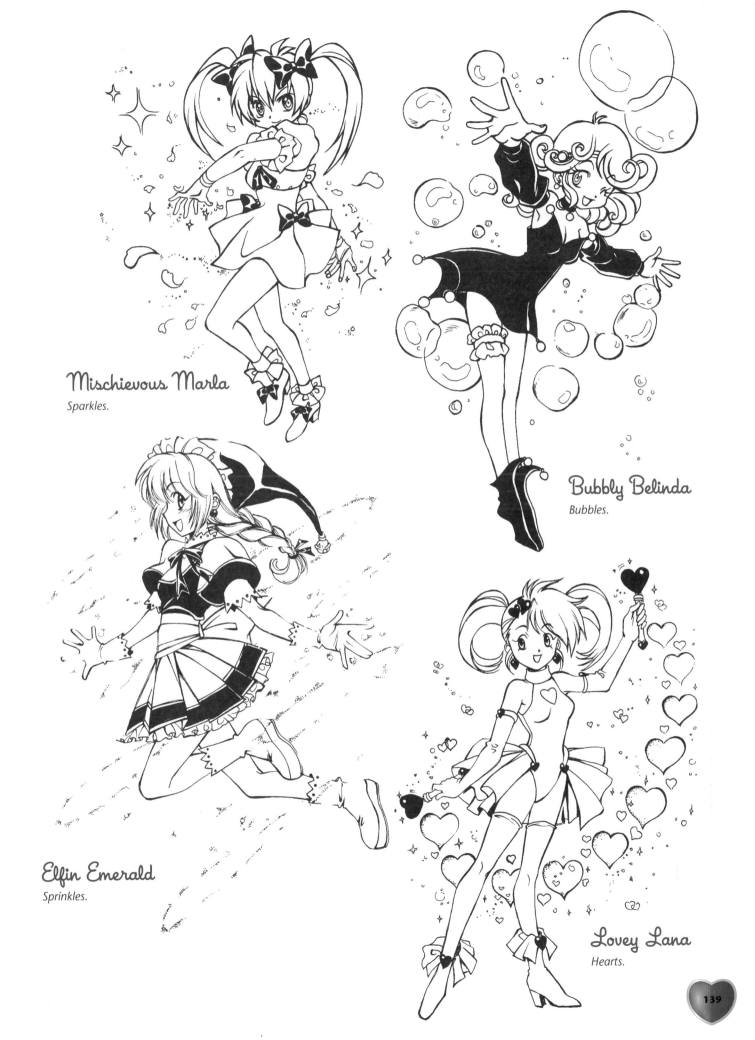

Mischievous Marla
Sparkles.

Bubbly Belinda
Bubbles.

Elfin Emerald
Sprinkles.

Lovey Lana
Hearts.

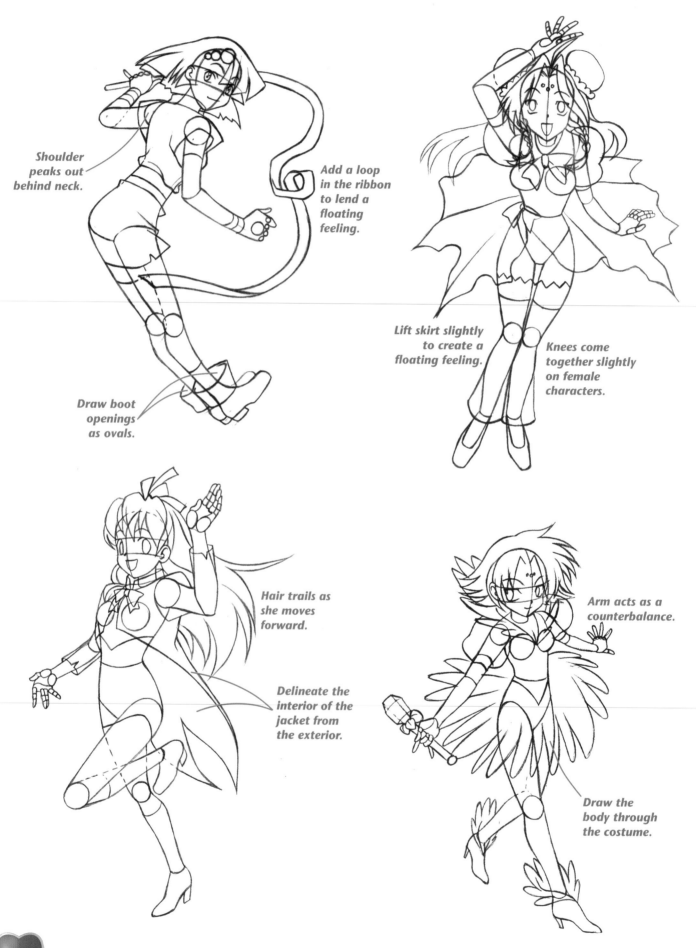

Shoulder peaks out behind neck.

Add a loop in the ribbon to lend a floating feeling.

Draw boot openings as ovals.

Lift skirt slightly to create a floating feeling.

Knees come together slightly on female characters.

Hair trails as she moves forward.

Delineate the interior of the jacket from the exterior.

Arm acts as a counterbalance.

Draw the body through the costume.

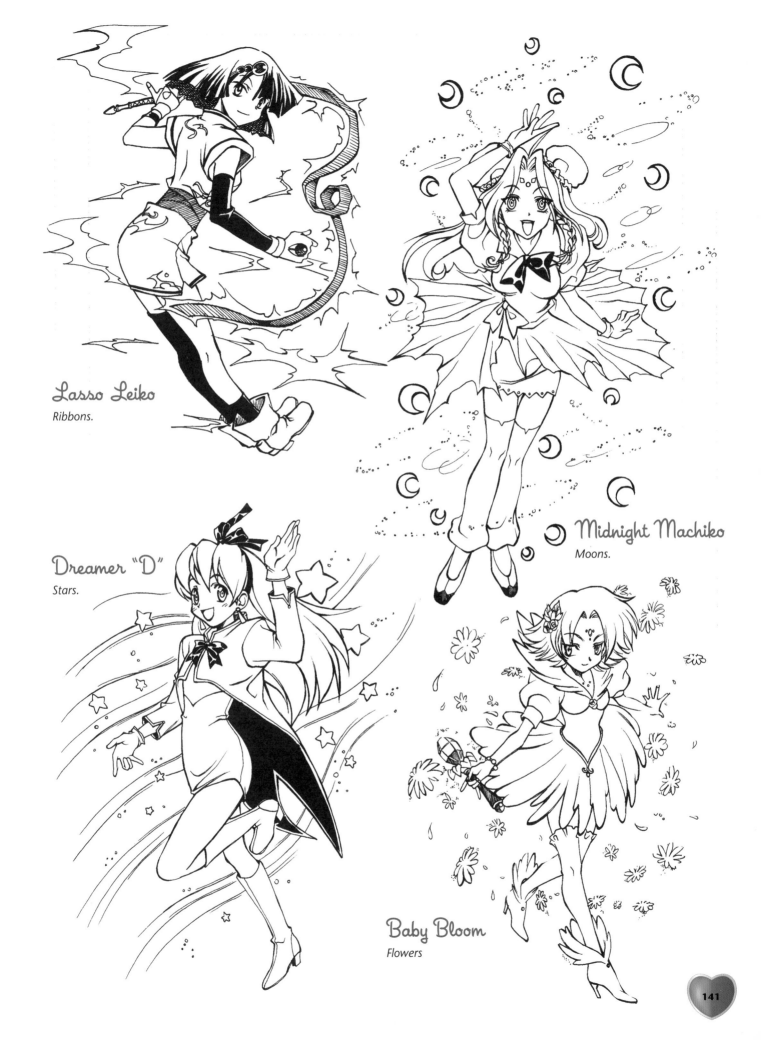

Lasso Leiko
Ribbons.

Midnight Machiko
Moons.

Dreamer "D"
Stars.

Baby Bloom
Flowers

Special Effects in Panels

By filling a graphic novel panel with special effects, you can see how magical girls command a scene. It's important to note several design techniques:

First, special effects don't always stop before they reach the panel's edge. Sometimes they bleed to the edge, where they're cut off. This makes the special effect look as if it's growing in size and strength.

Next, the magical girl doesn't have to be the biggest object in the panel. Often, she's outsized by the special powers she wields. But since her powers lead directly back to her, she's the nexus and, therefore, the focus of the panel.

Also, you can place the magical girl anywhere in the panel. She can be in full figure, cut off, floating, or standing.

In addition, the special effects can illuminate a dark background or can add a different hue to an already colorful background. They can serve as foreground or background, or they can surround her.

Sparks and Bursts	Hearts and Clouds	Rising Powers

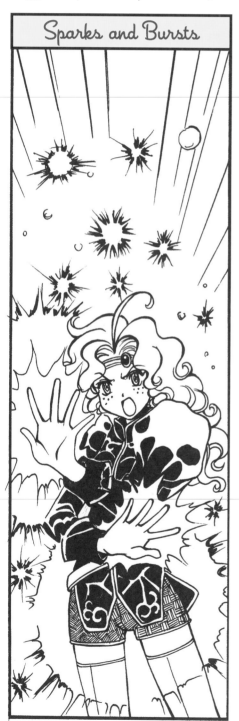

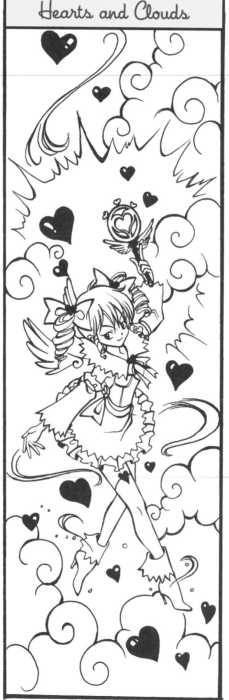

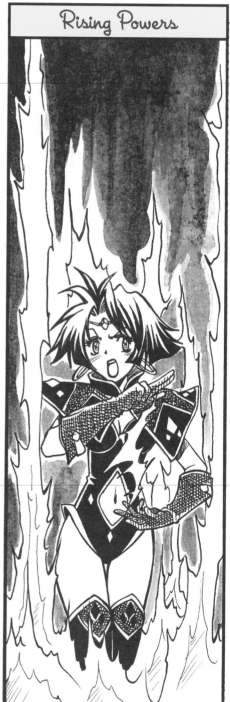

Giant Lightning Storm

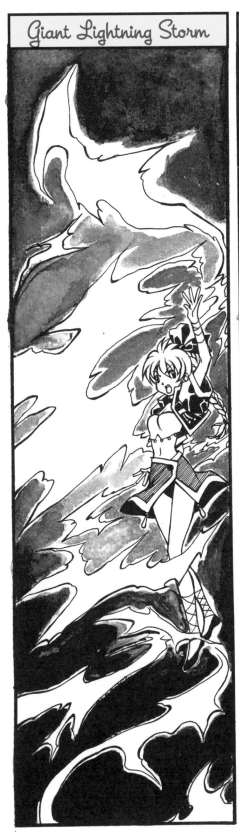

Electrical Charges

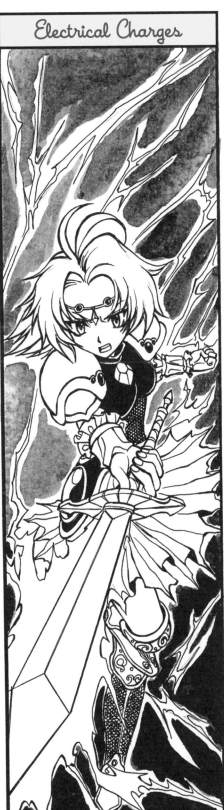

Sea of Flowers and Petals

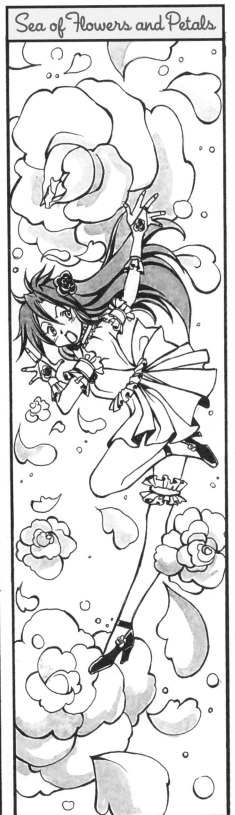

Index